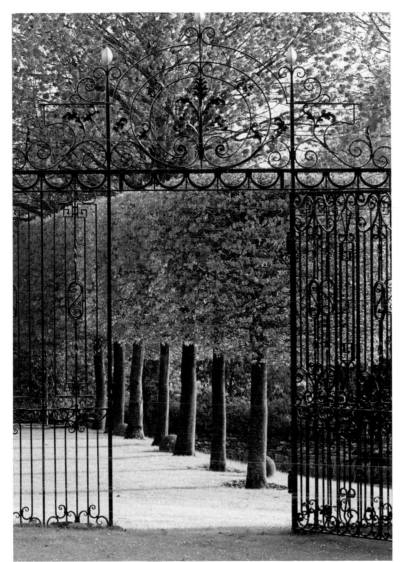

SECRET GARDENS OF THE COTSWOLDS

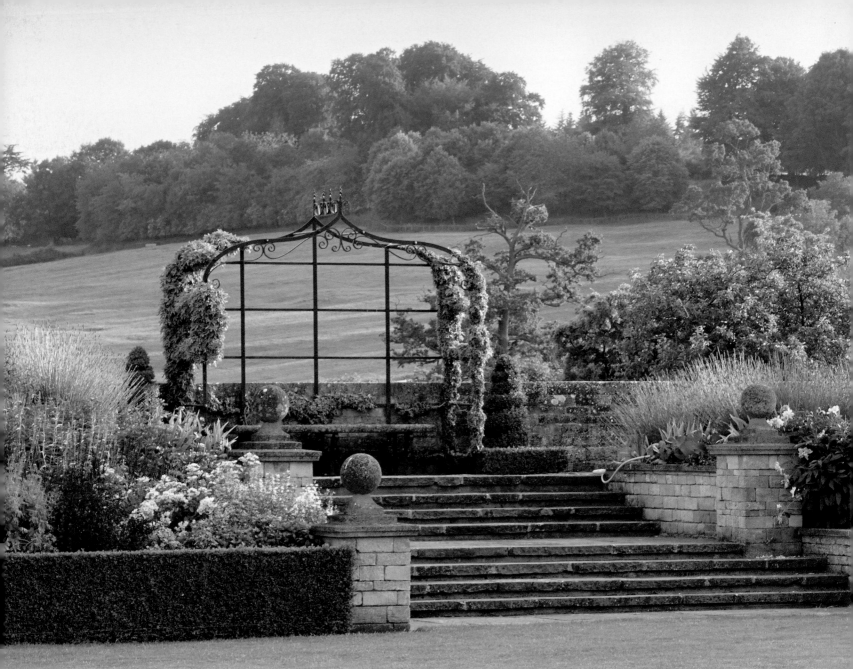

VICTORIA SUMMERLEY

PHOTOGRAPHS BY
HUGO RITTSON-THOMAS

F

FRANCES LINCOLN LIMITED
PUBLISHERS

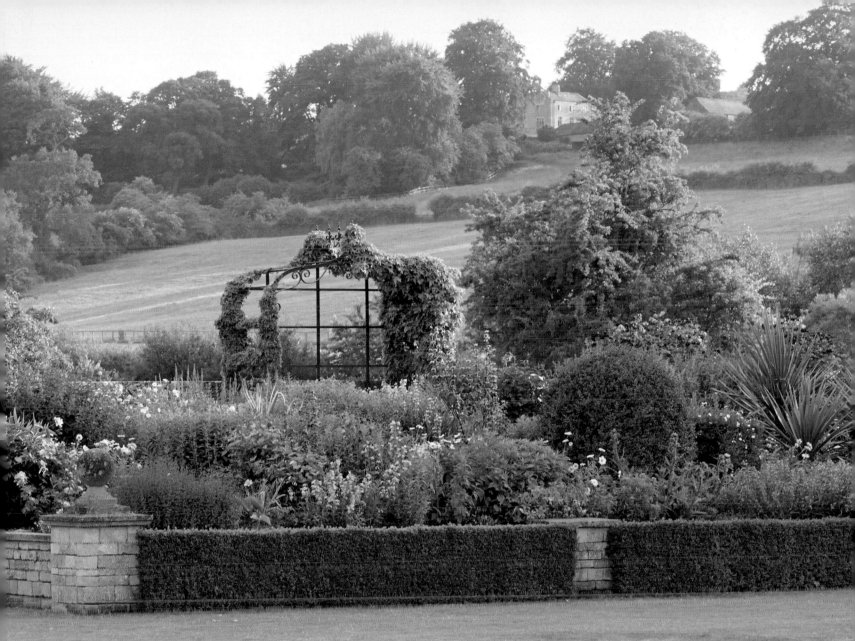

SECRET GARDENS OF THE COTSWOLDS

A PERSONAL TOUR OF 20 PRIVATE GARDENS

Contents

Secret Gardens of the Cotswolds
© 2015 Quarto Publishing plc
Text © Victoria Summerley 2015
Photographs copyright © Hugo Rittson-Thomas 2015

First Published in 2015 by Frances Lincoln,
an imprint of The Quarto Group.
The Old Brewery, 6 Blundell Street,
London N7 9BH, United Kingdom.
www.QuartoKnows.com

A catalogue record for this book is available from
the British Library.

978 0 7112 3527 4

Designed by Anne Wilson

Printed and bound in China

10

HALF TITLE A line of pleached hornbeams at Upton Wold
invites you to wander through the wrought-iron gates.
TITLE The raised walk at Bourton House, with its
stone benches and ogee arbours, looks out on to classic
Cotswold landscape.
OPPOSITE At Sarsden a mown path leads to the serpentine
lake designed by Humphry Repton.

Brimming with creative inspiration, how-to projects and useful information
to enrich your everyday life, Quarto Knows is a favourite destination for those
pursuing their interests and passions. Visit our site and dig deeper with our books
into your area of interest: Quarto Creates, Quarto Cooks, Quarto Homes, Quarto
Lives, Quarto Drives, Quarto Explores, Quarto Gifts, or Quarto Kids.

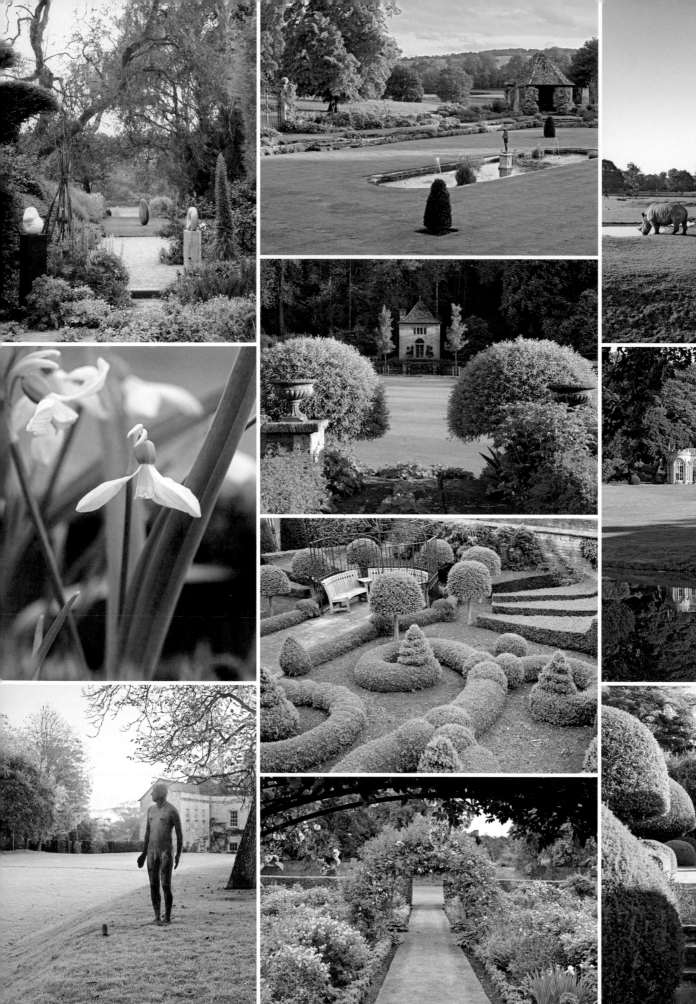

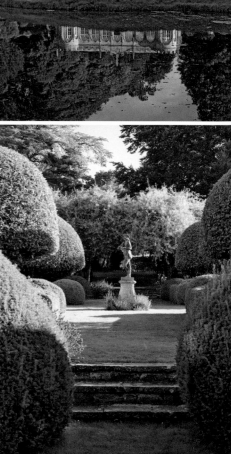

Introduction

AROUND TWENTY-FIVE years ago, I spent a weekend with the writer Anne de Courcy, at her cottage in Barnsley, in Gloucestershire. Anne, the biographer of Diana Mosley and Lord Snowdon as well as author of several other bestselling books, was at that time a colleague on the *Evening Standard* in London.

I was charmed by her pretty cottage, in a picturesque Cotswolds village. I loved the nearby town of Cirencester, with its market square and Roman history. Most beguiling of all, however, was the garden next door to my friend's cottage. It was Barnsley House, the home of Rosemary Verey. In those days you could wander out of the back of Anne's garden and into Rosemary's garden to admire the laburnum walk or the famous potager.

The year before my visit to Barnsley House, Prince Charles had come to seek advice from Rosemary Verey on the garden he was making at Highgrove, his Gloucestershire home. I had no such great project and felt far too intimidated by Mrs Verey – by then a horticultural household name thanks to her royal connections – to ask for her thoughts on my tiny basement garden in south-east London. I merely smiled politely when we were introduced and shuffled my feet like a bashful schoolgirl.

I have to confess that much of the thrill of that informal visit to Barnsley House came not from admiring the plants, nor the design of the garden, but from a sense of privileged access. Throughout history, the notion of a secret garden has cast a spell over us, whether it is the *hortus conclusus* of Renaissance art and literature or the classic children's story by Frances Hodgson Burnett. The chance to explore other secret gardens for the purpose of writing this book became irresistible.

Not all of the gardens described in *Secret Gardens of the Cotswolds* are completely secret. Many open one day a year for charity, or even for three days of the week (such as Sezincote and Bourton House) during the summer months. I felt it would be rather frustrating for readers of this book if they had absolutely no chance of seeing any of these gardens for themselves.

Roses around the door

As a result of my trip to the Cotswolds to stay with my friend Anne, some sort of seed must have lodged in my brain, because during the following decades, while I toiled in Fleet Street and brought up my family, I used to dream of moving to the country. I wanted to be somewhere within reach of a civilized town such as Cirencester; I wished for a chocolate-box cottage with roses around the door; and I dreamt of being surrounded by a garden that dripped with wisteria and clematis, and of breathing air that was heavy with the scent of lavender.

In November 2012 my dream came true. I quit my job as executive editor of *The Independent* and moved to a Cotswolds village just 5 kilometres/3 miles from Barnsley. Rosemary Verey had meanwhile died in 2001, and today Barnsley House is a hotel. Its garden is open on a fairly regular basis for garden tours – led by head gardener Richard Gatenby, who also worked for Mrs Verey – but this is not the same as sneaking in through the back gate.

A disappearing world

I will not try to pretend that my motives for writing *Secret Gardens of the Cotswolds* involved anything other than deep-seated curiosity. I am not an academic, nor am I an antiquarian, and I cannot cloak my inquisitiveness in the clean white gloves of the archivist. It did become clear to me, however, that, by their very nature, some gardens in the Cotswolds were in danger of being unrecorded in any great detail. Take Abbotswood, for example – the garden created by Mark Fenwick in the first half of the twentieth century. It is open to the public only twice a year under the National Gardens Scheme, and little is generally known about Fenwick himself, despite the fact that he was a distinguished plant collector. The head gardener at Abbotswood, Martin Fox, is a plantsman par excellence. He and his wife Bridget know every bit of the garden and, when you talk to them, it is obvious that they have a genuine sense of stewardship. Yet when they retire, their knowledge and experience will be lost.

Thus I became very aware that my glimpse over the garden walls or yew hedges of these secret gardens was more than just a casual glance. It was an insight into a world that is slowly disappearing.

At many gardens, the gardening staff now number two or three, often part-time workers. A hundred years ago, there would have been ten gardeners at such properties. Owners such as Stephanie Richards at Eastleach House make up the deficit in manpower, defying the typical war wounds suffered by gardeners of advancing years – arthritic hips, knees, shoulders, hands – in order to do so.

Shared experience

Photographer Hugo Rittson-Thomas also lives in the Cotswolds, and we are both keen gardeners. Our gardens are works in progress. Hugo's garden at Walcot House (see page 130) is on a far grander scale in terms of archaeological importance, yet mine is no less challenging for being in full view of any passers-by. My efforts to tame my plot (the previous owners used the house as a holiday home for forty years) are daily documented by the coachloads of tourists who visit the village.

Hugo and I could sympathize with the owners who told us, 'When we came here, there was nothing but a tangle of brambles, nettles and ground elder', as we know only too well that this is the state to which any Cotswolds garden left to its own devices will gleefully revert.

I would like to take this opportunity to thank these and the other owners and the head gardeners who gave up their time to talk to me, and who allowed Hugo to photograph their gardens. This was often at rather antisocial hours, such as dawn, when the oblique light produces a softer, more glowing result.

People often ask if we visited the gardens together. The answer is 'No'. The jobs of the writer and the photographer are similar in that they both aim to provide an impression, but in order to create this snapshot a vast mound of information is required, much of which is later discarded. You do not know what is going to be useful until you come to write the piece or edit the pictures, but, in the meantime, the idea of Hugo having to listen to a discussion about when to mow a wildflower meadow while he was trying to work out the best shot of a Judas tree in full bloom did not seem to be a sensible one.

There is a tradition – and as far as I can tell this applies throughout the world – that gardeners are generous with their advice, their time and their produce. This proved overwhelmingly to be the case in the Cotswolds. Again and again, I would climb wearily into my car to return home with my head spinning with information and the back seat laden with a bunch of freshly picked flowers, a couple of squashes or a bag of apples, or some leeks, or some cuttings. In the case of Colesbourne Park, of course, it was a choice snowdrop.

The value of good design

Throughout my visits to the extraordinary gardens described in this book, Rosemary Verey's personality never seemed very far away. She had either designed part of the garden (as at Kingham Hill House) or had advised the owner (as at Eastleach House and Ablington Manor), or had left her mark in other ways. One head gardener told me she was once invited to lunch by his employers, who asked her advice about a particular corner of the garden that was proving problematic. Mrs Verey immediately made a suggestion, sketched it out on a piece of scrap paper – and, a week later, sent in her invoice for the design.

She was never one to undervalue the worth of a skilled garden maker. I think this book proves that, despite social changes and economic crises, there are still plenty of such gardening experts left in the stunningly beautiful region we know as the Cotswolds.

Victoria Summerley

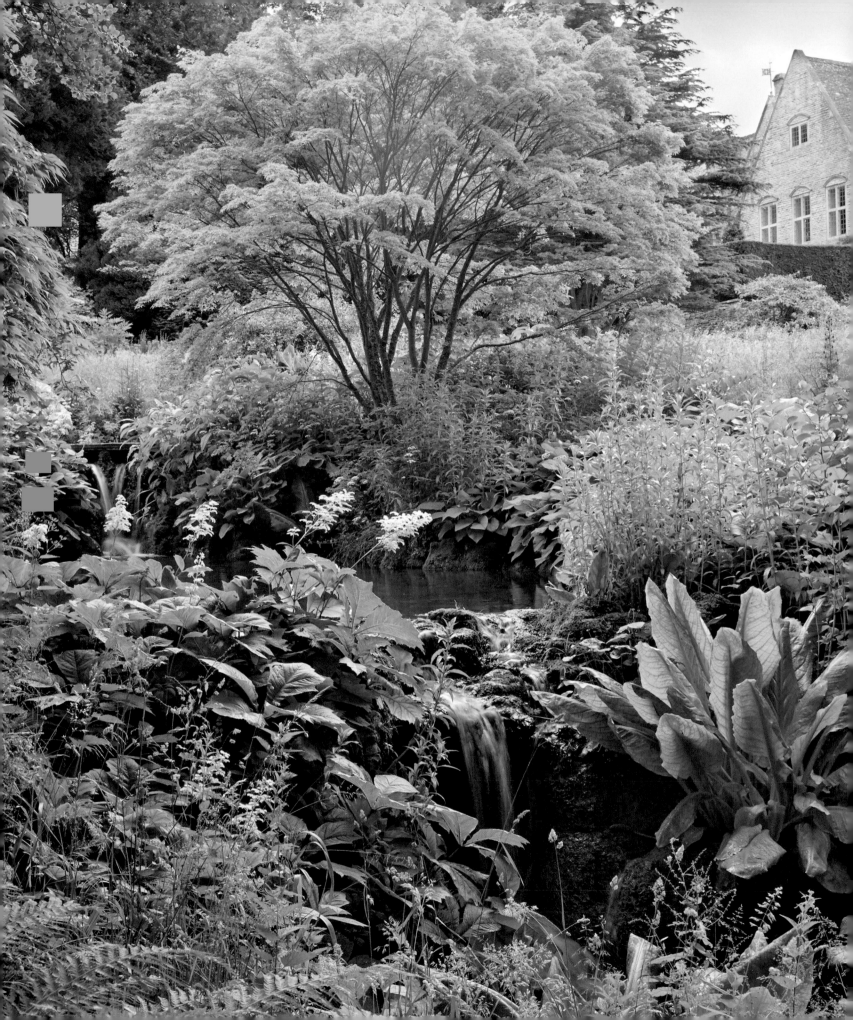

1
Abbotswood

Stow on the Wold

SOME GARDENERS would move heaven and earth, as the saying goes, to create the garden of their dreams. Mark Fenwick contented himself merely with moving the earth. He was a member of a Northumberland banking family (they owned Lambton's Bank, later sold to Lloyds), and a director of the Consett Iron Company. He had money, therefore, but more importantly he had enthusiasm and knowledge.

Fenwick was a keen amateur gardener with a particular penchant for plants that like acid soil – rhododendrons, camellias and azaleas, in particular. He was typical of that generation of self-taught English gardening heroes – Vita Sackville-West at Sissinghurst, Lawrence Johnston at Hidcote, Lionel Fortescue at The Garden House in Devon and E.A. Bowles at Myddelton House in Enfield – who used their enthusiasm and vision to create very personal spaces that still delight gardeners today. What Alexander Pope called the 'genius of the place' seems far more willing to obey the summons of a determined and inspired individual than to answer to a committee.

One is tempted to wonder what Fenwick saw in Abbotswood, when he bought it in 1901. The estate is situated just outside the Cotswold town of Stow on the Wold, and it lies on Cotswold limestone – not exactly an ideal environment for calcifuges (lime-haters) such as rhododendrons. As far as the house was concerned, the advice of Sir Edwin Lutyens, commissioned by Fenwick to remodel the building and the surrounding gardens, was: 'Blow it up and start again!'

Fenwick's wife was devoted to country sports, however, and an estate in the Cotswolds has been an attractive proposition since Roman times. Fenwick therefore solved the limestone problem by importing acid topsoil from Somerset – tonnes of it. It was transported

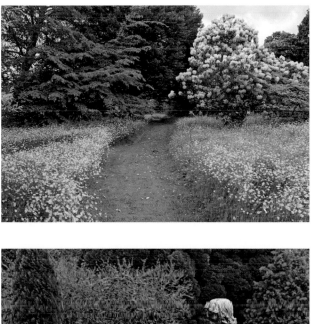

TOP In late spring and summer, paths are mown through the wildflower meadows.
ABOVE One of the most spectacular spring-blossom displays at Abbotswood is provided by its Judas tree.
OPPOSITE As the stream reaches the lowest part of the gardens, the planting becomes increasing lush, with the huge leaves of skunk cabbage vying for the spotlight with *Aruncus dioicus* and *Rodgersia pinnata*.

to Moreton-in-Marsh by rail, then loaded into horse-drawn carts for the 8-kilometre/5-mile journey to Stow. The result is more 'Monarch of the Glen' than Moreton-in-Marsh, and if you visit on a day when the weather is damp and misty (a not unknown phenomenon in south-west England), it seems as if you have been transported out of Gloucestershire and into Yorkshire or the Scottish Highlands.

In late spring, the blazing pinks and oranges of the rhododendrons and azaleas vie with the vibrant purple blossom of a huge Judas tree (*Cercis siliquastrum*), while native wild flowers such as cow parsley and snake's-head fritillaries (*Fritillaria meleagris*) grow alongside non-native species such as skunk cabbage (*Lysichiton americanus*) and ornamental rhubarb (*Rheum palmatum*) where the stream waterfalls its way down the hill.

Lutyens's contribution to the garden was a series of formal, south-facing terraces, linked by his trademark shallow stone steps and views over idyllic pasture. The gazebos are reminiscent of the pavilions at Hidcote and may indeed have inspired them, because Lawrence Johnston and Mark Fenwick were great friends. Fenwick seems to have been a kind and thoughtful landlord,

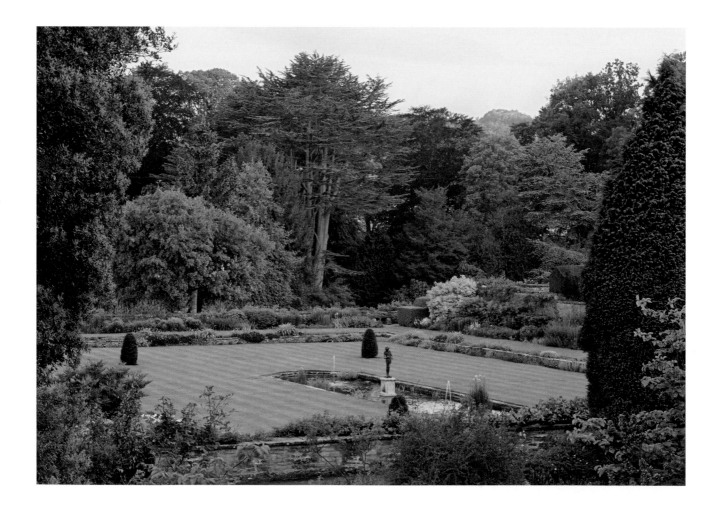

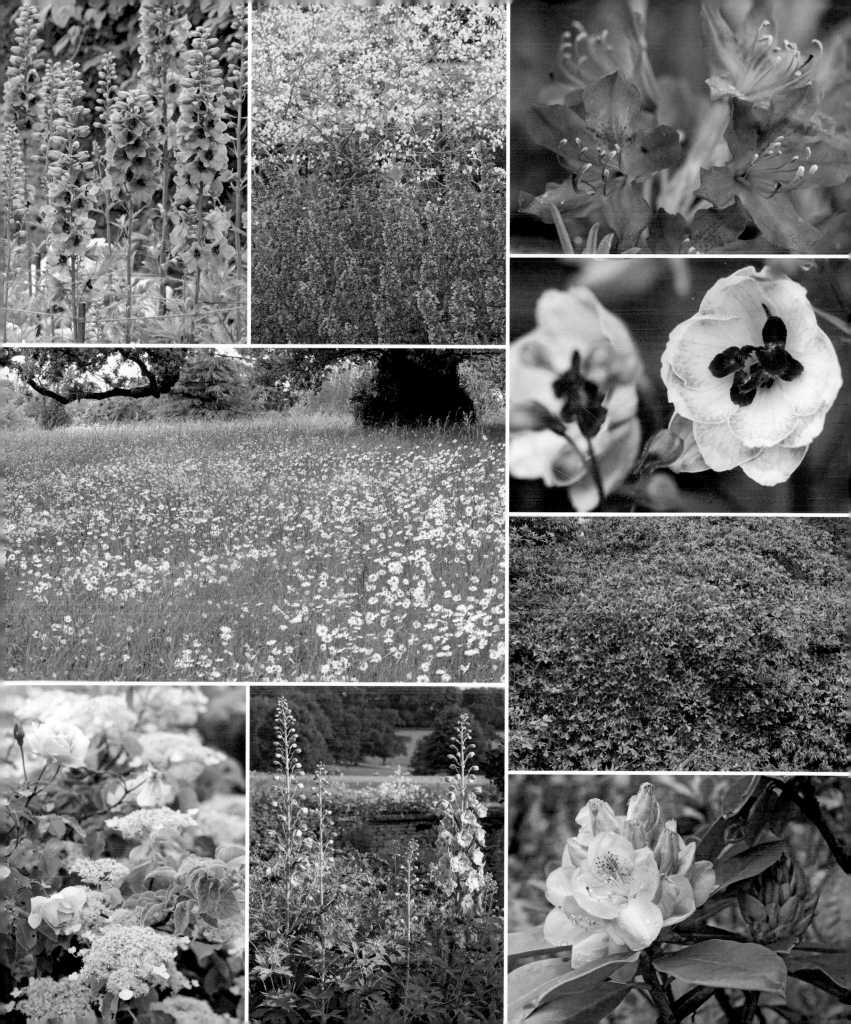

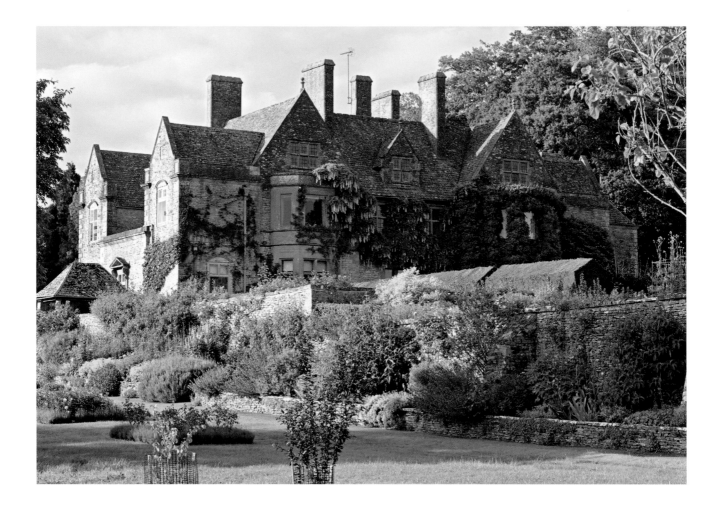

'The advice of Sir Edwin Lutyens, commissioned to remodel the house and gardens, was to blow it up and start again.'

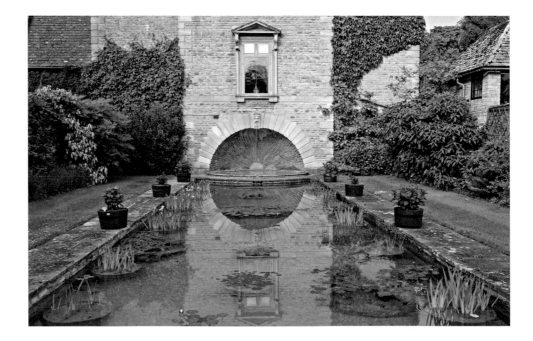

ABOVE The stone pavilions in the formal gardens are thought to have inspired the pavilions at Hidcote.

LEFT The rose garden is a series of geometric shapes reminiscent of a Greek key design and hedged in box.

OPPOSITE ABOVE The house at Abbotswood was originally built in 1867 by its then owner, Alfred Sartoris.

OPPOSITE BELOW The formal pool on the west side of the house, known as the 'lily tank', was designed by Lutyens. The keystone in the semicircular arch bears a head of Neptune.

because he also commissioned Lutyens to design the war memorial for the village of Netherswell.

To a generation accustomed to thinking of Lutyens as a patron saint of garden design, these formal gardens might seem the ultimate in desirability, but they are not regarded as universally successful by those who know them well. Current head gardener Martin Fox mutters about the narrow width of the borders, and Russell Page, the great British landscape designer who died in 1985, condemned them as 'over-mannered'. Indeed, Page reported that Fenwick slightly lost interest in the formal gardens almost as soon as they were finished; instead, he devoted his time

ABOVE In the 'wild' garden, Mark Fenwick planted the many trees and shrubs he collected.
OPPOSITE Martin Fox, here with his wife Bridget, is head gardener at Abbotswood.

to the hillside 'wild' garden he was making, where he could indulge his love of plants with a vast collection of specimens. Not surprisingly, this Wild Garden formed yet another common interest for Fenwick and Johnston, who went plant hunting together in the Haute Alpes, and it is the highlight of Abbotswood.

Page visited Abbotswood around 1930, by which time Fenwick was crippled with arthritis. In Page's autobiographical *The Education of a Gardener* (1962), he describes the daily excursions to inspect the new garden's progress: 'Morning and afternoon, Mark Fenwick would heave himself into his electric bath chair, see that his notebook and pencil were securely fastened to his coat by bits of string, summon Mr Tustin his head gardener, and off we would set.'

The problem with plantaholics' gardens is that they can be more like stamp albums than gardens, with greater

attention given to the specimens than to the overall effect. Page felt Fenwick had overcome this tendency with a keen appreciation of form and texture.

'I came to know this garden at every season [writes Page] from the first young growth of *Cercidiphyllum japonicum* [katsura] and the flowering of the tulip species, anemones and primulas in spring to the mid-autumn scarlets of Japanese maples, the mauve of autumn crocuses and the muted tones of the heath in winter.

'A feeling of youth and gaiety ran right through the garden and most touching of all was my host's enthusiasm, his patience with youth and ignorance, his vitality and good spirits. He seemed happy to inculcate his love and knowledge of gardening into anyone who wished to learn.'

Mark Fenwick's generosity included lending Abbotswood to the Red Cross as a hospital during the First World War. He included the use of his own kitchen staff, the dairy and the vegetable produce, and the Red Cross yearbook of 1915 describes it as 'one of the most beautiful gardens in Gloucestershire'.

Botanical legacy

The kitchen gardens at Abbotswood are approximately 0.8 kilometre/½ mile from the house – they were built to be near the original house on the site – but it is worth the walk. They are surrounded by high brick walls, except to the south, where the wall has been replaced by a hedge of field maple (*Acer campestre*). Along the north side, there are the glasshouses and back sheds.

The plot is huge: about 0.8 hectare/2 acres. It is too big for the needs of a modern household, and part of it has been turned into a Rose Garden, hedged with *Rosa rugo*sa. This is a romantic oasis amid the utilitarian, regimented rows of the kitchen garden, yet it has a practical benefit in that it helps to encourage pollinators. There are roses inside the glasshouses too, as well as a mouth-watering selection of peaches.

Mark Fenwick died in 1945, and the estate was sold to Harry Ferguson, the tractor designer, whose main contribution to the gardens was the excavation of the lake.

Naturally, when doing this he used his highly successful Ferguson TE20 design – commonly known as the 'Little Grey Fergie'. Abbotswood is now owned by the Dikler Farming Company. Martin Fox is only the fourth head gardener there since Fenwick's time, which adds to the sense of a strong connection to the past. Head gardeners are far too discreet to express a preference for any part of their garden, but you sense that Fox, like Fenwick, is happiest in the plantsman's paradise that is the Wild Garden.

Fenwick's contribution to English gardening was rewarded by the Royal Horticultural Society (RHS) with their prestigious Victoria Medal of Honour, so it is not surprising that his legacy hangs in the air like the perfume from one of his beloved azaleas. If you visit today, you can almost imagine he is still somewhere about the grounds in his electric bath chair, issuing instructions, making lists and enthusing about the latest additions to his plant collection.

2
Ablington Manor
Ablington

NO ONE QUITE KNOWS when J. Arthur Gibbs came to Ablington Manor. He was about twenty-six at the time, and saw his role as that of 'a young squire of whom nothing more is expected than to stay at home farming and looking after the place'. He died in 1899, at the age of thirty-one, but the previous year he had published *A Cotswold Village*, a lyrical account of Gloucestershire life.

To modern eyes, it may seem archaic ('Alas! that there should exist in so many country places that class feeling that is called Radicalism!') and sometimes even offensive in parts, with its constant references to various forms of hunting, shooting and fishing – such as the Sparrow Club, which gave boys a farthing a head for every sparrow they killed and awarded prizes for the greatest number killed. However, *A Cotswold Village* played an important part in the start of a tourism trend that still brings thousands of visitors to the Cotswolds each year.

Gibbs felt strongly that landowners should take an interest in their humbler neighbours, and he would never have been able to chronicle the traditions and pastimes of village life if he had not been a friendly, approachable figure. It must also have helped that he was a first-class cricketer, playing for Somerset and then his country.

Sportman's paradise

The garden today looks in many ways the same as the one Gibbs saw when he first viewed Ablington. It had:

> 'a broad terrace running along the whole length of the house, and beyond that a few flower beds with the old sundial in their midst . . . Beyond these a lawn, and then grass sweeping to the edge of the river some hundred yards away. The river here had been broadened to a width of some [27 metres] 90 feet, and an island had been made. The place seemed to be a veritable sportsman's paradise! Dearly would Izaak Walton [the seventeenth-century author of *The Compleat Angler*] have loved to dwell here!'

LEFT The River Coln, which offers some of the best trout fishing in England, runs through the grounds of Ablington Manor, which was built in the late-sixteenth century.
RIGHT Robert Cooper, the current owner of Ablington Manor, is seen here with his wife Prudence.

The island is still there, and so is the 'magnificent hanging wood' on the other side of the river, where Gibbs saw rabbits at play. However, Robert Cooper, the current owner of Ablington, has planted more than a hundred varieties of trees since he came here thirty-nine years ago. These include *Parrotia persica* 'Vanessa', *Acer rubrum* 'October Glory', *Malus* x *atrosanguinea* 'Gorgeous', with its vivid cherry-coloured crab apples, and yellow buckeye (*Aesculus flava*). The buckeye is a favourite with Cooper's wife Prudence, a knowledgeable and enthusiastic gardener who, Cooper stresses, has made a huge contribution to the garden during the past fifteen years. Cooper's planting philosophy is very much 'The more gold and purple the foliage is, the better. I have got to the age where I do not need to conform.'

On the edge of this young plantation stands a pink granite memorial. It is dedicated to 'Polly, a favourite mare', who died at the ripe old age of twenty. Polly's owner

was Cooper's great-grandmother. According to Cooper: 'She wrote to her son, who was fighting in the Boer War, to say how upset she was by the death of her horse. He was very unsympathetic to such sentimentalism, being more concerned that the troops did not have enough food.' The beds around the memorial are planted with *Iris* 'White Swirl' – an inspired and sophisticated choice.

When Cooper bought Ablington, he recalls, there was 'not a single stone path, just gravel; not a single border except two island beds full of rotting roses, and the river banks were not walled.' Since then he has transformed the garden, but, being a former keen soldier, he is the first to admit to being rather regimented in his planting scheme. He has no formal training and says he never had a grand plan for the garden.

He designed the elegant pavilion that faces the house from across the river, and if its appearance is reminiscent of a French pigeonnier then that seems entirely appropriate. Nearly every Cotswold farm or estate has its dovecote, usually in the form of chequered brick pigeonholes in a barn gable. The birds were introduced to Britain by the Normans, who had far more success in convincing the English that pigeon eggs might help to see them through the winter than they ever had in persuading the recalcitrant Anglo-Saxons that French should be their chosen language.

Some changes to the Ablington garden have been the result of a lucky chance; others were more pragmatic. The terrace at the rear of the house, for example, is York stone, salvaged from Leeds Town Hall. On another occasion, Rosemary Verey, creator of the world-famous Barnsley House gardens a couple of villages away, was asked to redesign part of the old Kitchen Garden as a Sunken Garden with a criss-cross design of pleached limes (*Tilia*). On the day work was due to start, the foreman pointed out that the garden was not square, and the criss-cross would be more of a shallow X-shape. Cooper therefore suggested they abandon the criss-cross idea and instead form two avenues with the pleached limes. At this point, the foreman drew attention to a second problem – the garden was not flat. In the end, Cooper decided to build steps and pergolas to accommodate the change of level, and the Verey plan was consigned to the wastepaper basket. Ten years later, Verey brought out a book on garden design, which nonetheless included this alteration as her own.

ABOVE Yew topiary rises
from the lawns like the
ramparts of an ancient castle.
LEFT Shrub roses
line the riverbank at
Ablington Manor.
OPPOSITE TOP The pavilion,
which faces the house from
the other side of the river,
was designed by Robert
Cooper, the current owner.
OPPOSITE CENTRE This
memorial is to 'Polly, a
favourite mare'.
OPPOSITE BOTTOM The
wooden bridge that leads
from the main garden to the
pavilion is supported on
piers of local stone.

Ablington Manor 21

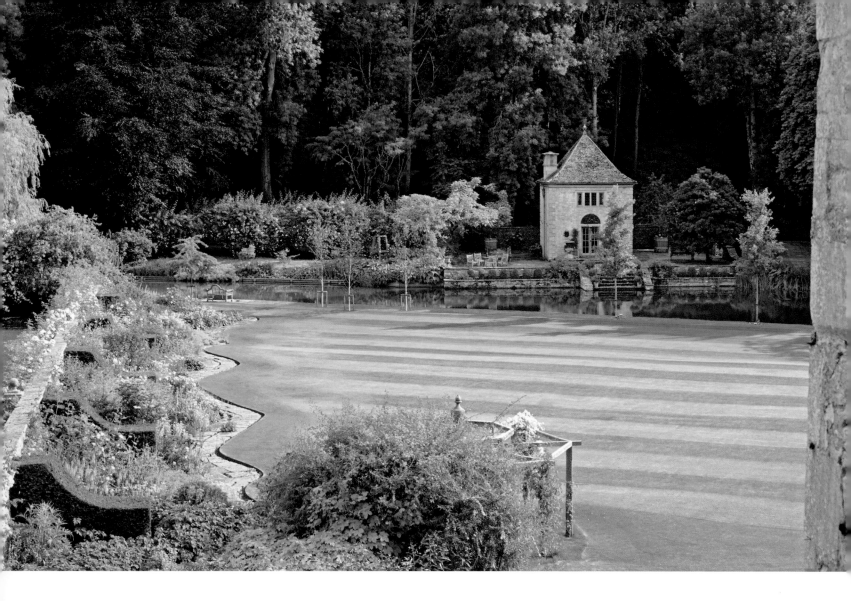

ABOVE The yew buttresses
that punctuate the main
herbaceous border are
emphasized by the
serpentine path. In the
foreground, the 'Catherine
Wheel' pergola is
just visible.

RIGHT A detail of the
planting reveals the smoky
purples of *Sambucus nigra*
and sedum, and the deep
reds of penstemons.

OPPOSITE The Sunken
Garden was created from
part of the old Kitchen
Garden. The design, by
Rosemary Verey, was subject
to a few 'modifications'.

In another area of woodland, which runs along the riverbank before the Coln flows into the estate, the canopies of the trees have been raised, and roses and hardy geraniums planted beneath them. Germander (*Teucrium fruticans*), with its blue flowers and aromatic foliage, takes the place of low box hedging.

On the sunny terrace, there are cushions of rock rose (*Helianthemum*), and beyond the terrace is the 'Catherine Wheel' – a circular pergola planted with *Rosa filipes* 'Kiftsgate'. Originally, there was a crab apple (*Malus*) here, with a Kiftsgate rose climbing through its branches, but the tree eventually collapsed and the pergola took its place. This all happened around the time of the wedding of Prince William to Catherine Middleton, in 2011, hence the nickname.

In the border by the Walled Garden, the 'bright orange marigolds and large purple poppies' of Gibbs's time have given way to more subtle contemporary favourites, such as sedums and penstemons. If he were to step into the garden today, however, I think that the young squire would probably agree with the words he recorded in his book more than a hundred years ago: 'What a charm there is in an old-fashioned English garden.'

'What a charm there is in an old-fashioned English garden.' J. ARTHUR GIBBS

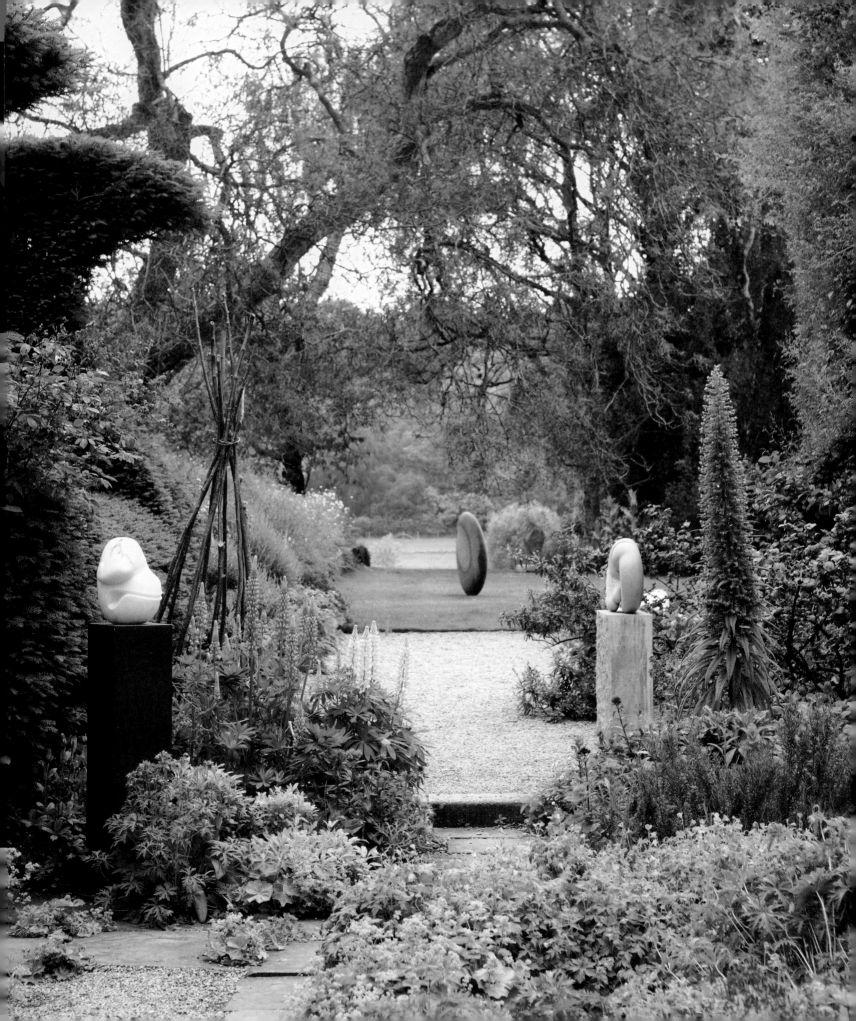

3
Asthall Manor
Burford

THERE IS A FAMOUS PICTURE of the Mitford family sitting on the steps of Asthall Manor, where they lived from 1919 to 1926. Lady Redesdale (immortalized as Muv/Aunt Sadie in Nancy Mitford's novels) stands on the left, with an air of vague detachment. Lord Redesdale – the irascible Uncle Matthew of Nancy's stories – sits on the right next to Pamela (the second eldest daughter), looking down at his family. Nancy herself is at the back, next to her brother Tom, while her sisters – Unity and Diana (with their hair in plaits) and the two youngest, Jessica and Deborah (Debo) – stare into the camera with the typically challenging Mitford gaze.

Asthall itself is immortalized in Nancy's novels as Alconleigh, which forms the backdrop for *The Pursuit of Love* and *Love in a Cold Climate*. The Mitfords had moved there from Batsford Park, now an arboretum with Britain's biggest private collection of trees and shrubs. When they left it was to go to the neighbouring village of Swinbrook, where Lord Redesdale built a house to his own design.

But it was Asthall that they loved: this is where the Mitfords met in the Hons' Cupboard (which, being a linen cupboard, was the warmest room in the house). As daughters of a baron, the girls were entitled to the prefix 'The Honourable', which is a courtesy address and only ever used in correspondence. Invariably, it is abbreviated to 'The Hon.'

Asthall was where Debo Mitford, later to become the Duchess of Devonshire, kept hens and sheep – a forerunner of the farmyard at Chatsworth House – and where Unity and Jessica Mitford, who supported fascism and communism

respectively, carved swastikas and hammers and sickles into the window panes with a diamond ring.

The house was built in the early seventeenth century. It was a mellow Cotswold limestone building, with mullioned windows, basking on the south side of the River Windrush between Burford and Witney in Oxfordshire. John Freeman-Mitford, the 1st Baron Redesdale, acquired

LEFT Sculpture on show in the garden competes visually with the spires of lupins and an echium.
RIGHT Rosie Pearson is the current owner of Asthall.

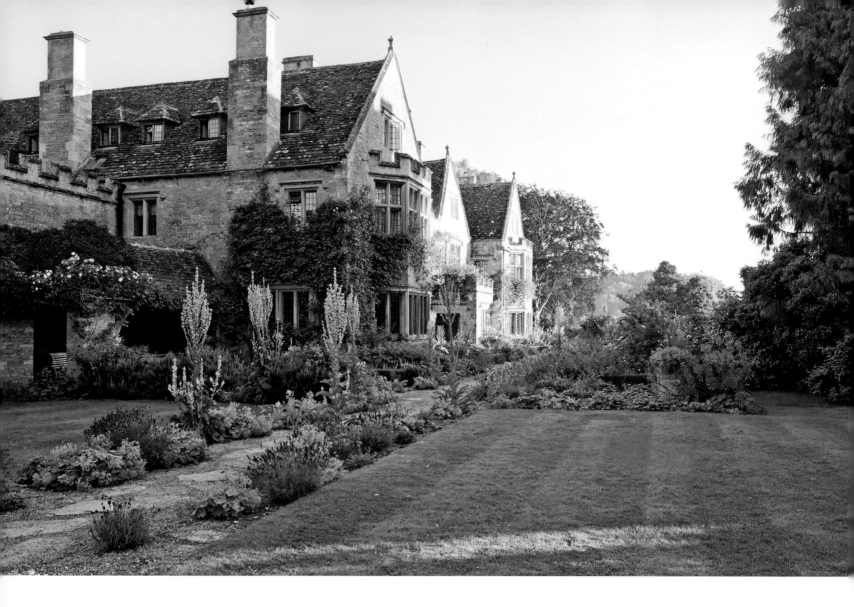

A living embodiment of the classic English garden – billows of cow parsley and roses, peonies and irises, with hedges of box and lavender.

the estate between 1810 and 1812, and Lord Redesdale (David Freeman-Mitford) inherited it in 1916, although the family did not immediately move there.

Despite its antiquity and beautiful vernacular stone, Asthall Manor might have continued to slumber beside the Windrush for another century or two of respectable anonymity had it not been for a delightful, historic quirk – the impact made by the Mitfords and then its current owner, Rosie Pearson.

The Mitfords, despite their multifarious talents and interests, were not gardeners, however. Indeed, the landed gentry at that time would have regarded the creation of a new garden as a bit middle-class – a bit like buying your own furniture. In *The Pursuit of Love*, Nancy ridicules the suburban garden that is the pride of Linda's rich father-in-law, drawing an unfavourable comparison between his neat stockbroker-belt rose beds and the wild abandon of Alconleigh.

Stone sculpture

Today, we are better at conservation and less hidebound by this particular class prejudice. When Rosie Pearson bought Asthall in 1997, she commissioned Isabel and Julian Bannerman to redesign the gardens – primarily as a way of putting

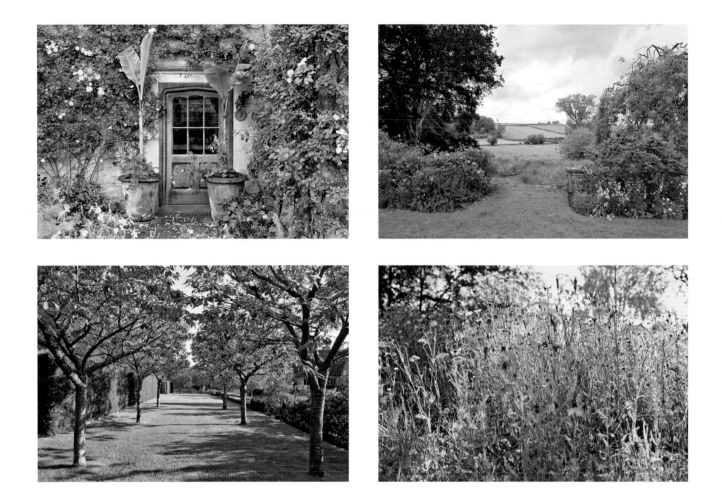

the house back into its rural context by allowing the planting to blend with the surrounding landscape, in which Roman roads march past ancient burial grounds.

The gardens are Grade II listed – more because of their structure than their contents. The Bannermans' trademark is the ability to create a garden that looks as if it has been there for centuries. Therefore, they retained the original parts of the garden such as the borders next to the house, while adding new features that enhanced its setting.

Their designs are a living embodiment of the classic English garden – billows of cow parsley (*Anthriscus sylvestris*) and roses, peonies and irises, with hedges of box and lavender. *Alchemilla mollis* seeds itself in cracks in the paving, while hummocks of hardy geraniums and pinks (*Dianthus*) have been allowed to escape over the low box hedge and grow unconstrained in the gravel paths. The Bannermans also love to incorporate witty acknowledgements of architectural heritage such as the green-oak pavilions and pergolas based on designs by Inigo Jones at Arundel Castle, the Duke of Norfolk's estate in West Sussex.

At Asthall, however, there are other ingredients to consider. Although it is primarily a private home, Rosie Pearson (a member of the Pearson family who

TOP LEFT, TOP RIGHT, ABOVE LEFT, ABOVE RIGHT Despite formal elements such as yew hedges and stone terraces, Asthall is very much a country garden, where woodland and wild flowers blend seamlessly with the Windrush Valley beyond.
OPPOSITE The yellow branches of verbascum hover like candelabras above the lavender and *Alchemilla mollis*, which line the path by the house.
OVERLEAF The box parterre was designed by Julian and Isabel Bannerman.

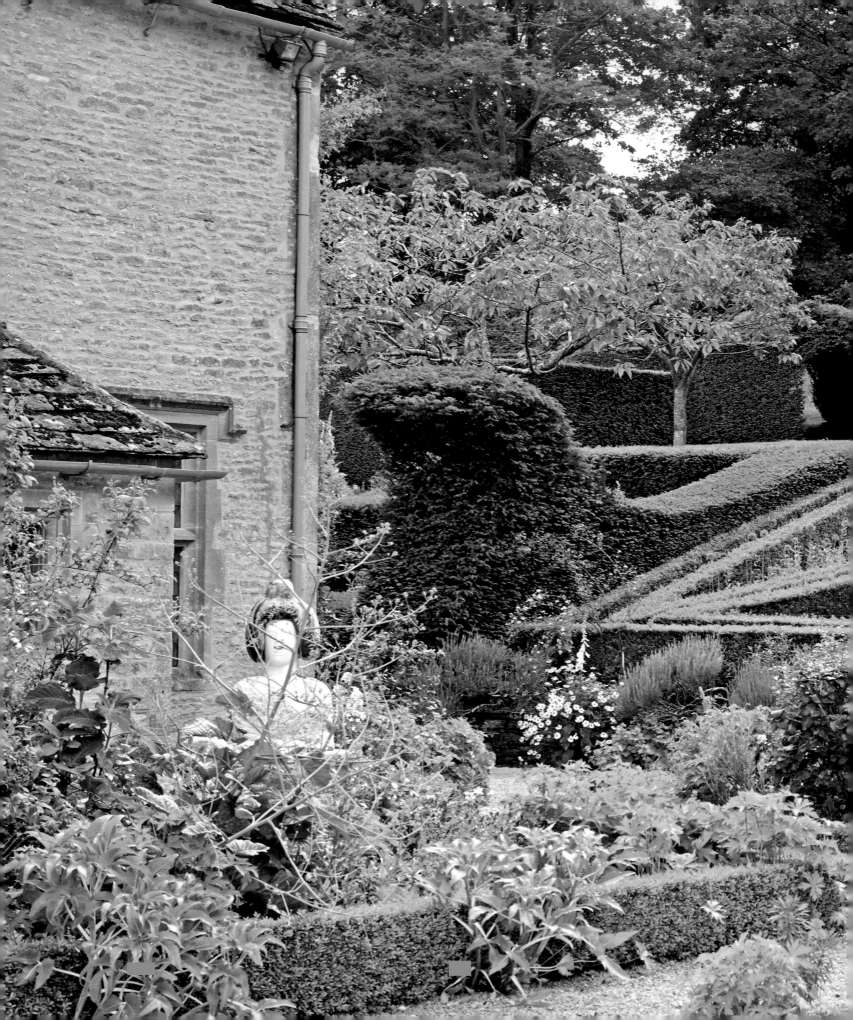

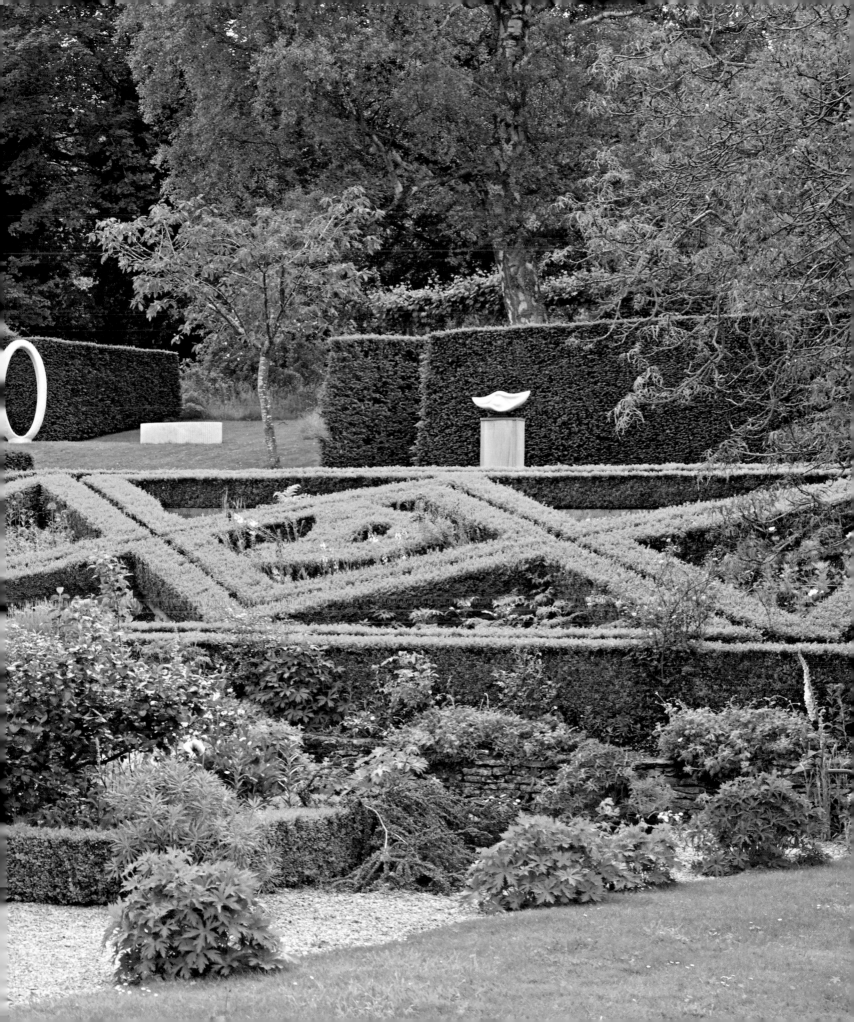

hold a huge stake in the *Financial Times* publishing group) is the instigator of On Form, a biennial exhibition of stone sculpture, which features the work of artists from all over the world. Visitors to Asthall are encouraged to touch the exhibits, and to talk to the artists in the informal country garden setting, which is cleverly employed as a backdrop. Thus a pair of contemporary stone heads might appear to converse behind the Parterre, and other sculptures might echo the arch of a doorway or lie like bizarre windfalls on the lawns.

In 2002 Pearson commissioned the sculptor Anthony Turner to make some gateposts for the house, and the idea for the exhibition, she says, came from there. According to her: 'Stone is a material that stands out from others, because it has so many eons of history in it before the sculptor even starts to carve it.' Turner is inspired by organic themes, such as pods or seeds or tendrils, as is his mentor Peter Randall-Page, who is also an On Form exhibitor.

Asthall now hosts a range of events, from exhibitions of paintings in the ballroom (added by Lord Redesdale) to yoga classes. It is also open under the National Gardens Scheme, all of which ensures that this warm family home, with its nostalgic, Bannerman-designed garden, and its literary legacy, can be enjoyed by the general public.

Perhaps it is just as well that Nancy Mitford was not one of the great English women gardeners of the past hundred years. If she had been, we might have been deprived of her tales of Alconleigh and the eccentric tribe of Radlett children who inhabited it — children who were based so closely on her own family. And we might never have had the chance to wander the paths of Asthall as it is now — a tribute to Pearson's modern vision and approach to garden design that seek to enhance and amplify the past rather than pay it slavish homage.

LEFT ABOVE The sculptures on the pillars of the main gates are by Anthony Turner and are typical of his organic style.
LEFT BELOW Sculpture is also evident in the long grass of a wildflower meadow.
OPPOSITE Asthall, with its mix of open vistas and secret corners, provides a wealth of settings for artworks that are just as effective as if they were in a conventional gallery.

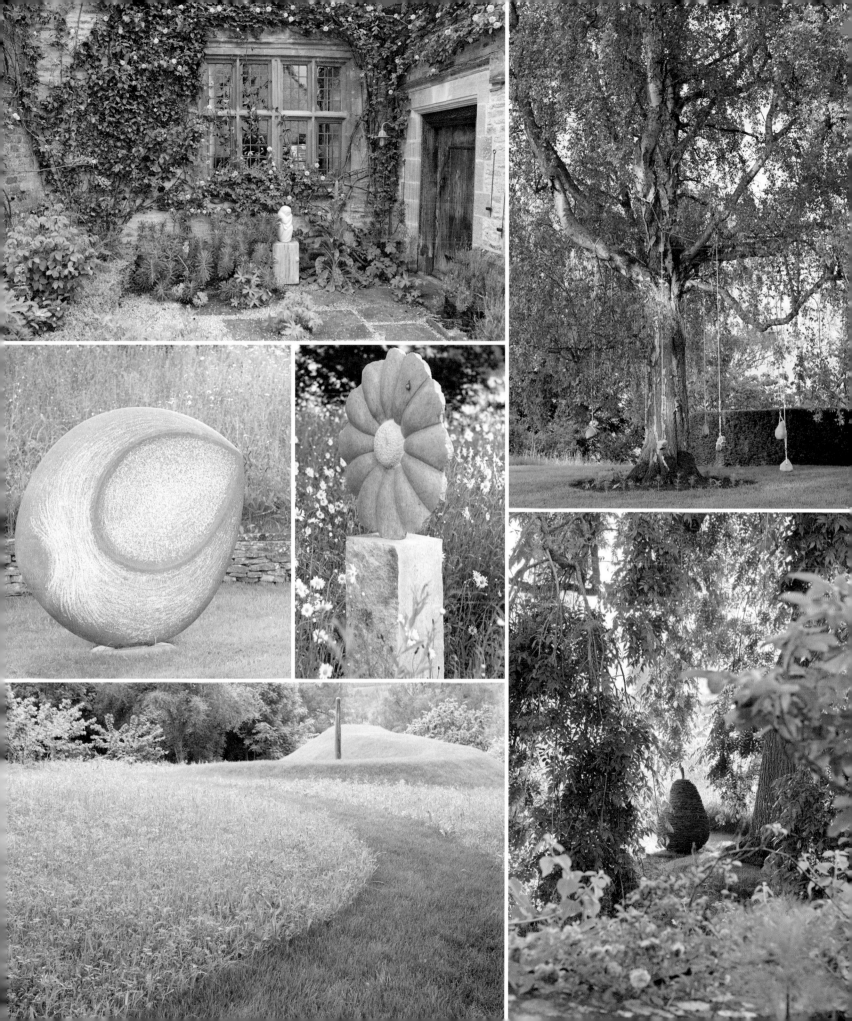

4
Bourton House
Bourton on the Hill

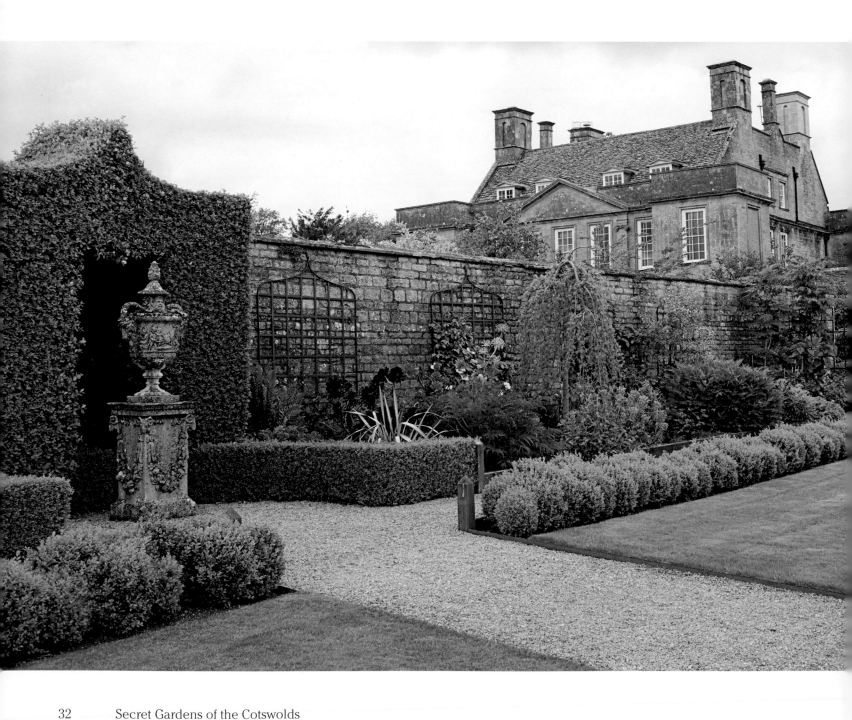

A CASUAL GLANCE through the gates of Bourton House, as you pass through the pretty Cotswold village of Bourton on the Hill, offers a glimpse of immaculate box and yew topiary and a graceful house of honey-coloured stone. How traditionally English, you might think – the sort of place that has stood for centuries, untouched by wars or aristocratic rivalries or other convulsions of history.

Well, that is true up to a point. The house is indeed old – built around 1700 – but it is the third house to stand on the site. It replaced a Tudor mansion, which itself succeeded an earlier manor house. The gardens, however, are comparatively new. They date from 1983, when the house was bought by Richard and Monique Paice. Although they contain some traditional elements – herbaceous borders, topiary and clipped yew hedges surrounding 'garden rooms' – there are also some contemporary and surprising ones.

According to documents in the RHS's Lindley Library in London, the American landscape architect Lanning Roper was commissioned in 1962 to design a garden by Lieutenant Colonel Henry 'Bunny' Nugent-Head, who bought Bourton House in 1958. Sadly, by the time the Paices bought the house some twenty years later, the garden was derelict.

Cloud pruning

Those in search of historic vernacular English architecture may be consoled by the thought that visitors enter Bourton via a tithe barn dating from 1570. It is a nice synchronicity that, during the second half of the sixteenth century, topiary first became fashionable in England.

From the tithe barn, you walk through a meadow known as the Orchard (although there is very little in the way of fruit trees there today), into the Topiary Walk. Cones and spirals and spheres of box stand like guardsmen on parade along the length of the lawns, while along the walls buttresses of clipped box are punctuated with containers of marguerites. It is a very simple arrangement, but very effective – the sort of thing that you could copy in your own garden or courtyard, especially when you discover that

the containers themselves, far from being priceless antique urns, are upturned rhubarb forcers set in the ground.

At the end farthest from the house, there is a cloud-pruned box hedge, one of many in the garden. Clipping it is the sort of job, says head gardener Paul Nicholls, best given to someone who has partaken of a bottle of whisky. He is joking, but cloud pruning is about irregularity and natural shapes rather than straight lines. A relaxed approach, following the lines suggested by the way the plant itself wants to grow, really does help.

Box blight is a spectre that haunts head gardeners throughout the UK, and Bourton is not immune. Nicholls says they clip their box only once a year and feed it with a good-quality, slow-release fertilizer. Keeping the plants as healthy as possible helps to fend off infection, and pruning only once a year reduces the opportunity for the fungal disease to take hold.

LEFT Topiary of every shape and form, and ogee arches, are the design leitmotifs in the gardens at Bourton House.
RIGHT Dutch businessman Roelof Quintus is the current owner.

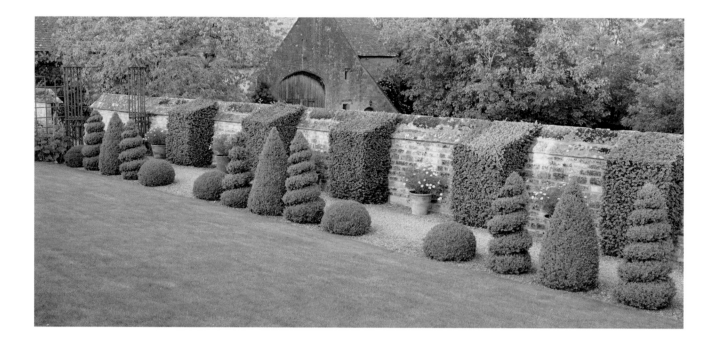

So far, planting choice in the garden seems straightforward, until your eye is caught by more containers and the planting along the wall between the tithe barn and the brewhouse, which also dates from 1570. Surely that is *Salvia confertiflora*, an exotic, tender perennial from Brazil with red, velvety flowers the colour of old-fashioned theatre curtains? And aeoniums? And *Begonia grandis* subsp. *evansiana*? These plants are tender, it is true, and require winter protection, but they also prolong the season of interest. Many English gardens are early summer performers, with their roses and peonies. Bourton is still on flamboyant display to visitors in mid-autumn.

From the Topiary Walk, you enter the White Garden, where the colour scheme is white, cream and limey-greens. There are *Rosa* Iceberg with bergenias, penstemons and Japanese anemones. Silver-leaved plants such as plectranthus add to the ethereal feel.

One of the benefits of splitting a garden into 'rooms' is that it allows scope for lots of vistas. In the White Garden, the main axis runs from the house to the boundary wall that separates the garden from neighbouring Sezincote (see pages 112–17); its owners kindly gave permission for the Paices to erect gates in the wall, thereby providing a view out on to the countryside.

Beyond the White Garden is another walk, known as Lovers' Lane. It used to have a hornbeam (*Carpinus*) hedge, but hornbeam grows so fast that it covered half the path by midsummer. Lovers' Lane is now edged by a low, cloud-pruned box hedge, using two varieties of box – a happy accident, says Nicholls – which provide a subtle colour contrast.

In the final border in this part of the garden are more exotics: the subtropical shrub velvet groundsel (*Senecio petasitis* syn. *Roldana petasitis*), with its huge, soft leaves; *Amicia zygomeris*, which has yellow flowers in autumn (another example of late-season interest); variegated giant reed (*Arundo donax*); and the rice paper plant (*Tetrapanax*). Like the groundsel, the rice paper plant is root-hardy in the southern UK, so it helps to give it a winter 'coat' of horticultural fleece.

ABOVE The Topiary Walk is decorated with box cones, spirals and spheres, as well as white marguerites planted in upturned rhubarb-forcing pots.
OPPOSITE Bourton is a garden of many rooms, each with its own distinct character. Some are traditional, such as the White Garden, while others feature more exotic ingredients, such as yuccas, cannas and aeoniums.

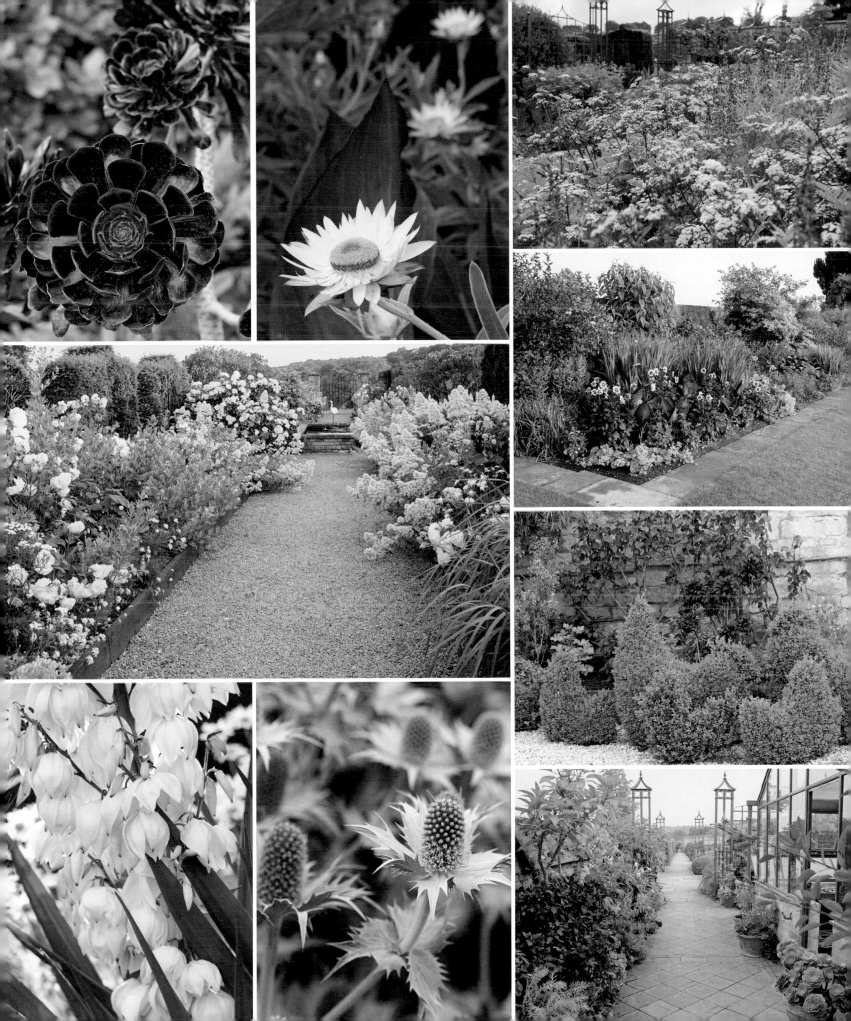

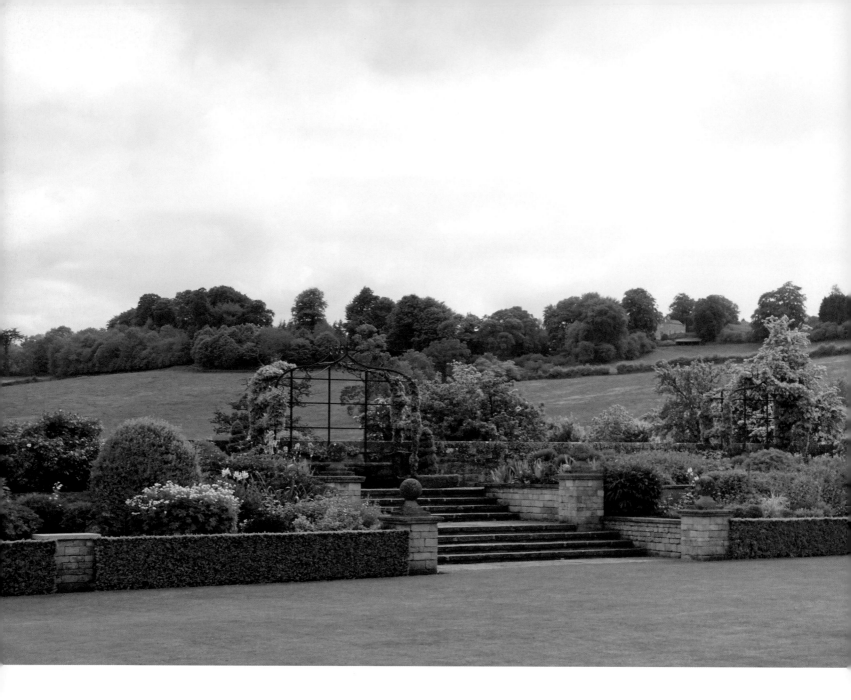

The main garden, with its Raised
Walk, looks out on to the parkland of
neighbouring Sezincote. To the right,
behind the curved yew hedge, is the
Shade House.

Herbaceous borders lead up to the main garden and are planted with
conventional perennials such as penstemons, hardy geraniums, cimicifugas
and nepetas. However, here too are more exotic additions such as the dwarf
bamboo *Pleioblastus viridistriatus* (syn. *P. auricomus*) with its brilliant yellow
foliage. One of the stars of these borders is *Molinia caerulea* subsp. *arundinacea*
'Bergfreund', a slightly shorter, tidier version of *M. caerulea* subsp. *arundinacea*
'Transparent'. An architectural grass, it makes a great substitute for *Stipa
gigantea*, with bronzed orange autumn colour.

The most compelling architectural feature of the Bourton House garden is the
ogee arches (ogee means a double S-shape meeting at a point in the middle). The
motif is picked up again and again, in the form of metal arches or trellis or clipped
yew. These are Monique Paice's design signature, and they are carried through into

the main garden on the south side of the house, where stone benches sit beneath ogee arbours along the Raised Walk, said to date from the eighteenth century.

In the main garden, the East Border has a warm colour theme: *Canna* 'Durban' with *Dahlia* 'Moonfire' and *Crocosmia* 'Lucifer' alongside heleniums and hemerocallis. Along the Raised Walk, the colours are purple and dark pink.

Beyond the main garden, the Shade House protects specimens such as *Podophyllum versipelle*, and Nicholls hopes that it might also eventually house a fern collection. A path leads from here to the Knot Garden, an intricate, rectangular design a bit like a Greek key motif, with cones of box in the corners. At the centre is the Basket Pond, which was on show at the Great Exhibition in 1851 and arrived at Bourton shortly after. According to Nicholls, it has had four different positions in the garden before settling in the

Many English gardens are early summer performers, but Bourton is still on flamboyant display in mid-autumn.

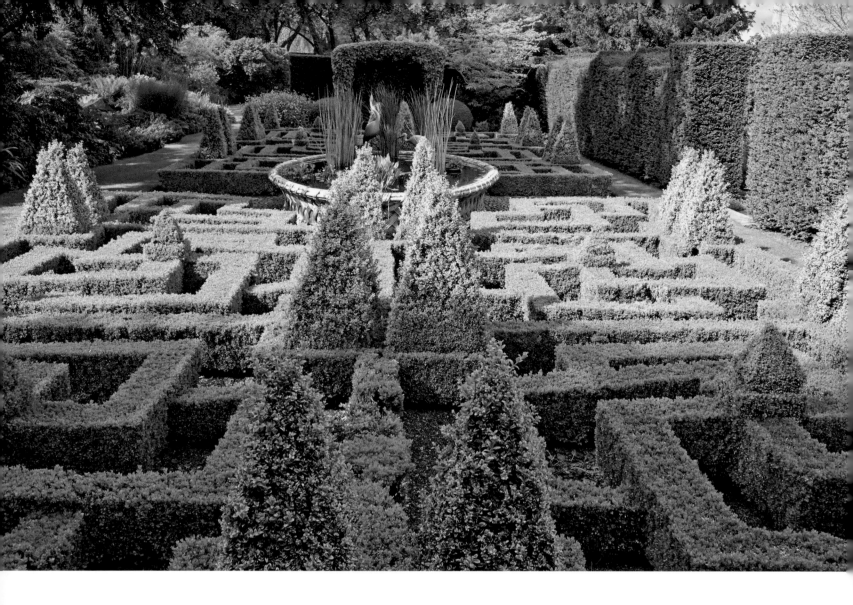

ABOVE The formal pond in
the centre of the intricate
Knot Garden is in the shape
of a huge stone basket.
RIGHT Head gardener Paul
Nicholls hopes to establish
a fern collection in the
Shade House.
OPPOSITE Parterres were
traditionally intended to be
seen from above, so that the
intricate design could be
fully appreciated.

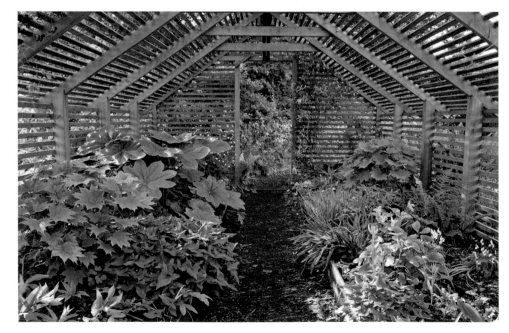

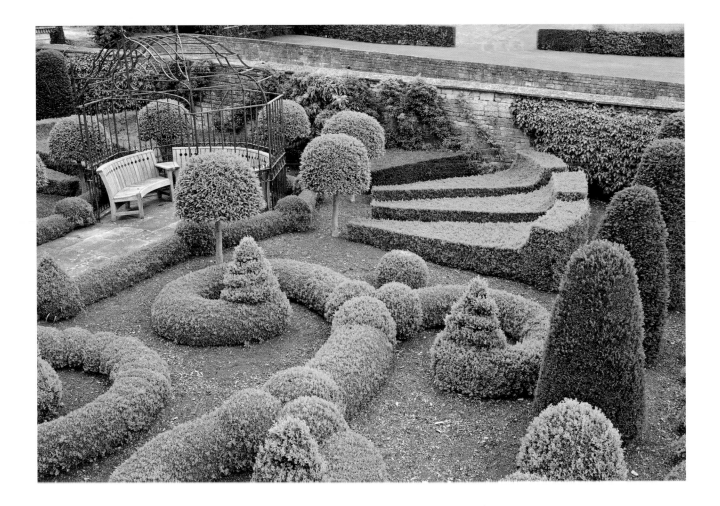

Knot Garden, where its curved shape makes a pleasing contrast to the straight lines of the knot design. The pond is fed by a spring, and the water is piped all the way from the top of the hill beyond the house. Like any beautiful, old pond, it is prone to leaks.

The lawn beyond the Knot Garden is dominated by a small-leaved elm, *Ulmus × hollandica* 'Jacqueline Hillier', and along the roadside wall there are several *Malus × robusta* 'Red Sentinel', which have white flowers in spring and brilliant red fruits. These wear ivy 'socks' – the ivy being allowed to grow up the lower part of the trunks and then clipped in a horizontal line at about 1.25m/4ft high.

Other specimen trees at Bourton House include a lovely sprawling specimen of *Rhus × pulvinata* Autumn Lace Group (often called *R. glabra* 'Laciniata') and two *Parrotia persica* on the main lawn. These grow in a goblet shape which, says Nicholls, is said to be the result of being nibbled by stray cows. However, they look far too elegant to be the work of itinerant bovines. One of the best ornamental trees for gardens, they have wonderful autumn foliage.

To the north side of the house and at the front are two more knot gardens. The one at the front, known as the Parterre, was designed by Monique Paice from an upstairs window. It is laid out like a series of box ropes around a central, circular gazebo and a fan of wedge shapes which Nicholls calls the 'quiches'.

The Paices opened Bourton House for the first time under the National Gardens Scheme in 1987, an astonishing achievement given that they had begun work on the gardens only four years before. They sold Bourton House in 2010, and fortunately the new owners still open the gardens to visitors, from April until the end of October, on Wednesdays, Thursdays and Fridays.

5
Burford Priory

Burford

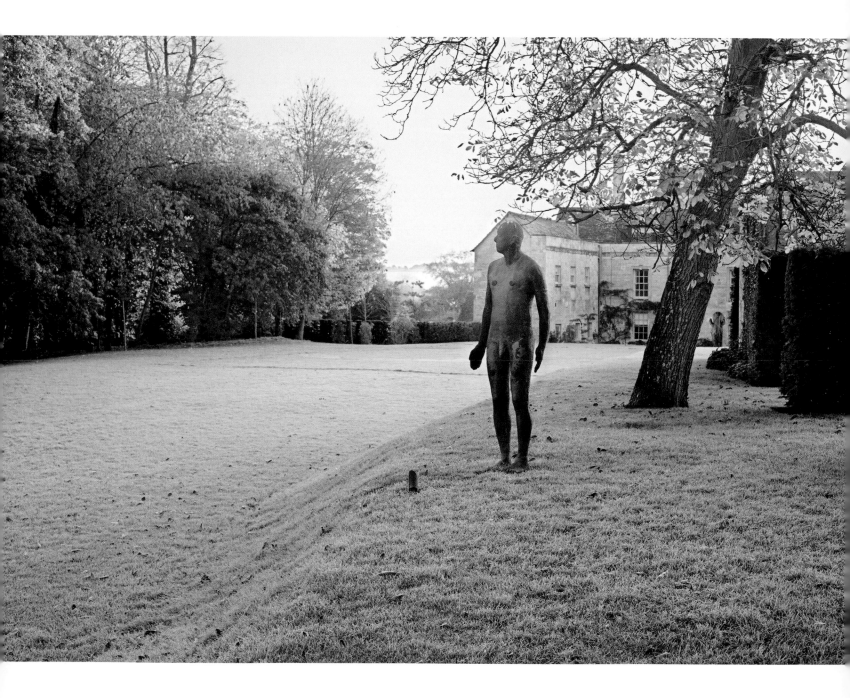

When you see the word 'Priory' in the name of an English house, it is not unreasonable to assume that this was an institution that fell victim to the Dissolution of the Monasteries during the time of Henry VIII. From 1536 to 1541, the king disbanded the religious houses of England, Wales and Ireland, often using these high-revenue estates to reward his friends and allies. Mottisfont Abbey, Woburn Abbey, Newburgh Priory and Horton Priory are among the great houses that saw the expulsion of their religious communities and the installation of the ambitious men of the time.

Burford Priory, on the other hand, was a monastery until very recently, and there is still evidence — even a sense — of that community in the gardens. It lies at the heart of the bustling Cotswold town of Burford, only a few steps from the high street. Tourist coaches park outside the gates, and yet within its walls all seems serene.

In 2008, the Priory was bought by Elisabeth Murdoch and her husband Matthew Freud. She is chief executive of the television company Shine Ltd and daughter of the media tycoon Rupert Murdoch; her husband is a public-relations guru whose clients include some of the best-known brand names in the world. You might expect that such a high-powered, high-profile couple would be at pains to close off their house from public view. Yet one of the first things they did was to tear down the 5.5m/18ft yew hedge that surrounded the lawn at the front of the house, so that the morning sun illuminates the mullioned windows and honey-coloured Cotswold stone.

You can now clearly see the extraordinary, almost pagan figures either side of the coat of arms above the door. If you look to your left, you can spot another coat of arms — no less than the royal one — above the chapel door. James VI of Scotland stayed here for three nights in 1603, the year of his accession to the English throne as James I.

Spirit of the place

Head gardener Marcus Wilden knows Burford Priory well — he grew up here and was married in the chapel. His father Brian worked at Burford for thirty years, and the family lived in what is still known as the Rectory, a separate building across the lawn from the main house. He is very sympathetic, therefore, to Murdoch's aim of retaining the spirit of the place, an aspiration that is also

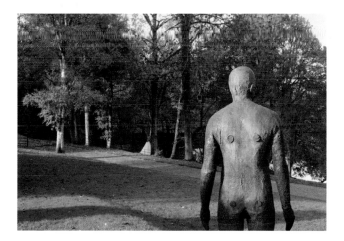

TOP AND CENTRE Originally an Elizabethan manor house, Burford Priory and its adjoining chapel were remodelled in the Jacobean style in the seventeenth century.
OPPOSITE AND ABOVE An Antony Gormley sculpture — the figure is cast from the artist's own body — looks out across the water meadows.

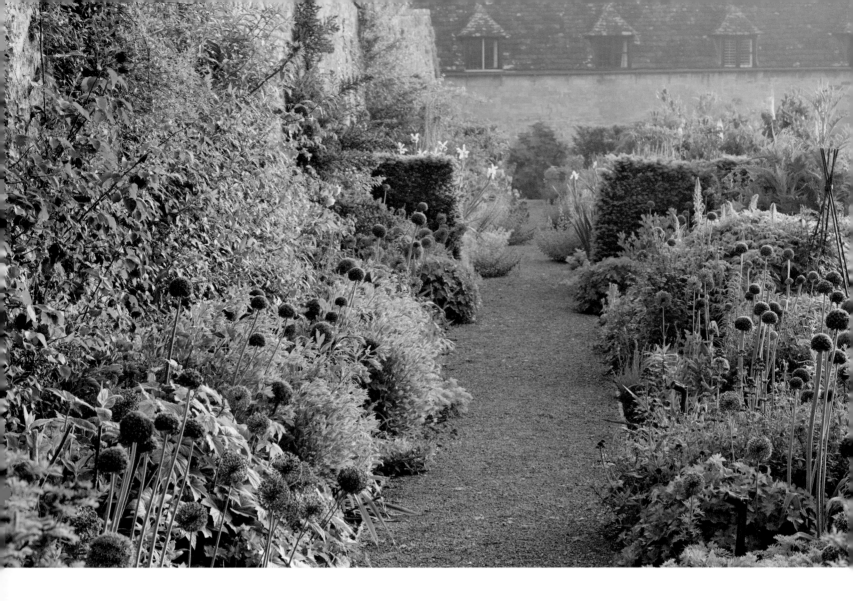

The main garden to the south seems to exploit every single ray of sunshine, giving the impression that it is always summer here.

 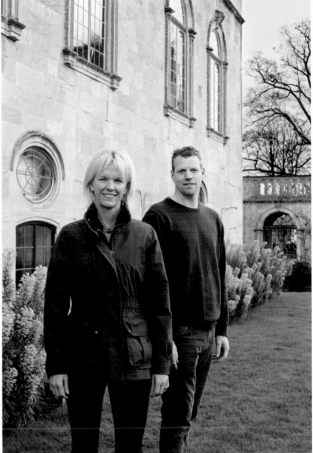

fuelled by childhood memories of her late grandmother's garden at Cruden Farm, near Melbourne.

There is a intimate quality about the gardens at Burford Priory. The main garden to the south of the house, like the adjoining walled Vegetable Garden, is sheltered and seems to exploit every single ray of sunshine, which gives the impression – even in winter – that it is always summer here. Expansive garden furniture and a huge table suggest that the residents like to exploit every grudging ray of English sunshine.

Garden designers Mary Keen and Pip Morrison decided to widen the main terrace, and have used a restrained palette of plants with grey and glaucous foliage, such as *Euphorbia characias* subsp. *wulfenii* and the woolly ears of *Stachys byzantina*.

The garden slopes, and there are several changes of level between the lawn and the swimming-pool terrace, also designed by Keen and Morrison. This is screened by a massive yew hedge, which straddles the area between the pool terrace and the terrace below, neatly solving the problem of how to accommodate the change of level without yet more steps or

ABOVE LEFT The colour scheme on the chapel side of the garden is hotter, with fiery dahlias raising the temperature.
ABOVE RIGHT Elisabeth Murdoch and her husband Matthew Freud (not shown) have spent the past five years restoring the Priory as a family home, while work in the garden is overseen by head gardener Marcus Wilden (above), who is the second generation of head gardeners at the property.
OPPOSITE ABOVE A raised walkway, running the length of the main garden, brims with roses and hardy perennials.
OPPOSITE BELOW On the wide terrace, designed by Mary Keen and Pip Morrison, large, all-weather sofas and a big dining table create a sense of warm, relaxed hospitality.

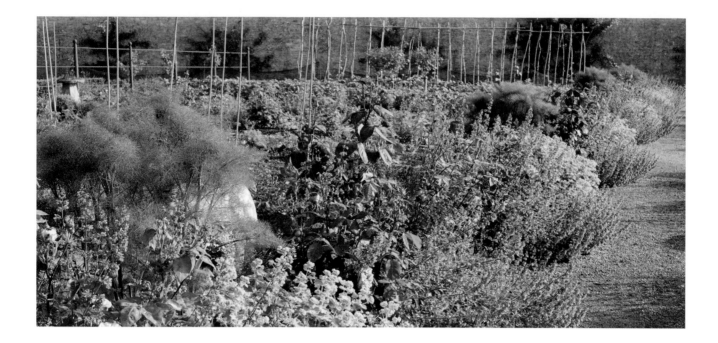

slopes. White glazed pots stand like statues around the pool, and steps lead up to the final terrace, an informal orchard area.

Below, on the main lawn, a circular labyrinth cut into the grass marks the praying circle used by the monks when they wanted to meditate. From a garden design point of view, it is a good way of breaking up an expanse of lawn without sacrificing the sense of spaciousness that a large lawn gives a garden. It is also the sort of feature that is easy to copy in your own garden; all it needs is a bit of careful marking out before you mow.

From this part of the garden, a door leads through the wall into the Vegetable Garden. Instead of stepping out between rows of apple trees or cabbages, you find yourself in a glasshouse, scented with *Trachelospermum jasminoides*, and filled with orchids and pelargoniums. A matching glasshouse on the other side of the Kitchen Garden houses cuttings and seedlings, although Wilden and his team do not grow a huge amount themselves.

Like many old kitchen gardens, it is far too big for modern needs and requires a huge amount of work. Some of the beds have already been given over to ornamental plants or transformed into a Cutting Garden. There are plans to line the main walkway through the Kitchen Garden with beds of *Rosa* 'Dame Elisabeth Murdoch',

the hybrid tea rose named after Elisabeth Murdoch's grandmother, who died in 2012 at the age of 103.

Sometimes a garden designer's work bears a hallmark: a favourite plant, a favourite device (such as a way of creating a focal point) or a favourite colour palette. At Burford Priory, one of the most impressive changes made by Keen and Morrison is invisible – it is the lowering of the ground level behind the house to allow a clear view of the woodland and dew ponds to the north-west beyond the gardens. If no one had told you, you would not know that it had been done, but when it is drawn to your attention you can see what a master stroke it was.

An Antony Gormley bronze figure stands here contemplating the landscape, while in the woods below stands a tepee belonging to one of Elisabeth Murdoch's children. It looks as if Dame Elisabeth's namesake will pass on her love of gardening to yet another generation.

ABOVE The enormous Vegetable Garden is slowly being converted to include more space for ornamental plants, such borders of roses edged with herbs.
OPPOSITE A glasshouse full of orchids and pelargoniums links the main garden with the Vegetable Garden, while the Cutting Garden includes traditional favourites such as cosmos, scabious and marigolds.

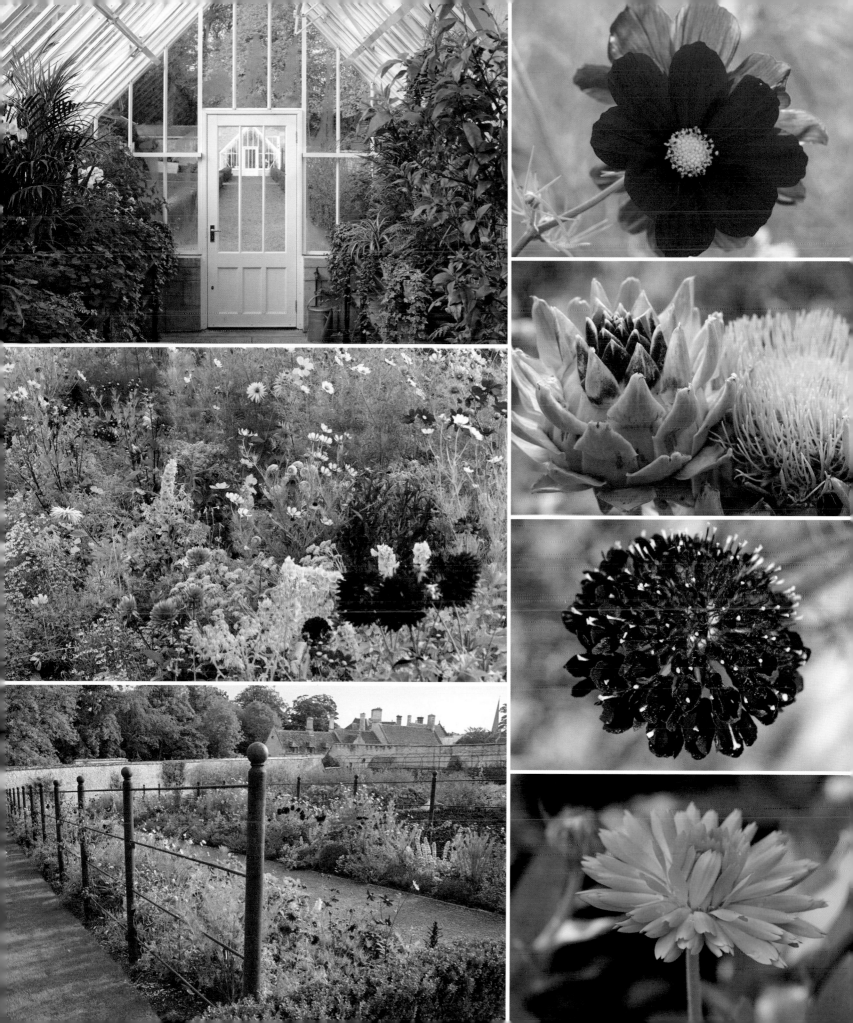

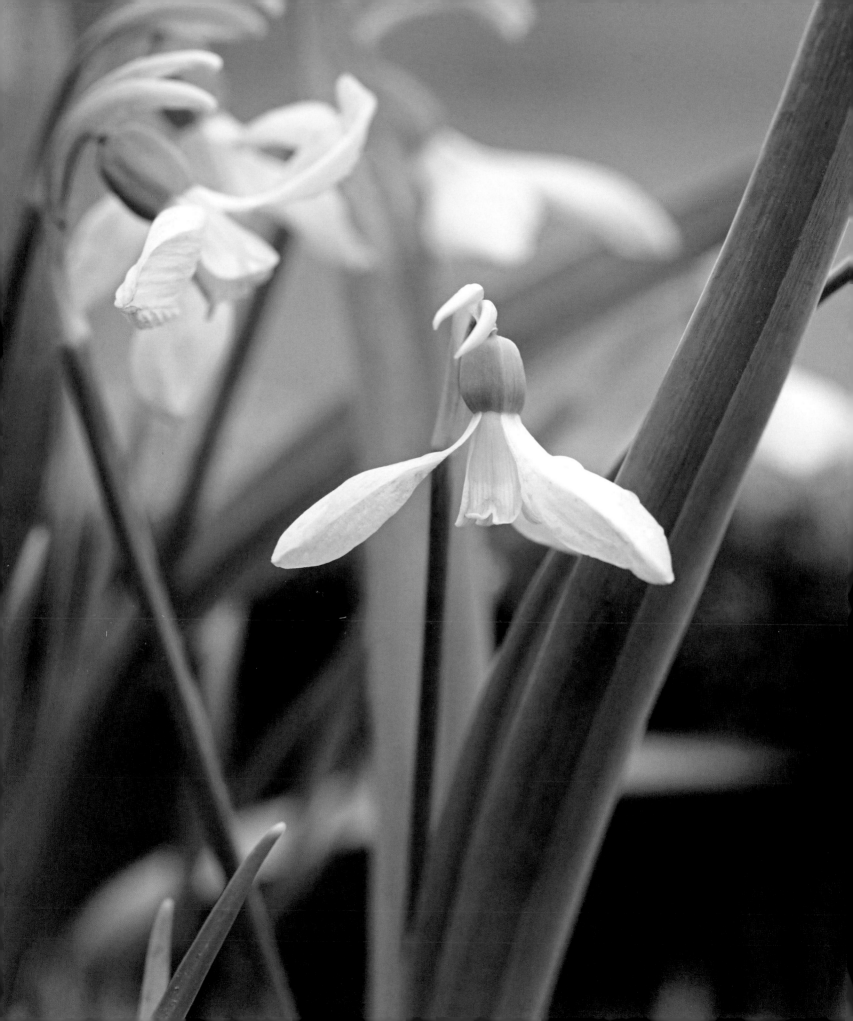

6
Colesbourne Park

Colesbourne

WHEN A RARE SNOWDROP BULB sold for more than £725 on eBay in February 2012, breaking the £360 record set the previous year, the story made headlines in the national papers. It gave their readers a rare glimpse into a strange freemasonry – the world of galanthophiles. For these snowdrop enthusiasts, the various species and cultivars of *Galanthus* inspire a devotion that mean-spirited people might describe as obsessional.

One of the most important pilgrimages that a galanthophile can make is to Colesbourne Park, home of the Elwes family since 1600. Sir Henry Elwes and his wife Carolyn are the current custodians at Colesbourne, the estate famous for the introduction of *G. elwesii*, a large form of snowdrop with a delicious honey scent. Sir Henry's great-grandfather was Henry John Elwes (1846–1922), who discovered this species in Turkey in 1874. Colesbourne today now includes many cultivars descended from this plant, such as *G. elwesii* 'Comet'.

'My wife and I are both very keen on the gardens and snowdrops. But it is also about perpetuating my great-grandfather's legacy,' says Sir Henry Elwes, who is immensely proud that Colesbourne has been described by *Country Life* magazine as 'England's Greatest Snowdrop Garden'.

As well as being a snowdrop enthusiast, Henry John Elwes was also interested in lilies and other bulbous plants. Trees were a passion too. A cryptomeria, recorded by him as being planted 'on the bank in front of the

'My wife and I are both very keen on the gardens and snowdrops. But it is also about perpetuating my great-grandfather's legacy.' SIR HENRY ELWES

LEFT *Galanthus elwesii* 'Carolyn Elwes' is one of the choice cultivars discovered at Colesbourne. It is the first-ever yellow marked *G. elwesii*, and costs around £100 a bulb.
RIGHT Sir Henry Elwes's great-grandfather introduced *Galanthus elwesii* to Britain from Turkey.

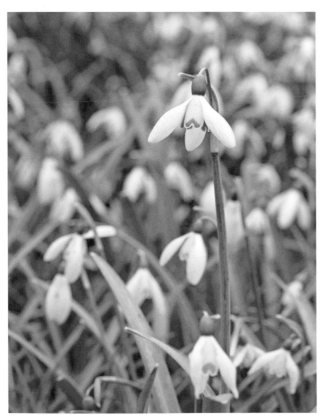

ice house' at Colesbourne – and still there today – was brought home by him as a tiny seedling in a cigarette tin.

Henry John Elwes was the co-author with Augustine Henry of *The Trees of Great Britain and Ireland*, first published in 1906 but still in print. He visited and recorded many of the specimens himself, wearing out two cars in the process. No wonder he was one of the first people to receive the Royal Horticultural Society's Victoria Medal of Honour in 1897 – along with Joseph Hooker, Gertrude Jekyll and many other famous names of British horticulture.

By 1914, Henry John had built Colesbourne into an important collection of plants, with fourteen glasshouses – each with a different climate – and ten gardeners to cater to their needs. Unfortunately, his son was not at all interested in botany, and when he inherited the estate he sold everything – apart from the snowdrops, which of course were underground.

The present Sir Henry inherited Colesbourne in 1956, by which time the house, which had been requisitioned during the Second World War, was derelict. He was twenty-two and still at agricultural college, so he decided to pull the house down, build a smaller, more manageable version and get on with the job of farming the estate.

It was his wife, Carolyn, who first became interested in snowdrops as she came across them while clearing the arboretum during the 1980s. The current collection is derived from a clump she found under a bramble bush. Regular division and replanting have increased the stock to around 350 cultivars, and bulb swaps with other collectors continue a tradition that began when the Scottish gardener Samuel Arnott sent some of his hybrid snowdrops to Sir Henry's great-grandfather.

Snowdrop thieves

There are twenty recognised species of *Galanthus* in the world, and hundreds of cultivars. The twentieth species, identified only in 2012 by Russian botanist Dmitriy Zubov and Aaron Davis of the Royal Botanic Gardens, Kew is *G. panjutinii*, a native of Georgia and Russia. It is found in only five locations, one of which is Sochi, where construction for the 2014 Winter Olympics destroyed most of the site.

Common snowdrop (*G. nivalis*) has become naturalized in Britain. Contrary to common perception, it was not

brought by the Romans, but was introduced around the beginning of the sixteenth century. Its subsequent hybridization, which has resulted in the large number of cultivars now available, has taken place during the past 200 years, and is still going on today. For example, one of the highlights of a visit to Colesbourne during the snowdrop season are the swathes of *G.* 'S. Arnott', a cross between *G. nivalis* and *G. plicatus*.

The first-ever yellow-marked *G. elwesii* cultivar, appropriately named 'Carolyn Elwes', is a more modern variety, and made its own headlines in 1997, when Colesbourne was first opened to the public for a snowdrop day. This unusual snowdrop cultivar is much sought after by collectors, and retails at about £100 a bulb. The original clump was stolen from Colesbourne, and despite nationwide publicity it has never been recovered.

You can buy rare varieties such as *G. elwesii* 'Green Tear' at Colesbourne open days in late winter, when the garden reaches its peak, But be warned – this particular cultivar sold at auction for £360 for a single bulb in 2011. However, just because a snowdrop is rare does not mean it is a better plant from the amateur gardener's point of view.

Chris Horsfall succeeded UK snowdrop expert Dr John Grimshaw as head gardener at Colesbourne in September 2012. He points out that the unusual varieties are often uncommon for a reason: they require much more pampering and, despite their high price tags, they are really only attractive to passionate galanthophiles. If you want to grow snowdrops as a garden plant, it is much better, he says, to choose one of the cultivars that carries a Royal Horticultural Society Award of Garden Merit (AGM). In addition, some varieties blend more easily with other species. For example, if you already have a clump of glaucous-leaved common snowdrop, why not accompany it with *G. plicatus* 'Colossus', which has soft green foliage. Another good variety is *G. elwesii* 'Comet', which has 'a good proportion of foliage to flower'. You might find that the foliage of some cultivars is too glaucous for a complementary planting.

Another important point when cultivating snowdrops is the optimum time to plant them. In the past twenty years, it has become popular to do this 'in the green' (that is, while they are in leaf) in mid- or late winter,

ABOVE Other early spring flowers at Colesbourne include crocuses, *Eranthis hyemalis* and *Cyclamen coum*.
OPPOSITE ABOVE *Galanthus elwesii* 'Green Tear' is a collector's item, with green, teardrop-shaped patches on the petals.
OPPOSITE BELOW *Galanthus nivalis* is the species you see growing in woodland or on road verges in the UK.

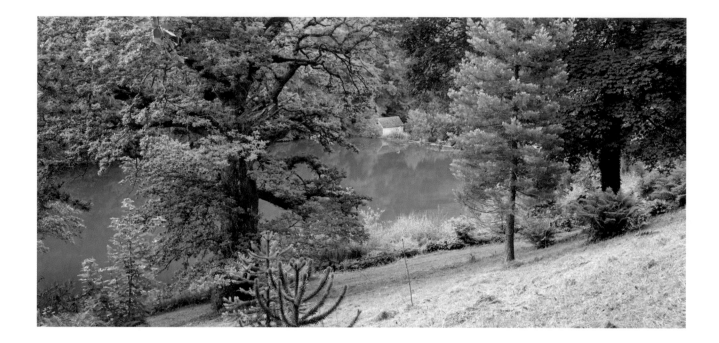

ABOVE The turquoise lake gets its colour from clay particles suspended in the water.

OPPOSITE The snowdrops disappear by midsummer, and in their place come turkscap lilies, cornflowers and candelabra primulas.

rather than plant the bulbs in autumn. The theory is that they establish better, but what is the Colesbourne view? According to Horsfall:

'There is a strong movement back towards planting snowdrops when they're dormant. It works if you transplant them in the green, but that doesn't necessarily mean that it's better. If you then have a dry spring, they will suffer. Most plants prefer to be moved when they are dormant.

The trouble is, many of the bulbs are imported and you only really have a six- to eight-week window to plant them when they're dormant. If they've been on the shelf too long, or dried out too much on the way here, they won't grow and that is what has given the bulbs a bad name.'

The turquoise lake

Horsfall would love to make Colesbourne more of a year-round garden, but the presence of such an important *Galanthus* collection means that any other planting has to be very carefully considered. However, during the snowdrop season, the magenta flowers of *Cyclamen coum* and *C. hederifolium* provide a vivid contrast, as do the fiery hues of dogwood (*Cornus*) stems against the turquoise-blue lake. There are also crocuses and hellebores beside the snowdrops, with daffodils and fritillaries taking up the baton in early spring.

If you are the head gardener at a snowdrop garden, what do you do for the rest of the year? 'You don't exactly put your feet up', retorts Horsfall. 'Once the snowdrops stop flowering in early to mid-spring, they start growing and continue until early to midsummer. Late spring and late summer can be quiet, but the rest of the time we are busy.'

7
Cornwell Manor
Cornwell, Chipping Norton

THE VILLAGE OF PORTMEIRION, in North Wales, has been a popular tourist destination for decades. It was designed by the British architect Clough Williams-Ellis as an Italianate fantasy, inspired by picturesque towns such as Portofino on the Italian Riviera. Meanwhile, the village of Cornwell, in west Oxfordshire, is a quiet hamlet 4 kilometres/ 2½ miles from Chipping Norton. Orchards separate a cluster of pretty cottages from the manor house, and the stream that flows through the hamlet has been turned into a formal canal and pool where it enters the manor house gardens. This too is the work of Williams-Ellis, but you will not see any crowds or gift shops here. It retains the atmosphere of a country estate, where the only noise is the clip-clopping of hooves or the occasional 'kork-kork' of a startled pheasant.

The manor house at Cornwell is of Jacobean origin, but the façade is eighteenth century. In 1939 it was bought by a young couple, Mr and Mrs Anthony Gillson. Anthony Gillson came from a British military family, but Mrs Gillson, née Priscilla Ogden Dickerson, was an American heiress; her grandfather had been attorney to Samuel Colt, defending the patent for his Colt revolver against rival manufacturers. She was horrified not only by the state of the house but also by that of the surrounding cottages. Tall trees hid the house from the road, and many of the estate workers lived in accommodation that was without basic sanitary amenities.

Priscilla Gillson commissioned Williams-Ellis to design a formal garden at the front of the manor house, and to improve the cottages, which underwent complete modernization. At the manor house, Williams-Ellis 'canalized' the stream, a tributary of the river Evenlode, to create a rill and formal pool, with steps leading down from the house and up on the opposite side of the pool, to wrought-iron gates. In the village, Williams-Ellis replaced the small Jacobean windows with Georgian-style ones, including a Georgian-style bow window in

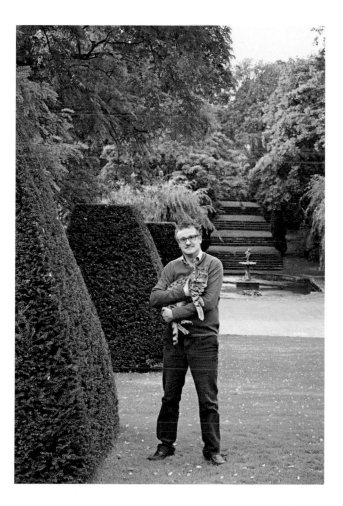

LEFT The steps leading down from the house to the formal pool, and up the slope to the main gates, are lined with yew topiary.
RIGHT Alexander Ward, the current owner, poses with his Bengal cat. His parents bought Cornwell Manor in 1962.

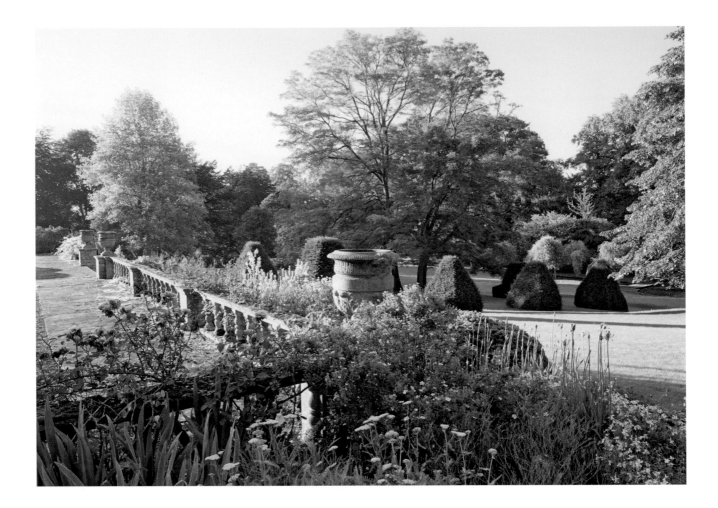

ABOVE The series of formal gardens around the house and along the terrace was designed by Claire Ward.
RIGHT Lavender hedges outline beds of roses in the sunny Pool Garden.
OPPOSITE The stone figure known as the Fiddler stands in the centre of a formal parterre, planted with box, peonies and Portuguese laurels. Beyond is the Spring Garden, and the enormous beech (top right of the picture), thought to be 200 years old.

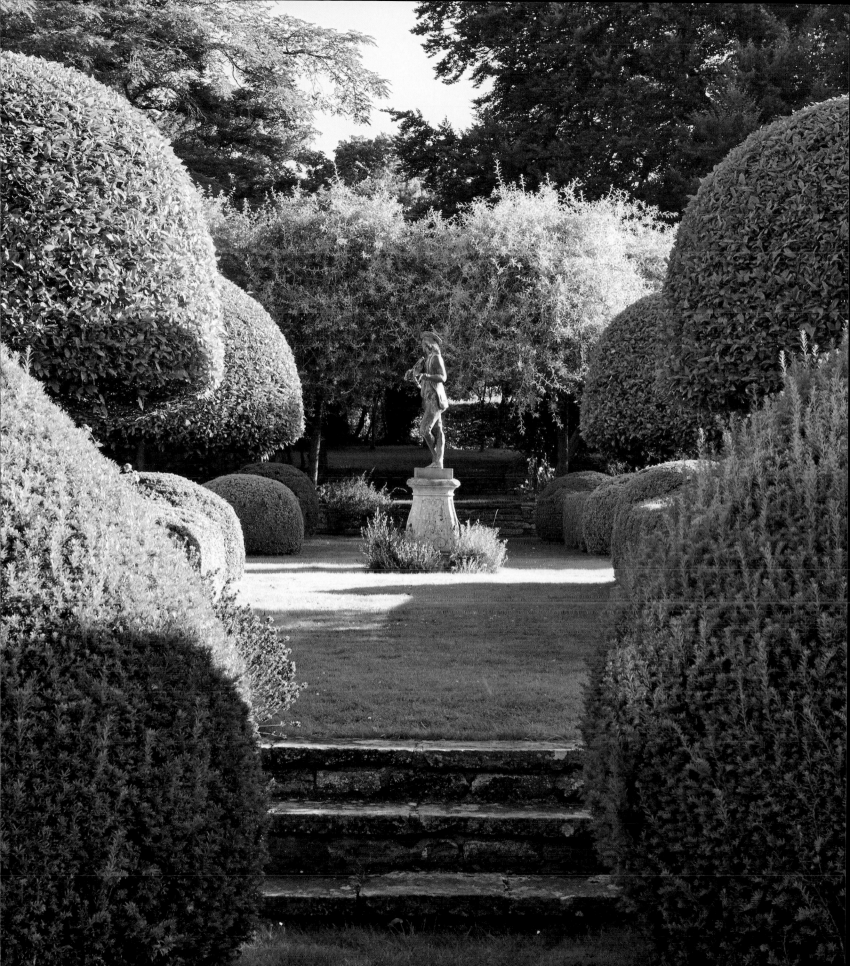

Pevsner dismissed the Clough Williams-Ellis changes as stagey, but then he did not have to live in a cottage without electricity or running water.

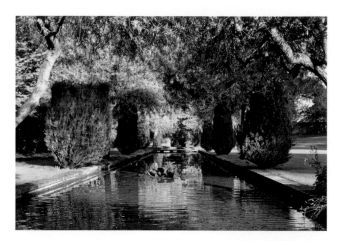

what used to be the village shop. The village school was given a belfry, while the stream – which effectively ran down the middle of the street – was contained in a rill. His designs were not as exaggerated as at Portmeirion, but there are obvious Williams-Ellis touches: a wrought-iron porch here and an eccentric round window there. Sir Nikolaus Pevsner, writing in *The Buildings of England*, dismissed the Williams-Ellis changes as 'rather stagey in manner', but then he did not have to live in a cottage without electricity or running water.

During the Second World War, Priscilla Gillson allowed the Auxiliary Territorial Service (ATS), the women's branch of the British Army, to use Cornwell as a rest centre, while she herself was based in London, driving ambulances during the Blitz. Her husband was killed in action in Burma in 1944 at the age of thirty-five, and she never returned to live in the Cotswolds. The house was bought by Peter Ward and his wife Claire in 1962, and it is now owned by their son, Alexander Ward.

Scent of magnolia

Claire Ward was a very keen gardener and she created the formal terracing around the house. The highest of these is a Spring Garden, dominated by an enormous beech (*Fagus*), thought to be 200 years old, which spreads its branches over the ha-ha and the neighbouring meadow. Beneath the trees, there are spring bulbs, including scillas, chionodoxas and narcissus.

The second terrace, on the east side of the house, is a much more formal parterre, with a statue nicknamed the Fiddler, possibly after the English sculptor John Cheere. Standard Portuguese laurels (*Prunus lusitanica*) rise above beds of peonies, surrounded by cushiony box hedging. The main terrace is more informal, with a mixed shrub and herbaceous border billowing with lavender, roses and hardy geraniums.

Alex Ward likes to give the credit for the garden to his mother, but he obviously also has a good eye. He has made further changes, which have streamlined some of the original Williams-Ellis design and swept away the fussier details. For example, the rather distracting (and today deeply unfashionable) rockery that led down from the pool has gone, and the ha-ha has been built up to form a sort of dry-stone bank. From a trough set in the top of the wall, the water cascades into the stream, now released from its canal bonds to meander through the meadow beyond the gardens. It is a logical contemporary extension of Williams-Ellis's hydraulic engineering.

Beside the cascade, your eye is caught by a magnificent specimen of *Magnolia obovata*, a native of Japan, which has huge leaves and big, single, creamy flowers that are heavily scented. Along the canal are weeping pears (*Pyrus salicifolia* 'Pendula'), and around the central pool stand

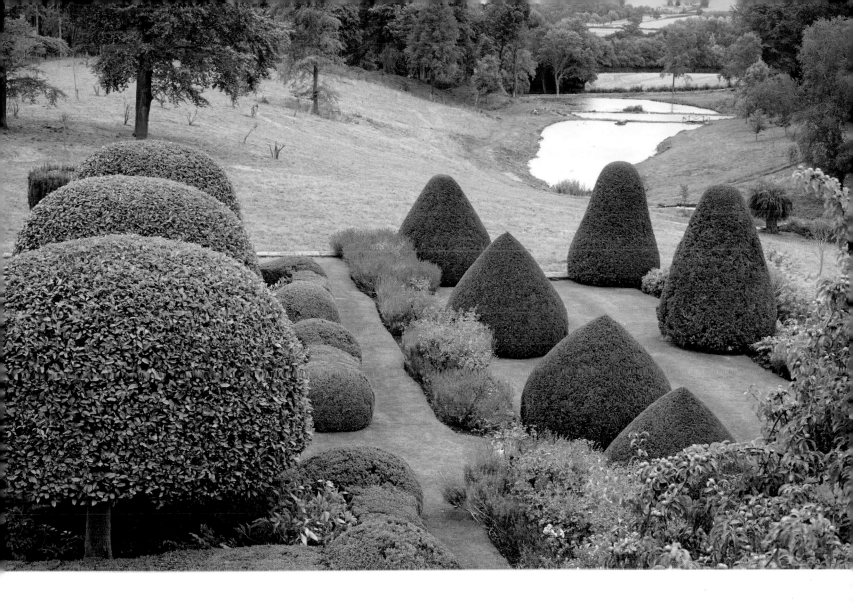

weeping willows (*Salix babylonica*), heavily pollarded to keep them from outgrowing their space. Cornwell Manor also boasts a large walled kitchen garden, but, since there are only two gardeners, some of it has been given over to grass and fruit trees.

Stuart Macdonald, who has been a gardener at Cornwell Manor for thirty-five years, recalls that in the time of his predecessor, David Hatchett, there were ten to twelve gardeners. These days, he and his colleague Alan Webb have a non-stop programme of clipping, pruning and digging, but you sense that they love being part of the estate 'family'.

Inside, the house itself is very much a family home. Alex Ward can remember that one Christmas, when some cousins came to stay, the children were given bows and arrows, which they promptly shot through some of the more valuable paintings.

Outside, the elegance of the Georgian exterior has merited a cameo appearance in the romantic comedy *The Holiday*, starring Cameron Diaz and Jude Law, in 2006. It is tempting to wonder what Priscilla Gillson would think if she knew that her ugly-duckling English manor house had turned into a movie-star swan.

ABOVE Beyond the ha-ha, Clough Williams-Ellis's formal canal becomes a broad stream, while the topiary of the formal terraces gives way to meadows and woodland.
OPPOSITE ABOVE Clough Williams Ellis used the stream that ran through the village to create the canal. It is a tributary of the river Evenlode.
OPPOSITE BELOW Alexander Ward has extended the ha-ha and built a spout that allows water to flow from the gardens and on through the rest of the estate.

8
Cotswold Wildlife Park
Bradwell Grove, Burford

A RHINOCEROS is not a common sight in a Cotswold garden. Village garden groups in Gloucestershire and Oxfordshire do not collectively scratch their heads over the problem of coming up with a planting scheme that lemurs do not want to eat, while local garden designers are more accustomed to box parterres than recreating a backyard from east Africa. It therefore made sense, when John Heyworth and his son Reggie, owners of the Cotswold Wildlife Park, were recruiting their latest head gardener, to look for someone who had experience of both exotic planting and zoo landscaping. Could there be such a person? Yes, there could – Tim Miles, formerly of Heligan and London Zoo.

The great thing about exotic gardens is that they are fun. There is a sense of braggadocio about the vast paddle leaves of hardy bananas (*Musa*), the reptilian texture of gunnera foliage and the preposterous frivolity of canna flowers, flaunting their petals like cabaret dancers at the top of 1.5m/5ft stems. At the Cotswold Wildlife Park, big leaves are combined with the tropical colours of dahlias, crocosmia and hemerocallis, and good taste – that great strangler of imagination and innovation – politely moves aside to make way for 'wow' factor.

The park is not just about exotics, however. There are also formal gardens with box hedging and clematis, which provide a traditionally English flavour. They lie close to Bradwell Grove, the manor house at the centre of the

In an exotic garden, big leaves are combined with tropical colours, and good taste – that great strangler of imagination and innovation – politely makes way for 'wow' factor.

LEFT The dark foliage of the dahlias is echoed by the purple-black leaves of *Phormium* 'Platt's Black' to create a dramatic foil for the oranges and yellows of zinnias, alstroemerias and *Rudbeckia hirta* 'Cappuccino'.
RIGHT Reggie Heyworth read history at Oxford before joining his father, John Heyworth, at the zoo in 1995.

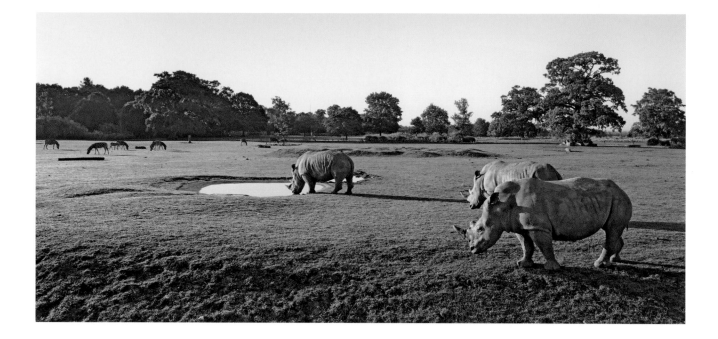

estate. It was built in 1804 in the Strawberry Hill Gothic style and bristles with crenellations and pinnacles. It is not a big house, so the effect is pretty rather than pompous.

Rhinos and zebras

John Heyworth had always been interested in wildlife. He was the sort of boy who kept grass snakes and, apparently, when he was at Eton during the early years of the Second World War, he had a cage of budgerigars in his room as well as a collection of reptiles. He even asked the British Mushroom Society for advice on growing mushrooms under his bed. Sadly, the views of his housemaster on these enthusiasms are not known.

His father was killed in 1941 and John himself joined the army in 1943, seeing active service in Denmark and Germany. In 1948, soon after he was demobbed, his grandfather died, and John found himself with 1,214 hectares/3,000 acres to look after and with only a correspondence course in farming to equip him for the job. Huge death duties forced him to rent out Bradwell Grove for twenty years, to the local health authority, and, as invariably happens in these cases, the garden became neglected and the house fell into disrepair.

When they regained control of the estate in 1968, John and his wife Susan were determined to restore it.

They decided to follow the example of Woburn and Longleat, which were establishing safari parks. Unlike Woburn and Longleat, however, visitors to the Cotswold Wildlife Park were to be able to walk around the park, and so have closer access to the animals.

They opened the Cotswold Wildlife Park at Easter in 1970, with a collection of forty species including wallabies and flamingos. The zoo now includes lions, giraffes, rhinos and zebras and is said to be the largest privately owned zoological collection in Britain.

John Heyworth died in December 2012, after suffering from Parkinson's disease for fifteen years. Reggie Heyworth, who had worked as a safari guide in Tanzania, joined his father in running the zoo in 1995. 'I was eight when it began,' he says, 'and having been brought up on *Daktari* and *Born Free* and surrounded by animals, I inherited my father's passion. My parents were both keen gardeners and were adamant that all new planting, as well as cage design, should enhance

ABOVE Rhinos graze peacefully – if somewhat incongruously – in this Cotswold landscape.
RIGHT Each enclosure has been designed to suit its inhabitants, whether they are penguins, meerkats or Bactrian camels. But the overall ambience is one of pastoral serenity.

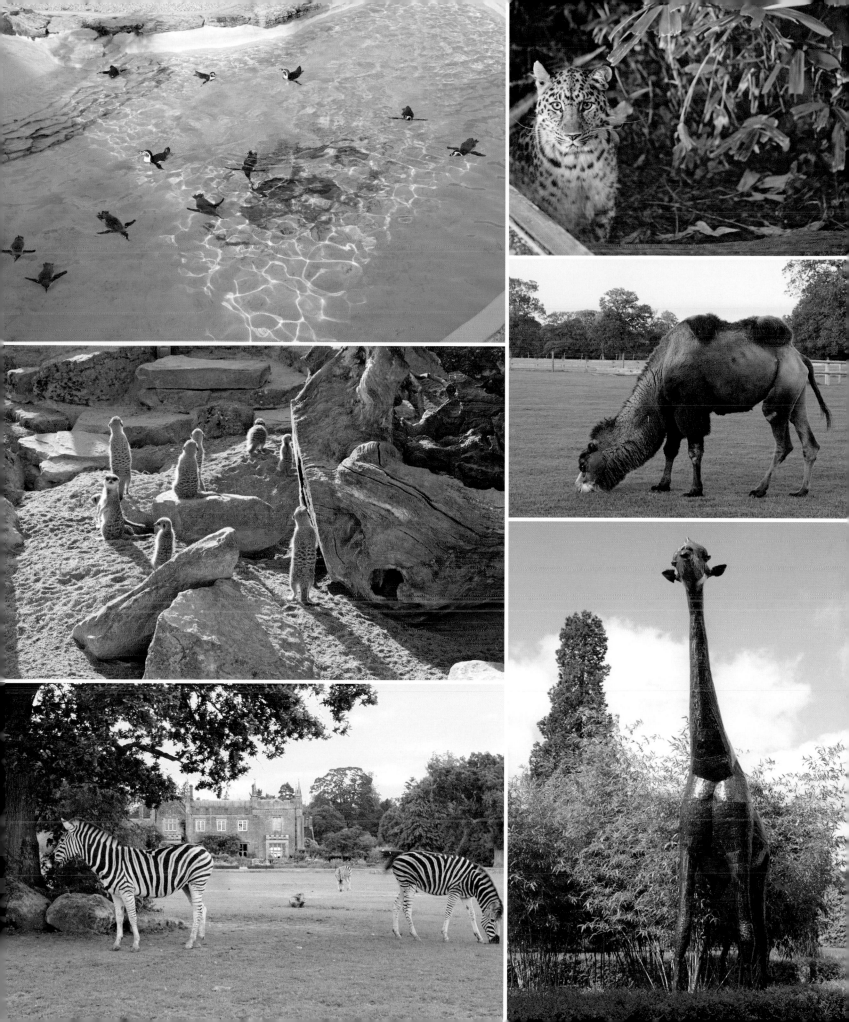

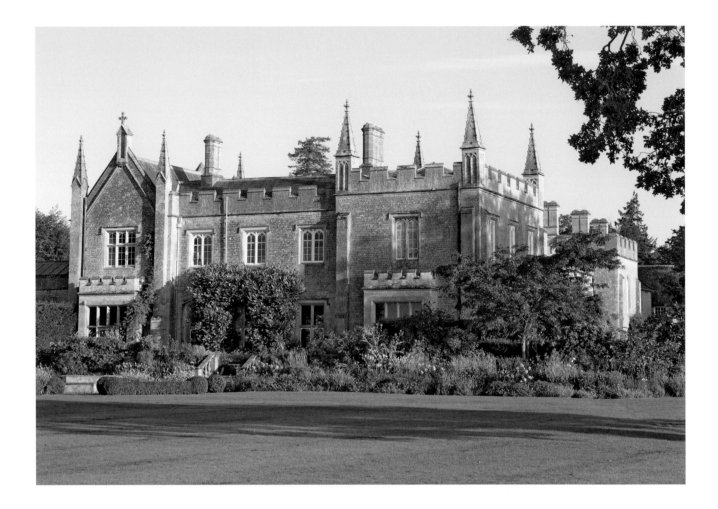

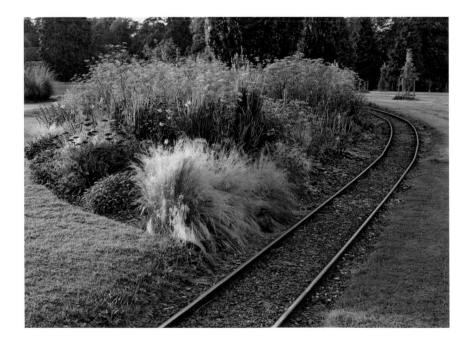

ABOVE Bradwell Grove, the manor house at the centre of the estate, was built in 1804.

RIGHT The miniature railway runs past some imaginative planting. Here, grasses are used to create the effect of a railway cutting.

OPPOSITE The *Yucca rostrata* (above left) may look fragile, but it is hardy to −15°C/5°F. Other exotic plants such as bananas (above right) are root-hardy. Pitcher plants (*Sarracenia*, below left) enjoy the steamy atmosphere of an indoor enclosure, while a sculpted handrail (below right) echoes the jungle atmosphere.

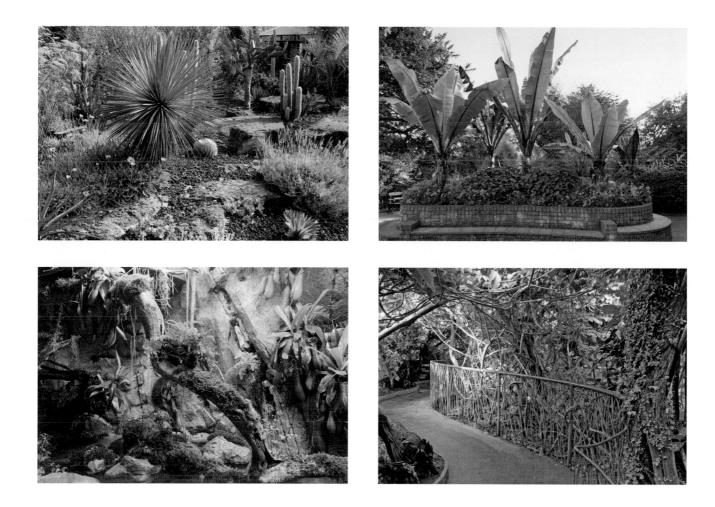

the Victorian parkland setting, which sports many fine specimen trees.'

The planting also enriches the sense of native habitat, although what might look exotic at first glance often turns out to be a much hardier alternative. The vines next to the macaws' enclosure are hardy kiwi fruit, not some rare Amazonian species. Bamboo – hardy and indestructible is used extensively, although, according to head gardener Tim Miles, the omnivorous lemurs will eat that too.

As exotic gardeners will tell you, many plants are surprisingly hardy. After being cut down by frost, the hardy banana *Musa basjoo* will grow back from the roots in late spring. Chusan palm (*Trachycarpus fortunei*) and *Trachycarpus wagnerianus*, with their more formal fans of leaves, will shrug off even quite cold winters. Cordylines are more likely to fall victim to long spells of wet and cold. However, as in most exotic gardens, come mid-autumn a

huge operation gets underway to move the more tender specimens into the glasshouses. Luckily, Miles has a full-time staff of six gardeners.

He says that the plants are not just there to look pretty, however. They also provide shade and privacy for the animals, which – given that the park has around 350,000 visitors a year – must come as some relief to the more thin-skinned species, such as rhinos, which are notoriously wary of strangers.

9
Daylesford House

Kingham

A MANSION OF GOLDEN STONE, nestled in an eighteenth-century landscape, and boasting a Secret Garden, a magnificent walled Kitchen Garden, a Rose Garden and a gothic Orangery, is the sort of place that makes the directors of costume dramas and Hollywood cinematographers salivate. Another impressive thing about Daylesford, however, probably goes unnoticed by the thousands of visitors to the National Gardens Scheme open day each late spring – its compost heaps. There are nine of them – six for general compost and three for leafmould – and they are huge. 'If I had to choose just one part of the garden as my favourite,' says the head gardener Dustin Hamilton, 'it would have to be the heaps.'

Good compost can awaken strong feelings of envy in the heart of the keen gardener. Thrust your hands into the oldest of the leafmould heaps at Daylesford, and they come away full of a dark, rich, crumbly substance that looks good enough to eat. In a sense, it is. These heaps of black gold are the lifeblood of the garden, and they sum up the philosophy behind the gardens here: local and sustainable.

Daylesford has become a byword for organic produce in the UK. Lady Bamford, who came here with her husband in 1974, opened a farm shop and café in 2002. She was inspired by the kitchen gardens here and at the Bamford estate in Staffordshire, which have been organic for the past thirty years. In 2006 Daylesford produced a show garden at the Chelsea Flower Show, and there are now two Daylesford stores in London as well as the shop in Gloucestershire.

Ironically, it is not easy being organic in the countryside. Tell many people that you do not use glyphosate, or slug pellets or any other products from the vast war chests produced by the agrichemical companies, and they look at you as if you were mad. Lady Bamford, like Prince Charles at Highgrove, has had to put up with her share of sceptical sneering, but she is used to it. She has spent nearly forty years convincing people not only to go green, but also to go green in style. 'You have got to be able to put your head above the parapet, and expect to get it shot off.'

LEFT The Kitchen Garden is laid out in the form of a parterre. In it, neat rows of vegetables nestle at the feet of topiary chickens.
RIGHT Carole Bamford, a committed environmentalist, has run the garden on organic principles for the past forty years.

Walled garden

When the Bamfords first arrived, she says, there was very little in the walled Kitchen Garden: 'It was very run down. There were just a few Christmas trees, and scarcely even a path.' Unusually, it is egg-shaped rather than rectangular and, at 1.4 hectares/3½ acres, is too big to meet modern needs, says Lady Bamford, so much of it is now orchard, with the inner part of the garden devoted to vegetables. Interestingly, the walled garden had been built before the house, which was designed in the 1790s by Samuel Pepys Cockerell for Warren Hastings, the first Governor-General of India. (Cockerell also designed Sezincote: see pages 112–17.) In its glasshouses, says Lady Bamford, Hastings could grow the sort of fruit for which he had acquired a taste in India: mangoes, pawpaw and other exotics. 'He loved the walled garden. He would ride around the estate on an Arab horse, and you can sense that he just loved the whole place.'

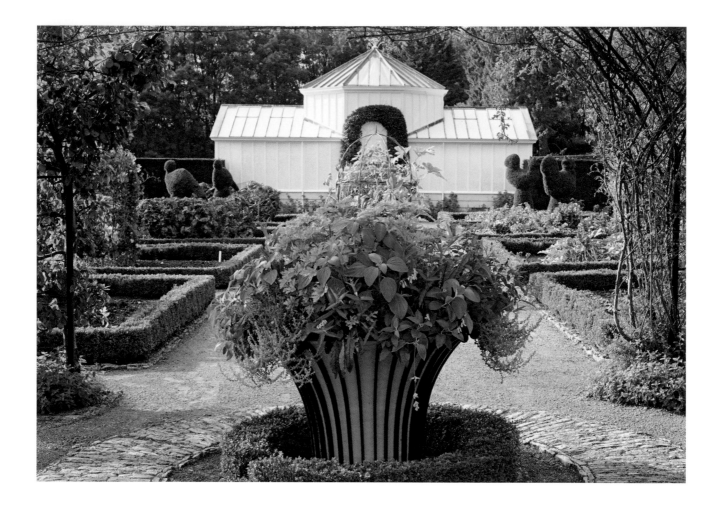

'[Warren Hastings] would ride around the estate on an Arab horse, and you can sense that he just loved the whole place.' LADY BAMFORD

ABOVE The Orchid House at the centre of the Kitchen Garden was designed by the architect Philip Jebb.
RIGHT The ferns and orchids in the Orchid House are due to be replaced by Malmaison carnations and scented pinks.
OPPOSITE The attention to detail in the Kitchen Garden and the outhouses is awe inspiring.

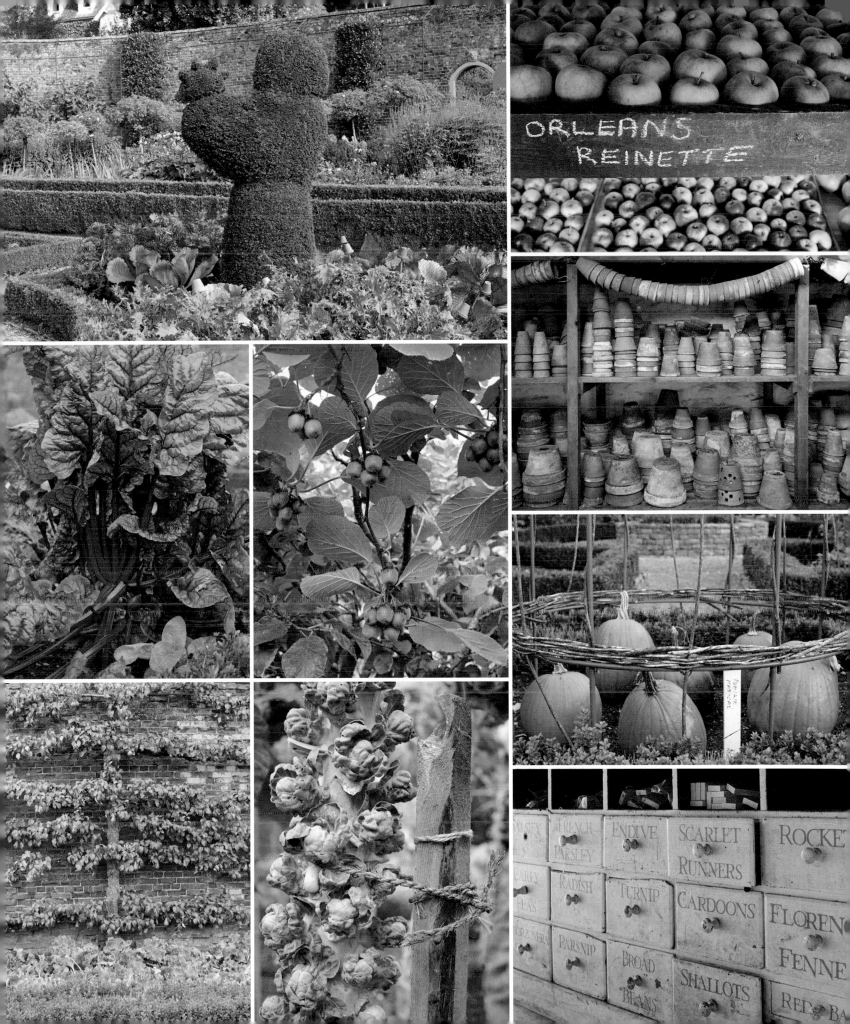

ORLEANS
REINETTE

Secret Gardens of the Cotswolds

At the centre of the walled garden is the Orchid House, designed by the late Philip Jebb, arguably one of the best traditional architects practising in post-war Britain. According to Lady Bamford: 'He was only capable of doing beautiful things. He would scribble a design on the back of an envelope or a scrap of paper and it was always wonderful.'

Contemporary garden designers Mary Keen and Rupert Golby have also helped to shape Daylesford, with Mary Keen responsible for much of the layout of the Vegetable Garden and the Rose Garden, with its pergola of *Rosa mulliganii*.

The parkland and the Orangery were laid out in the late eighteenth century by John Davenport, a landscape architect from Shropshire. Davenport based the Orangery windows on the designs of Batty Langley, a London garden designer who produced engravings of plans for 'Gothick' structures such as summer houses. Davenport designed the grounds in the English landscape style, with a lake and a bridge, but this proved to be his downfall. He was sacked for spending too much money in 1795 and died the same year.

Since the arrival of Dustin Hamilton in 2009, Davenport's original lake has been extended, and the revised design has incorporated the existing mature

OPPOSITE ABOVE Borders brimming with roses and foxgloves are divided by clipped buttresses on the Quince Lawn.
OPPOSITE BELOW The oriental-style pergola in the Rose Garden is planted with *Rosa mulliganii*. The design is by Mary Keen.
BELOW The lake and the meadows of the eighteenth-century, English landscape-style grounds are a complete contrast to the more formal gardens.

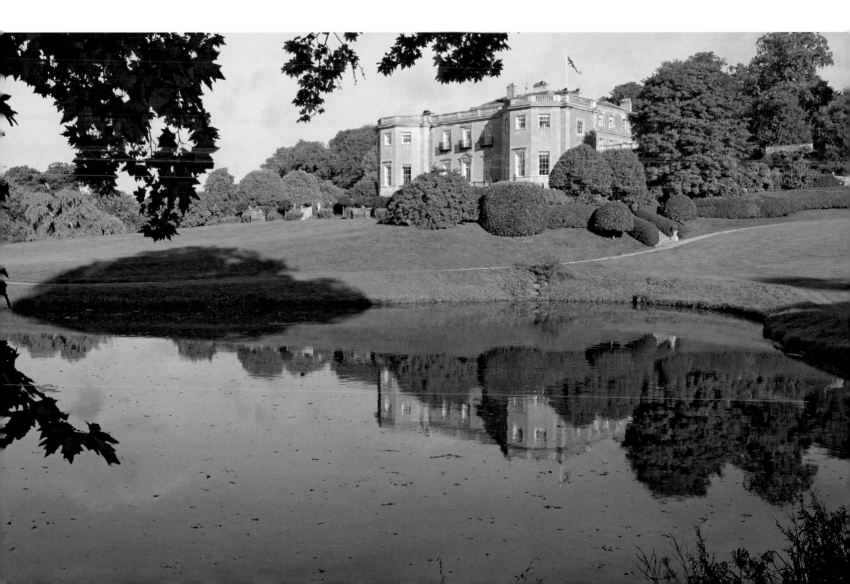

trees, so that the new vista of water stretching into the distance looks very natural.

Hamilton's office is filled with meticulously drawn planting plans of every section of the garden, and there is always a new project under way somewhere in the grounds. The latest plan is to convert the Orchid House into a Carnation House, growing both Malmaisons and scented pinks (*Dianthus*), with peach trees in pots outside.

Behind the Orangery, where discreet, little packets tied to the citrus trees indicate the presence of biological controls, is the Secret Garden, which looks as if it has been there for decades. In fact, it was created to celebrate the millennium. If you look closely, you can see that the octagonal pool is a swimming pool, and there is a pizza oven on one side of the shell grotto. Flanking the pool are two parterres, planted with clipped, conical hornbeams (*Carpinus*) and, in spring, 'White Triumphator' tulips with blue forget-me-

nots (*Myosotis*). The roses that scramble over the arches are *Rosa* Snow Goose, which, like *R. mulliganii,* has creamy white flowers. Unusually for a rambler, they are repeat-flowering if regularly deadheaded. It is a lot of work, says Hamilton, but it is worth it.

You could say the same for the endless programme of mulching that goes on throughout early spring at Daylesford. A thick layer of crumbly compost is spread beneath trees and shrubs, on borders and beds, ensuring that even calcifuges (lime-haters) such as the skimmias in the Scented Garden look green and healthy.

TOP LEFT, ABOVE LEFT AND OPPOSITE The Orangery houses dozens of citrus trees, and biological controls are used to deter pests.
TOP RIGHT AND ABOVE RIGHT The Secret Garden, with its grotto (top right), was built to mark the millennium.

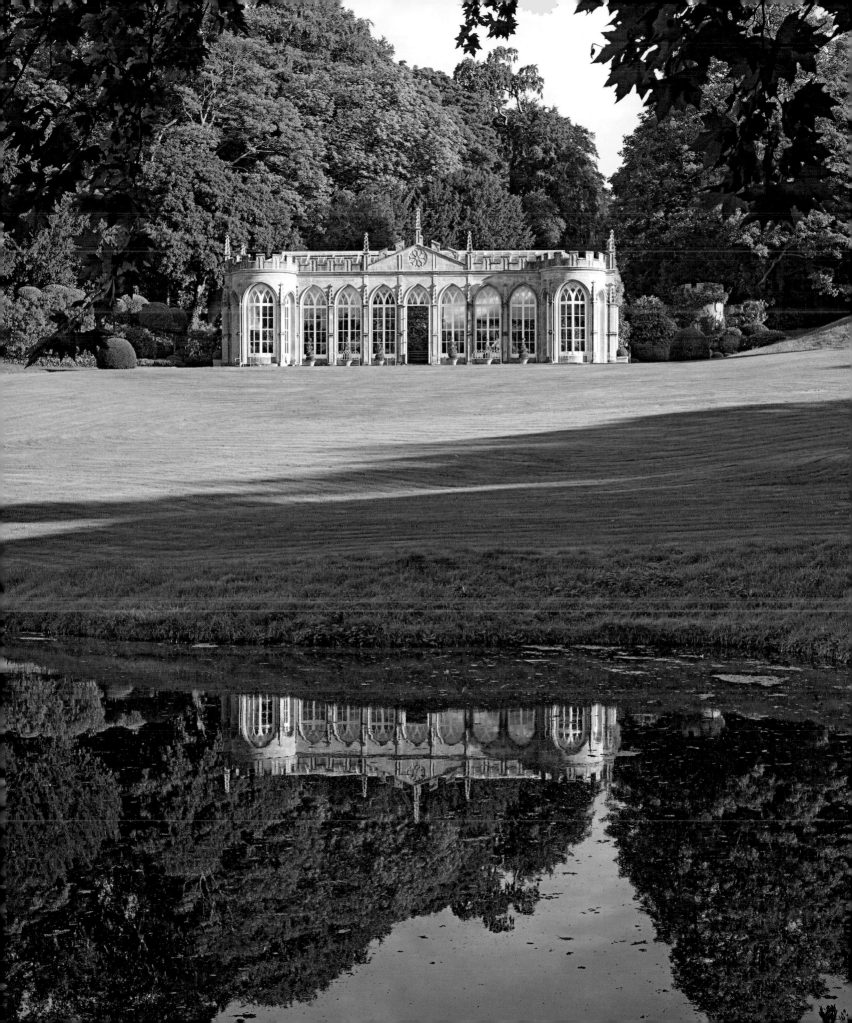

10
Dean Manor
Chadlington

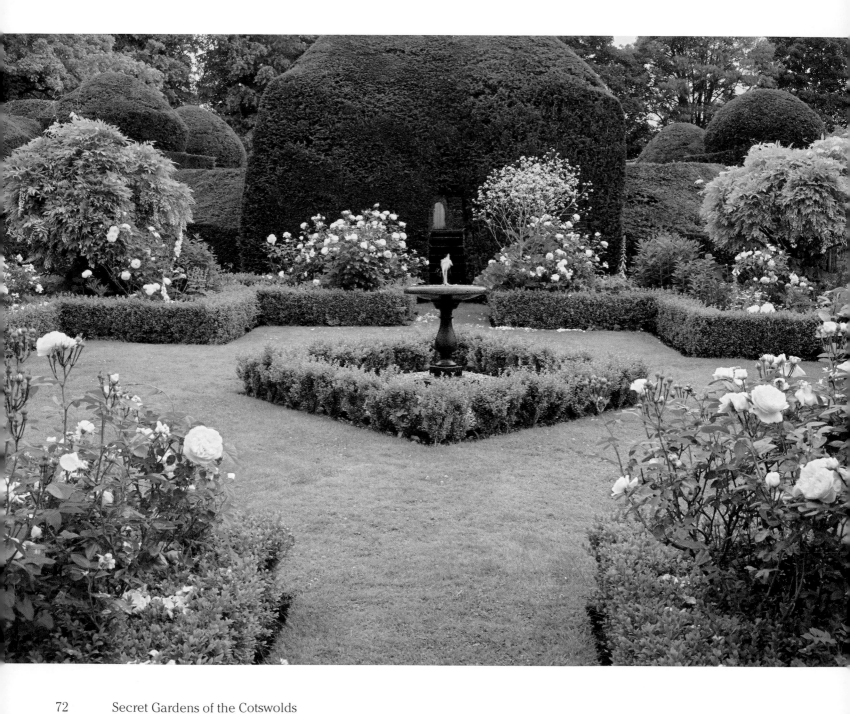

BRITISH LANDSCAPE ARCHITECTS, from Lancelot 'Capability' Brown to Sir Geoffrey Jellicoe, have all been concerned with the creation, or the retention, of vistas. Whether the view is of an idyllic stretch of English countryside, or a neoclassical sculpture at the end of a grassy path or avenue of trees, it is an integral part of good design – a feature that brings perspective to any area of planting, and makes landscaping architecture rather than horticulture.

At Dean Manor, near the Cotswold village of Chadlington, the most impressive vista is of the diving board at the end of the swimming pool, which can be seen from the kitchen window. It does not sound much on paper, although it is obviously very useful for those 'Look at me, Mummy!' moments. However, when you realize that, to see the diving board, the line of sight has to go through three yew hedges and over a fountain, it begins to seem much more impressive.

No one seems to be quite sure who should get the credit for this ingenious vista. The current owners of Dean Manor believe that it is the work of garden designer Arabella Lennox-Boyd, who created the White Garden as well as the two swimming pools, linked by a yew tunnel under which it is possible to swim. The previous owner, on the other hand, declared that it was her father's concept. One thing is certain: it is a clever solution to the problem of how to hide a bright turquoise swimming pool, while at the same time providing a very strong central feature around which the rest of the garden has been designed.

To one side of the White Garden, the current owners have created a second garden with high yew hedges, in which pollarded limes (*Tilia*) rise from beds of spring bulbs. The figure of a shepherd boy keeps watch from the end of the grassy path between the hedges of the two gardens.

On the other side, a 21m/70ft herbaceous border includes nepetas, hardy geraniums, poppies and penstemons, and neatly pruned apple trees form an avenue across the lawn – a tidier version of the original orchard.

Many Cotswold gardens have an orchard, or a couple of apple trees at the very least, and they represent an important part of Britain's plant heritage. Ancient cultures such as the Druids and the Vikings celebrated the apple as a symbol of fertility, or eternal life. However, orchards are in decline, with more than 60 per cent disappearing since the 1950s. Not only does this result in a loss of habitat,

TOP The house is surrounded by a series of garden 'rooms', each with its own focal point.
ABOVE A standard wisteria marks the entrance to the garden where pollarded limes stand sentry over wild flowers.
OPPOSITE The White Garden was designed by Arabella Lennox-Boyd. A gap in the yew hedge leads to the swimming pool.

*Long grass and
wild flowers add
to the sense of a
secret sanctuary
in summer.*

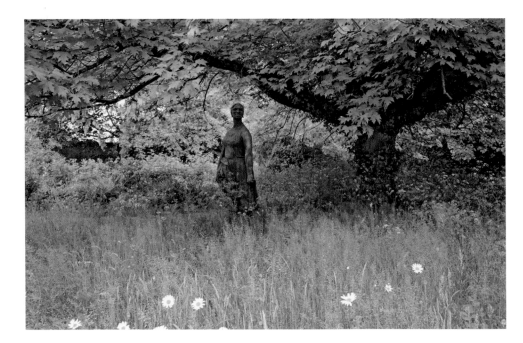

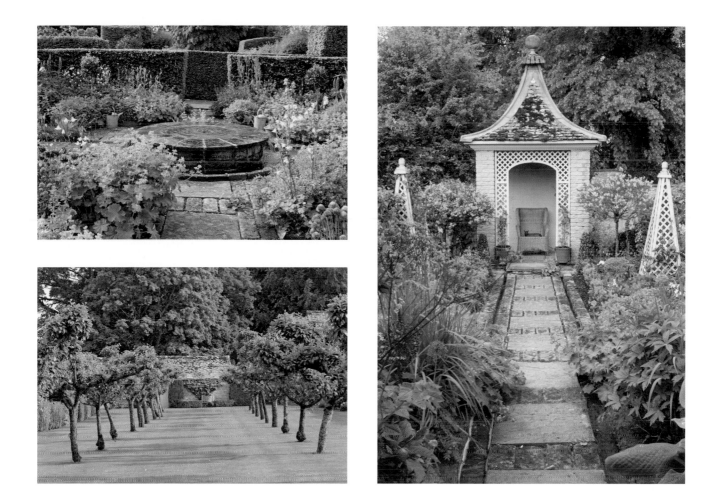

but also of the range of apple varieties available. Orchards are labour-intensive – witness the immaculately kept trees at Dean Manor – and, for many farmers, replacing them with paddocks or arable crops is a much more financially attractive prospect. So garden orchards are even more precious today, as well as being aesthetically pleasing.

Beyond the orchard is the Rose Garden, which originally stood alone within a hornbeam (*Carpinus*) hedge. To balance it, the current owners have created the Vegetable Garden, which now mainly contains herbs and an intricate rill, which leads down from a millstone fountain to a small pavilion, where a rattan chair is set invitingly. They have also made a Wild Garden, where a thicket of *Rosa* 'Cerise Bouquet' and parrotia specimens provide what Jane Austen's Lady Catherine de Bourgh might describe as a 'prettyish kind of little Wilderness'. Long grass and wild flowers add to the sense of a secret sanctuary in summer.

In what the owners call the Yellow and White Border, *R. xanthina* 'Canary Bird' romps beneath laburnum and white lilac (*Syringa*), while the east-facing terrace is enclosed by beds of *R.* Macmillan Nurse, a creamy white, fragrant modern shrub rose bred by Peter Beales.

TOP LEFT The rill that runs each side of the path in the Vegetable Garden is fed by the millstone fountain.
ABOVE LEFT The apple orchard runs parallel to the herbaceous border.
ABOVE RIGHT The little pavilion in the Vegetable Garden is a peaceful place to sit on a hot day.
OPPOSITE ABOVE Billowing perennials such as poppies and nepetas vie for attention in the herbaceous border.
OPPOSITE BELOW The sculpture in the Wild Garden is nicknamed 'Svetlana' by the family.

Old roses

Dean Manor was reportedly built for an Oxford MP called Thomas Rowney, who donated the land for the Radcliffe Infirmary, now part of the world-famous John Radcliffe Hospital in Oxford. Later alterations have not effected the early eighteenth-century façade, but have given the house a more informal feel, and this combination of formal and relaxed is carried through into the garden.

The planting throughout is traditionally English, with white wisteria, Iceberg roses, *Crambe cordifolia* and white foxgloves in the White Garden, and old roses – pink favourites such as *Rosa* 'Königin von Dänemark', *R.* 'Honorine de Brabant', *R.* 'Great Maiden's Blush' and rosa mundi (*R. gallica* 'Versicolor') – in the Rose Garden, which is underplanted with penstemon, hardy geraniums and *Viola cornuta*. A more modern rose, *Rosa* 'Phyllis Bide', climbs the walls each side of the original entrance.

Bred in 1923 from *R.* 'Perle d'Or' and *R.* 'Gloire de Dijon', this is a Polyantha with pale yellow flowers flushed pinky salmon, fading to cream. It looks good with traditional Cotswold stone and, although it is a rambler, it is repeat-flowering and does not grow too enormous.

Interestingly, although the current owners have created more such garden 'rooms', they have also removed some: for example, at the rear of the house, below the terrace walk. There, a series of hedged gardens – like a cross between garden rooms and a parterre – was felt to be too fussy, and a hindrance to the view of the garden beyond.

Clipped yew, beech or hornbeam hedges may surround the garden rooms, but within them the inclusion of pavilions, seats, fountains and rills gives the impression that this is a garden which is very much enjoyed by its owners. Many of the items within it – such as the lead pool behind the house – have been acquired at sale rooms or architectural salvage yards. The somewhat socialist realist figure of a sturdy woman who stands holding a kerchief or a shawl in the Wild Garden is nicknamed 'Svetlana'.

The gardens also include Dean Manor Barn, a converted Cotswold-stone barn, which is used as a venue for the Dean and Chadlington Summer Music Festival, which takes place each June. Events include concerts – ranging from lute recitals to jazz – and a singing competition open to young singers aged 18–28.

The owners' children are now grown up, with children of their own, but from the sunset-viewing platform at the rear of the Wild Garden, to the sculpture of the fearsome bull pawing the ground beyond the Rose Garden, it is still possible to find playful moments at Dean Manor.

LEFT Lucy Chadlington and her husband, Peter, have created new garden 'rooms' at Dean Manor while retaining the quintessentially English character.

RIGHT The roses are underplanted with bulbs and perennials, such as hardy geraniums, which help to provide a long season of interest in the Rose Garden.

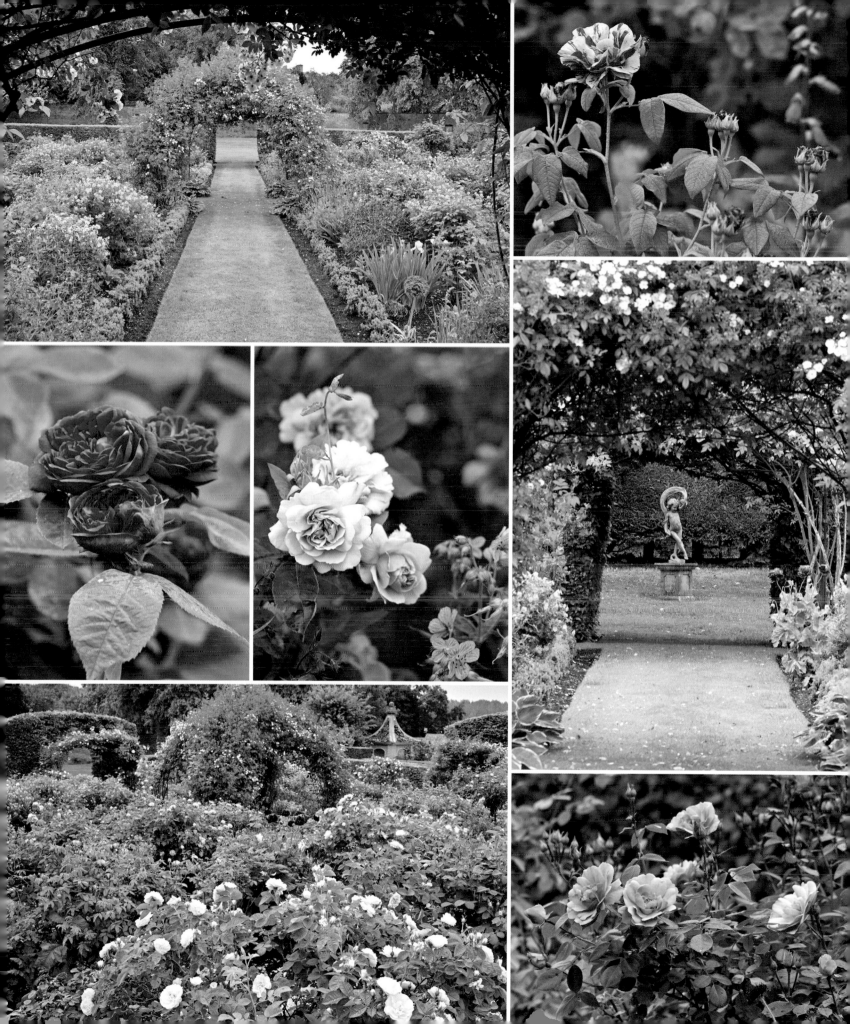

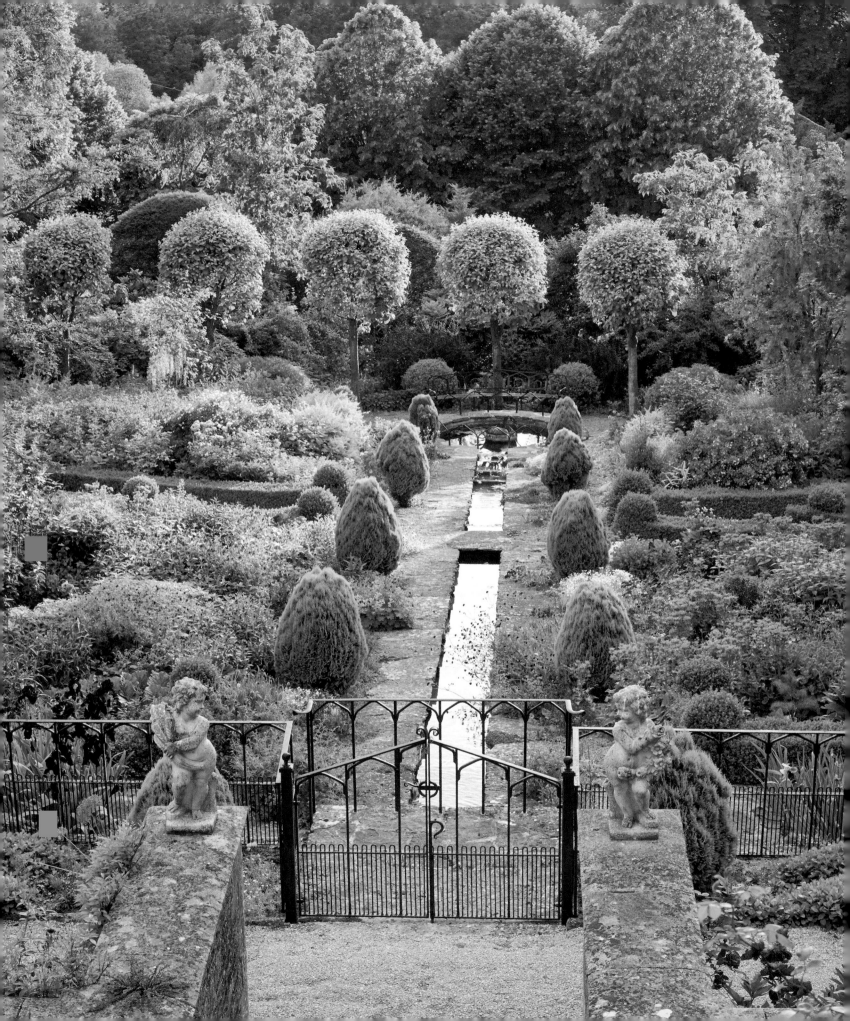

11
Eastleach House
Eastleach

IT WOULD BE MISLEADING to describe Eastleach House as a home-made, recycled garden. That might conjure up an image of something a bit homespun and frayed around the edges. Yet Eastleach is very much a home-made garden, and many of its features – whether they are the blue garden chairs that came from Lords cricket ground, or the stone from the boiler house that was used to build one of the terraces – have been recycled.

Stephanie and David Richards moved here thirty-two years ago, and their first impressions must have been daunting. The house had been let for years, recalls Stephanie, and the tenants had kept ducks and guinea fowl. The garden was overgrown, and everything was covered in ivy. For the first five years, the Richards did nothing but clear up.

On the plus side, however, there were wonderful views to the west over the village, and to the south over the Marlborough Downs. There was enough level ground at the top of the site to create a garden around the house, and there was already a walled garden. 'The position of the house is so important', says Stephanie. 'You can change the house, but you cannot change what is around it.'

What had been a 'completely derelict jungle' has now been transformed into 5.6 hectares/14 acres of formal gardens and parkland, but, even today, there is no hint of what you will find when you arrive at Eastleach House. The entrance gate is on the main road, and the drive

LEFT The Rill Garden is on a steep slope, which foreshortens the view. The size of the garden is apparent only once you walk down into it.
RIGHT Stephanie Richards poses with her Bernese mountain dog, Lily. Stephanie and her late husband David designed the gardens themselves.

'I've always tried to create a picture. I always had sketches of ideas in my notebook – I did the design for the Rill Garden in 30 minutes while in the car on the way to a wedding.' STEPHANIE RICHARDS

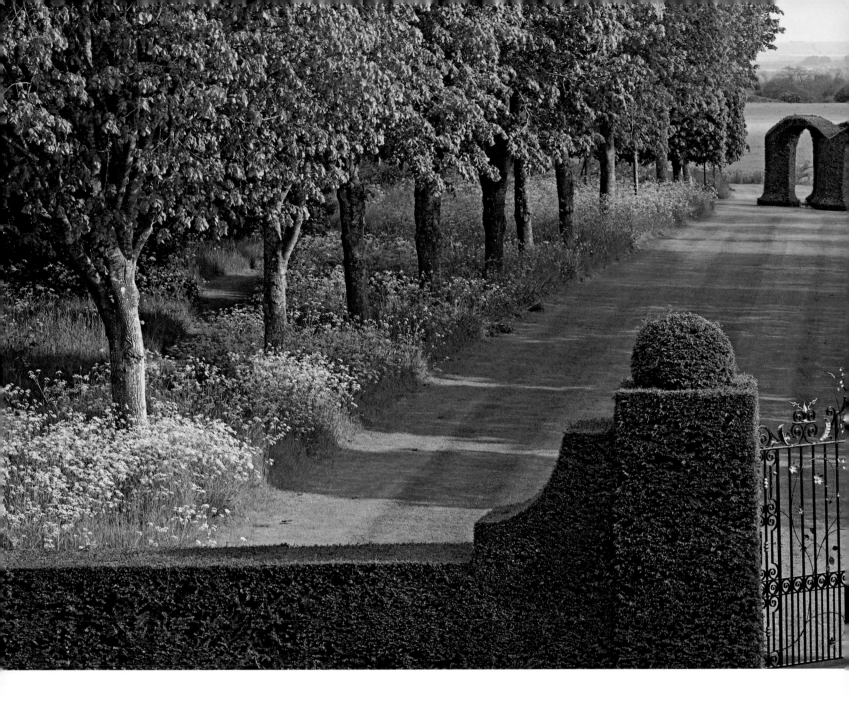

winds steeply uphill through trees. Even when you arrive at the house, there is still not much indication, because the formal gardens are mainly enclosed by yew hedges, and the view over the parkland can be seen only from the back of the house.

The Richards never had a grand plan for the garden. They did each bit at a time. While they were keen to provide contrasts in ambience and planting, they felt it was important that each area should lead into the next naturally, without too violent a change. They never employed a garden designer, but Rosemary Verey was very generous with advice – and cuttings, according to

Stephanie. Some of their first box hedges were grown from cuttings from Verey's Barnsley House.

Stephanie paints and, perhaps because of this, she says she really enjoyed the design side: 'With every bit of the garden, I tried to create a picture. I always had sketches of ideas in the back of my notebook, and in fact I did the design for the Rill Garden in 30 minutes while in the car on the way to a wedding.'

It was David Richards, however, who came up with the concept of the avenue of limes (*Tilia platyphyllos* 'Rubra'), which leads the eye through the park towards the distant view of the Marlborough Downs. Halfway

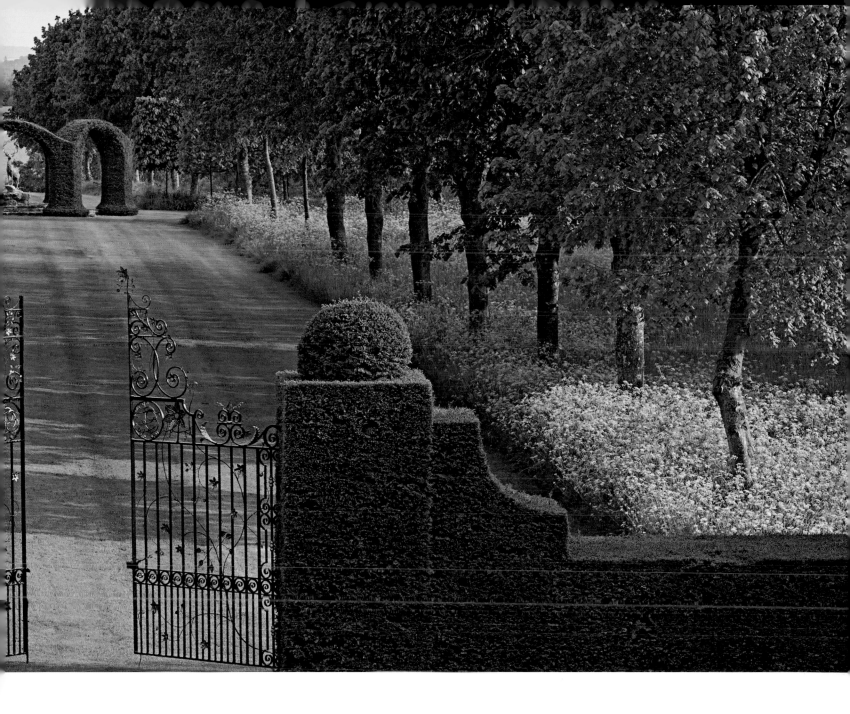

along the avenue is a crossroads, where the limes meet an avenue of beech (*Fagus*), and where they cross there is a roundel of yew arches, with a sculpture of a bronze stag in the centre. The roundel is known as 'Hedge-henge' — an impression that is heightened by the oval of pleached limes that surrounds it. The stone plinth on which the stag stands is another bit of recycling; it came from a heap of stone that had been dumped behind the old stables.

Tree planting

In many Cotswold gardens, a delicate balance has to be achieved between vistas and shelter. You do not want

to plant a row of trees across an idyllic view of verdant countryside, but neither do you want a Force 10 gale howling up the valley and blowing down your specimen trees. A shelter belt is good, says Stephanie, but you cannot protect yourself totally. All you can do is to keep planting trees, comforting yourself with the thought that you will have new introductions to replace any victims of the inclement weather.

Nicknamed 'Hedge-henge', this monumental yew roundel with its central bronze sculpture of a stag forms the focal point in an avenue of limes.

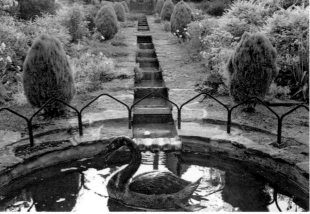

Sadly, David died in 2003, but the programme of tree planting goes on. More than 500 have been planted since the Richards arrived in 1982, and there is now a small arboretum. Altogether, Eastleach has four different types of oak (*Quercus*) and different varieties of maple and cedar, as well as exotic species such as *Pinus wallichiana* (a native of the Hindu Kush), *Picea glauca* 'Coerulea' (from North America) and *Nothofagus antarctica* (which grows as far south as Tierra del Fuego). Then there are the flowering trees and shrubs – cherries (*Prunus*), crab apples (*Malus*) and magnolias, including the beautiful *Magnolia* × *soulangeana* 'Brozzonii', which has huge, white flowers flushed with very pale pink. It is the latest of the soulangeanas to flower and often has a second flush in midsummer.

As the visitor explores the 4-hectare/10-acre park and the arboretum, it is difficult to remember that there is still the rest of the garden to see. Then you turn a corner and spot the Rill Garden, and suddenly all thoughts of perhaps sitting down on a bench and having a rest disappear.

The Rill Garden is on a sharply sloping site and was designed by Stephanie, in 1997, to save her husband having to mow what had been a rather mossy lawn. Beyond the row of nine standard sorbus at the bottom, the countryside slopes sharply uphill again. The effect is reminiscent of a Northern Renaissance landscape, such as those by Joachim Patinir, in which every bit of the vertiginous landscape is crammed with detail.

The rill itself runs down the centre of the garden, flanked by golden dwarf thuja (*Platycladus orientalis* 'Aurea Nana'). On either side are three large borders, planted as a colour wheel and edged with box. When seen from the top of the garden, where there are borders of irises, the rill has the effect of foreshortening the view,

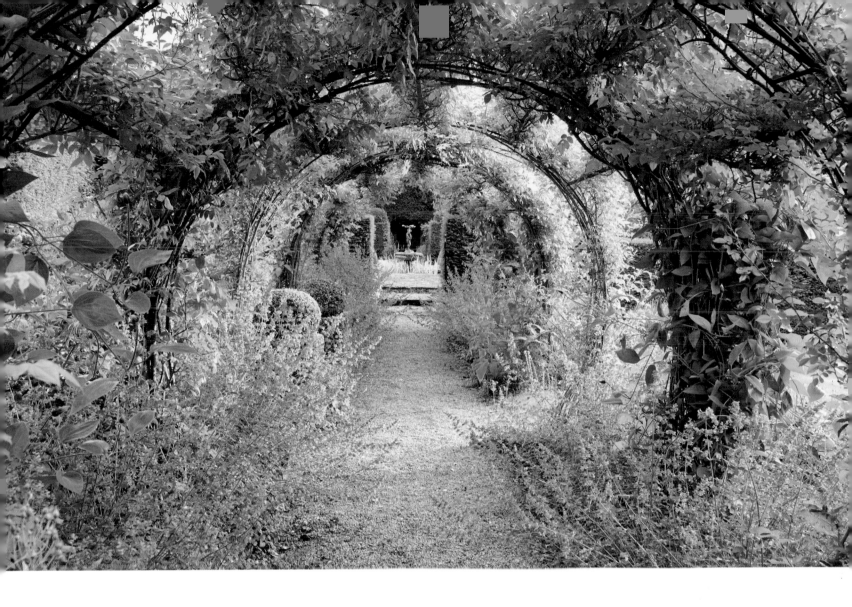

ABOVE The blues and purples of the clematis on the pergola are picked up by the soft blue of the nepetas planted beneath.

LEFT The oak used to make the doorway for the little summer house came from an old water tower.

OPPOSITE ABOVE LEFT The house dominates the skyline from the bottom of the Rill Garden.

OPPOSITE ABOVE RIGHT, BELOW LEFT, BELOW RIGHT The Rill Garden is laid out like a parterre, with each section planted in a different colour theme. The rill itself is flanked by rows of golden dwarf thuja.

so it is only when you reach the bottom that you realize how extensive this part of the garden really is.

At the bottom of the Rill Garden is an undulating yew hedge, and this is a feature that Stephanie has repeated in the walled garden on the other side of the house. Such hedges are currently very fashionable. One of their major advantages, even in a traditional garden, is that they provide shelter without drawing a hard, straight line across the landscape, while at the same time offering a glimpse of what is beyond.

Knot gardens

The walled garden is effectively a *hortus conclusus* (enclosed garden), which to some extent reflects the history of Eastleach House. This is an Arts and Crafts dwelling in the Jacobean Revival style, designed by Sir Walter Cave, and completed in 1900. The Arts and Crafts Movement was concerned with reviving crafts and skills that were beginning to disappear as a result of the industrial revolution and the rise of mass manufacturing. Its proponents looked back on the Middle Ages as a period when traditional craftsmanship was celebrated and fostered by guilds, or associations, of artisans. As a result, all things medieval became fashionable, including the idea of the *hortus conclusus*, which had at one time symbolized the Virgin Mary. Traditionally, a *hortus conclusus* was not just any garden that was fenced in, but was instead a very private space, modelled on the ancient Islamic gardens, with four quadrants of planting and a fountain at the centre.

Stephanie did not set out to design the walled garden as it now looks, but she instinctively had a vision of a garden with right angles and paths. A raised terrace at the centre looks down on two knot gardens, while rose arches frame the paths. If you look back across the garden to the house, you can see that the topiary shapes echo the gables and chimneys of Sir Walter Cave's design.

All self-respecting English gardens need at least one quirky feature, and in the walled garden it is the window in the wall at the far end which looks down on a sunken Woodland Garden. This is a haven for wildlife, with its lily pond spanned by a bridge reminiscent of the one at Giverny – Claude Monet's garden.

If Eastleach is a home-made garden, then it is no great wonder that gardening groups and other visitors come here every year in search of the recipe.

LEFT The bridge in the Wild Garden is modelled on the one in Monet's garden at Giverny.
RIGHT The walled garden includes two knot gardens and a central raised terrace. The pathways are framed with rose arches.

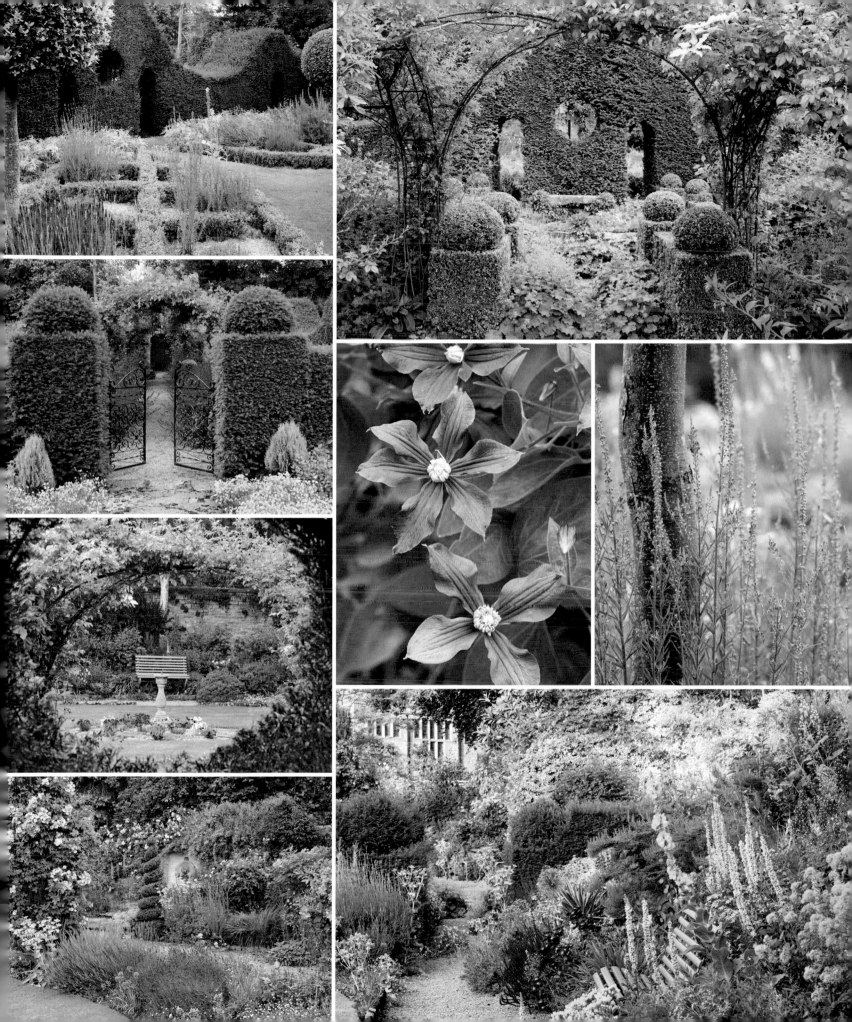

12
Eyford House
Upper Slaughter

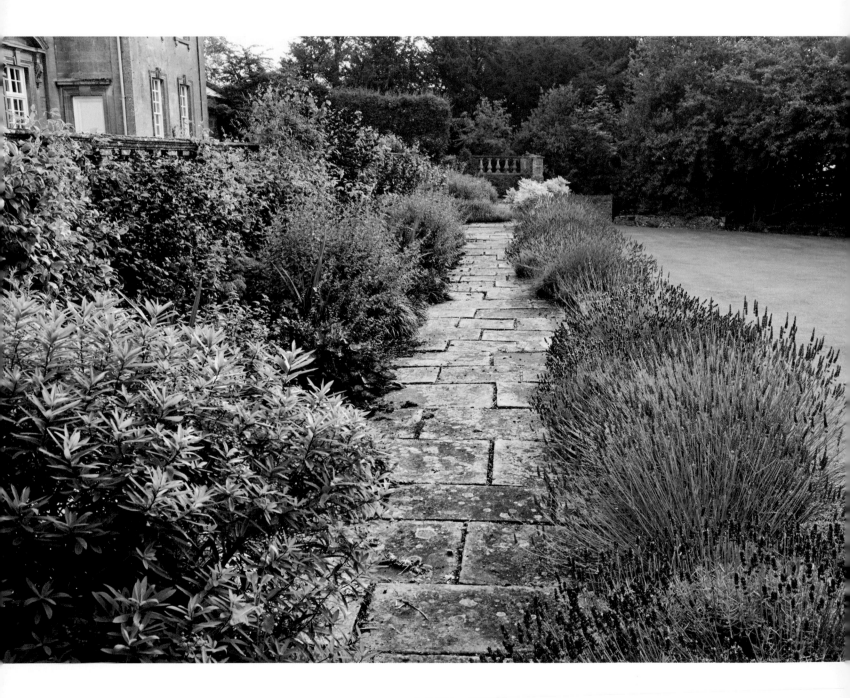

EYFORD HOUSE lies between the bustling Cotswold tourist haunts of Bourton on the Water and Stow on the Wold, but once inside its grounds you would never guess that you were within only a few kilometres of tea shops and coach parties. The parkland, first landscaped in the eighteenth century, creates a 60-hectare/148-acre pastoral idyll, and it is easy to believe the legend that John Milton was inspired to write part of *Paradise Lost* while walking here.

In the spring of 2011, Eyford was voted England's Best Country Home by *Country Life* magazine (Julian Fellowes, the creator of *Downton Abbey*, was on the judging panel). It is easy to see why. Set in what was originally water gardens and pleasure grounds dating from 1710, the house, built in 1910, is on a domestic, intimate scale. It is designed in Queen Anne style, with a charming doll's house façade in golden Cotswold stone punctuated by multi-paned windows. The architect was Guy Dawber, who like Edwin Lutyens trained with Ernest George and Harold Peto, and who like Lutyens specialized in the Arts and Crafts style. Dawber co-founded the Council for the Preservation of Rural England (now the Campaign to Protect Rural England) in 1926, and he designed the formal gardens around the house. These were restored in the 1970s by Graham Stuart Thomas, whose work for the National Trust included his masterpiece – the Rose Garden at Mottisfont Abbey.

Jinks on the lawn

In 1972, Eyford was bought by Sir Cyril Kleinwort, a partner in the banking house that eventually became the Kleinwort Benson group. In 1944, Sir Cyril and his wife, Betty, had bought the fabulously exotic Sezincote (see pages 112–17), now owned by their grandson, Edward Peake, and had turned to Graham Stuart Thomas for advice on restoring the gardens – a collaboration which lasted for thirty years. It must have seemed only logical to ask the the leading expert of his day for advice about restoring the gardens at Eyford.

Lady Kleinwort died seventeen years ago after a long illness. Her daughter, Charlotte Heber-Percy, inherited the house and immediately asked Graham Stuart Thomas to come back and advise her again.

The formal gardens at Eyford are not huge, and Guy Dawber's designs are straightforward. They include a

TOP The house was built in 1910, in the Queen Anne style.
CENTRE The quirky topiary along the yew hedge shows a pack of hounds chasing a fox.
ABOVE The formal gardens around the house were restored in the 1970s by Graham Stuart Thomas.
OPPOSITE The terrace border has a colour scheme of mainly red and bronze, and is hedged on one side by lavender.

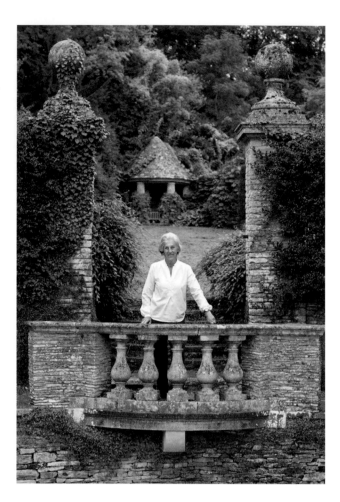

terrace at the back of the house, which overlooks the lawn. The terrace is now bordered on one side by lavender and is planted on the other in a colour scheme of red and bronze, including roses, clematis and phormiums.

When the house was built, the lawn would have been used for croquet, or as somewhere to take tea, but it is now more likely to feature a goalpost or a makeshift cricket pitch. It's a great place to have drinks on a sunny summer evening, says Charlotte Heber-Percy. She still lives at Eyford, but moved into the converted stable block after passing the house on to her daughter Serena Prest, who lives there with her husband and their three children.

As you walk back around the house to the front, you pass through a garden room surrounded by a yew hedge. Along the top of the hedge, a pack of topiary hounds race in perpetual pursuit of a fox past a summer house that is built of stone salvaged from the polo stables at Sezincote.

At the front of the house, the sculpture of a swift was Charlotte's parting gift to the house three years ago. Beyond it are Guy Dawber's flight of steps and high stone gateway that lead the eye to a pavilion at the end of the main garden. It is a lovely vista, but the effect has been heightened by the addition of two lines of Irish yews on the advice of Graham Stuart Thomas, which give the garden a more architectural feel.

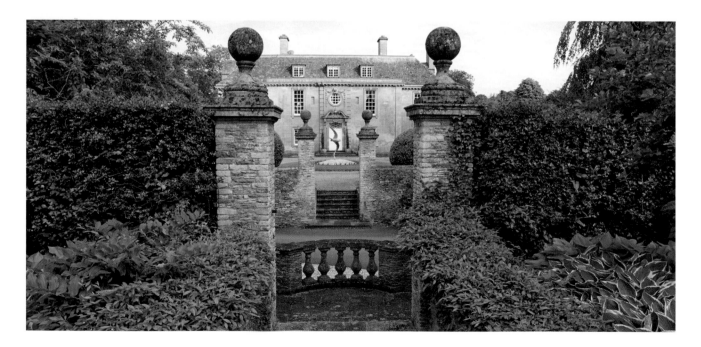

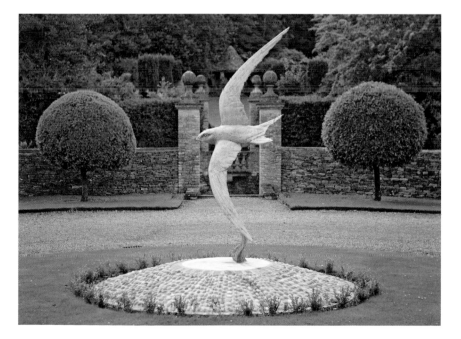

ABOVE The fastigiate yew pillars were added at the suggestion of Graham Stuart Thomas. The wide island beds give the effect of a serpentine border.

LEFT AND OPPOSITE BELOW The sculpture of a swift was Charlotte Heber-Percy's parting gift to Eyford when she passed the house on to her daughter, Serena.

OPPOSITE ABOVE Charlotte Heber-Percy stands in the gateway to the main garden.

Eyford House 89

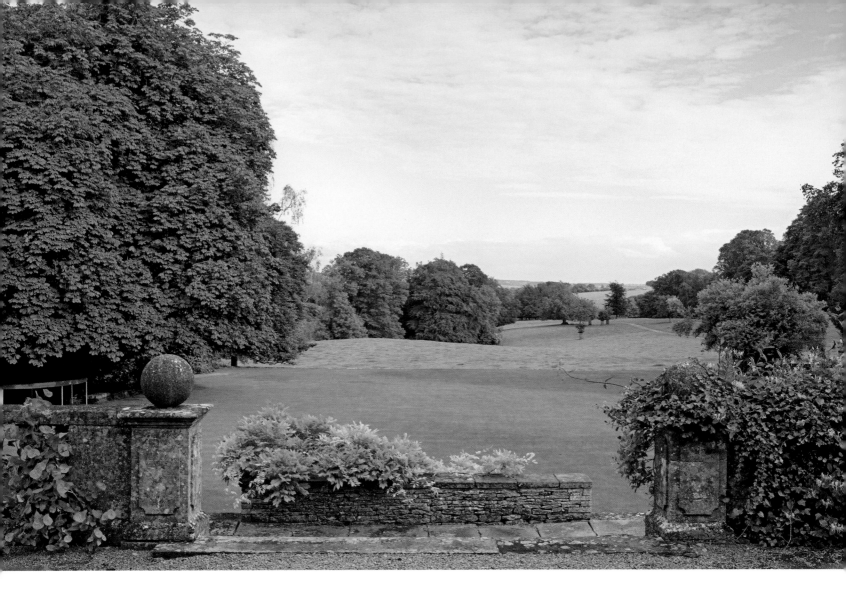

It is easy to believe that John Milton was inspired to write part of Paradise Lost *while walking through the grounds.*

ABOVE From the terrace, you can see for miles across Cotswold meadows and woodland.
OPPOSITE These gates lead to the estate. Eyford House may be postcard-pretty, but the estate is a working farm.

A casual glance through the gateway reveals what look like herbaceous borders on either side of the garden, but these are actually large island beds, planted predominantly in yellows on the left and in pinks and blues on the right. The garden is surrounded by woodland. According to Charlotte Heber-Percy, Eyford is always three weeks behind everyone else, so the use of yellow privet, golden hops, variegated iris and the gleaming leaves of *Acanthus mollis* 'Hollard's Gold' helps to create a warmer, sunnier effect.

Adam and Eve
Restoration work goes on: the walled Kitchen Garden was revamped in 2013 with a series of raised beds surrounded by stepover apple trees; and there are plans to convert the swimming pool area into yet another garden room.

It is thought the first house at Eyford was built during the seventeenth century for Charles Talbot, Duke of

Shrewsbury, who is said to have entertained William III there. The Milton rumour was reportedly promoted by a subsequent owner, a Mrs D'Arcy Irvine, who restored the well where the poet is said to have sat and written. The story goes that she asked a friend to write an inscription, which includes the sentence: 'Beside this spring Milton wrote Paradise Lost.'

It is not implausible that Milton visited Eyford, or at least the well – he met his wife, Mary Powell, while on a visit to Oxfordshire (albeit on the other side of Oxford from Eyford) – but there is no hard evidence to support the story.

However, it is a lovely image: the poet gazing out at some of the most beautiful rural scenery in England, and envisaging Adam and Eve walking through a verdant Gloucestershire Eden:

'So hand in hand they passd, the lovliest pair
That ever since in loves imbraces met,
Adam the goodliest man of men since borne
His Sons, the fairest of her Daughters *Eve*.
Under a tuft of shade that on a green
Stood whispering soft, by a fresh Fountain side
They sat them down, and after no more toil
Of thir sweet Gardning labour then suffic'd
To recommend coole *Zephyr*, and made ease
More easie, wholsom thirst and appetite
More grateful, to thir Supper Fruits they fell,
Nectarine Fruits which the compliant boughes
Yielded them, side-long as they sat recline
On the soft downie Bank damaskt with flours.'
(*Paradise Lost*, Book IV)

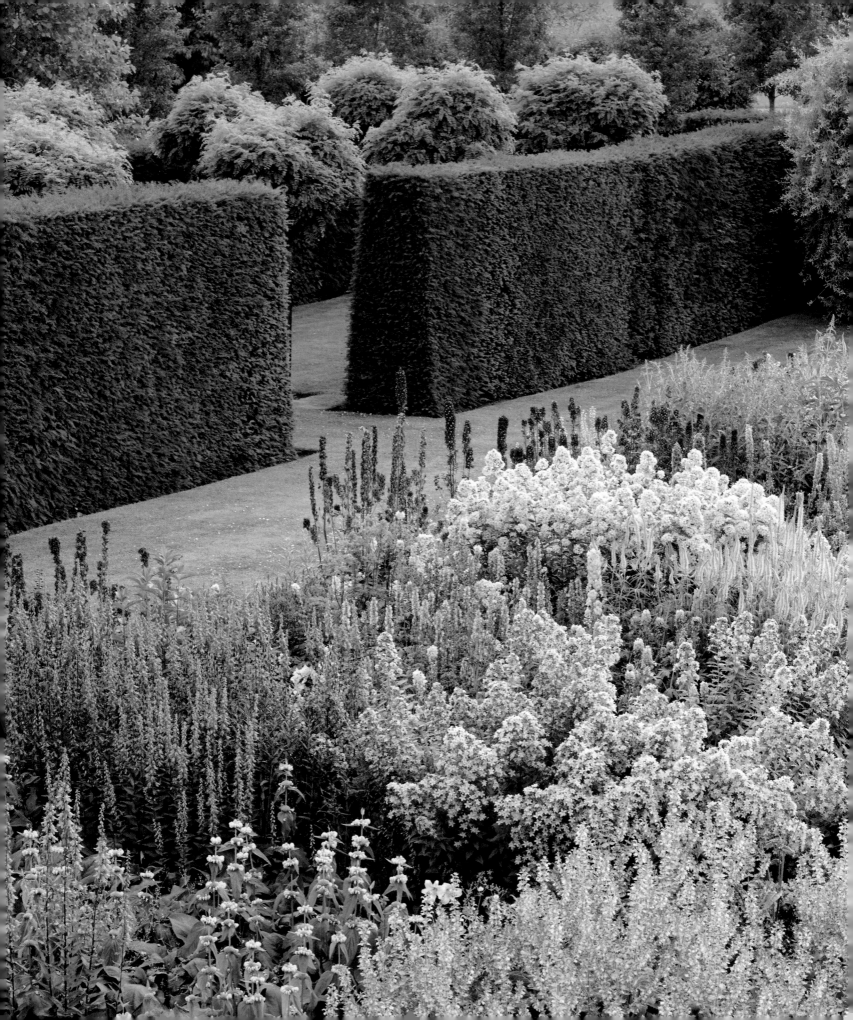

13
Kingham Hill House

Kingham

AS YOU MAKE YOUR WAY around the gardens of the Cotswolds, you become aware of a story of regeneration, told again and again. It always begins in the same way, in the best oral storytelling tradition, like an old fairy tale or a fable from *The Arabian Nights*. On this occasion, it does not begin with the words 'Once upon a time'; instead, it starts 'When we came here, there was nothing.'

Just as fairy tales have their princes and princesses, so this story has its heroes and heroines – the gardens' owners, and designers such as Mary Keen, Rupert Golby and Rosemary Verey. The villains are usually brambles (*Rubus fruticosus*), ground elder (*Aegopodium podagraria*), honey fungus and hungry soil, while the ending – as in the best fairy tales – is always a happy one involving triumph over adversity and the creation of a beautiful space. You may not have to kiss a frog in order to transform a garden in the Cotswolds, but you may well find yourself wielding a chainsaw or a digger.

Kingham Hill House used to be part of Kingham Hill School, which is still an independent secondary school in Kingham for day and boarding pupils, and was founded by Charles Edward Baring Young, in 1886, to be a self-sufficient community. Kingham Hill House, one of the boarding houses, had the most enormous Kitchen Garden – arguably one of the biggest in the UK – where the pupils were allowed to cultivate plots. Originally, the school occupied about 405 hectares/1,000 acres (it now has 39 hectares/96 acres), and pupils were encouraged to learn a trade and even given the opportunity to emigrate to Canada, where Young had a farm. Today it still places great emphasis on an awareness of the environment and the natural world, while offering a conventional modern curriculum.

In the 1980s Kingham Hill House was sold and is now privately owned. The current owners bought it in 1991, and, at that point, the Kitchen Garden was a sea of brambles, according to head gardener Ashley Hetherington. It is now a series of terraced lawns, with a central cascade leading down to a reed-fringed lake. The central cascade is flanked by box hedging and a double avenue of acers.

At the highest end of the Water Garden, roses grow against the wall, in a bed edged with germander (*Teucrium chamaedrys*), which is trimmed like a box hedge. Germander is used in this way in Prince Charles's garden at Highgrove, and many Cotswold gardeners have now followed his lead in trying to find a substitute for box, with its attendant problems of blight.

LEFT The magnificent borders behind Kingham Hill House are planted with delphiniums, campanulas and foxgloves.
RIGHT The view to the north is emphasized by a broken semicircle of pleached hornbeam.
OVERLEAF The former Kitchen Garden, once used by Kingham Hill School pupils to grow vegetables, now contains a cascade that leads down to the lake.

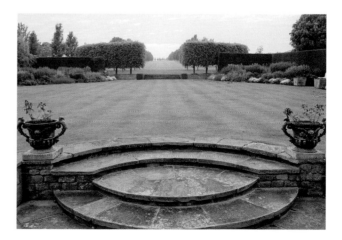

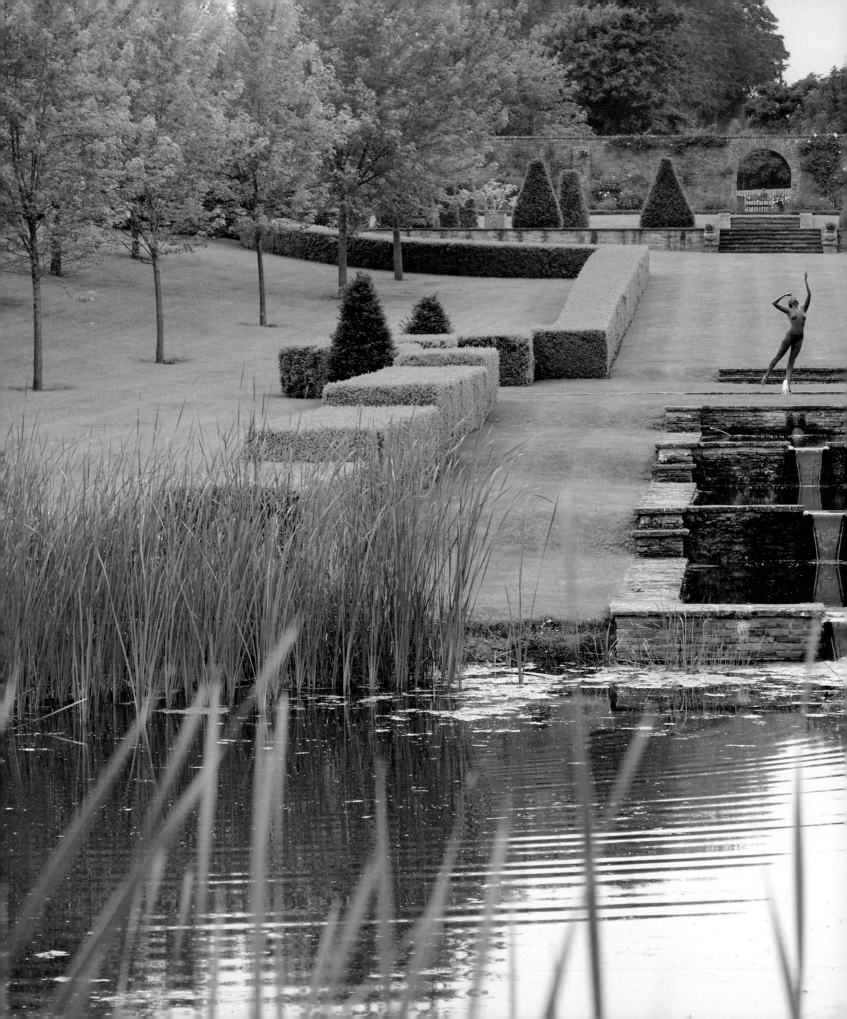

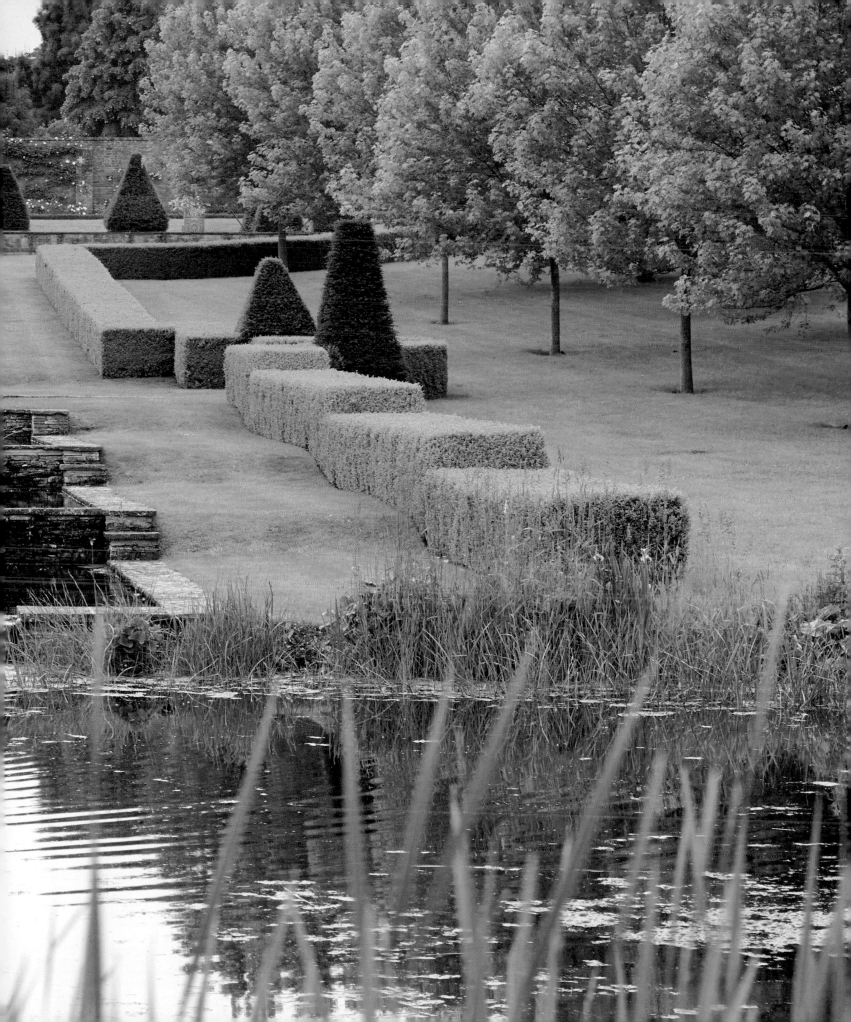

ABOVE Rosemary Verey's Four
Seasons Garden is now known
as the Lavender Garden. In
addition to lavender, it includes
many of her trademarks,
such as mopheaded standard
white wisteria, pergolas and
topiarized box.

RIGHT A closer view of one
of the pergolas, draped with
Wisteria floribunda 'Alba',
reveals that it is underplanted
with hostas.

OPPOSITE Enormous shrub
borders have been designed to
offer year-round interest, from
spring blossom to autumnal
leaf colour.

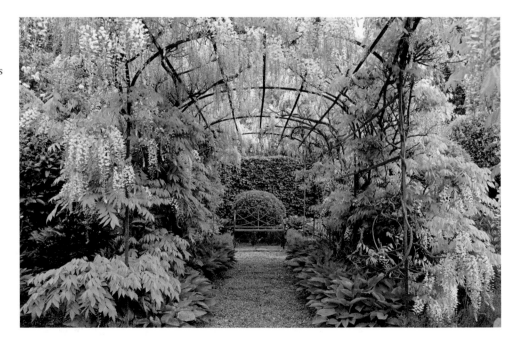

One of the highlights of the garden at Kingham Hill House is what is now known as the Lavender Garden, a parterre garden planted in predominantly blue and white and designed by Rosemary Verey in 1995, only a few years before her death in 2001. Verey called it the Four Seasons Garden, with the aim of providing something of interest for every season. It employs her favourite ingredients – clipped Portugal laurel (*Prunus lusitanica*), standard *Wisteria floribunda* 'Alba' (also known as 'Snow Showers') and box spheres – underplanted with *Iris* 'Jane Phillips', peonies, 'White Triumphator' tulips, and of course lavender.

Rupert Golby, who worked with Rosemary Verey at the start of his career, now oversees the design of the garden, and he has retained her favourite pastel palette, while introducing a slightly more architectural element to the overall design, which is more contemporary and restrained than the traditional Verey look. At the back of the house, curving borders billow with the blues, mauves and lilacs of delphiniums, campanulas and foxgloves (*Digitalis*), an exuberant contrast to the surrounding yew hedges.

A spectacular view of the village of Churchill, with its elegant church tower modelled on that of Magdalen College, Oxford, is framed by a wide series of grass 'steps' (if it were not for the terraced steps, you might even call it a ride). Instead of herbaceous borders, shrubs such as viburnum, hydrangea, buddleja, cornus, spirea and deutzia are planted on either side, interspersed with fastigiate English oaks (*Quercus robur*), offering year-round interest in the form of leaves, blossom, berries and autumn colour.

Golby is the quiet hero of many Cotswold gardens. He trained at the Royal Botanic Gardens, Kew, and at the RHS Garden Wisley, Surrey, and is now based in Oxfordshire. Although he denies having a signature style, his trademark could be said to be exactly that: a lack of

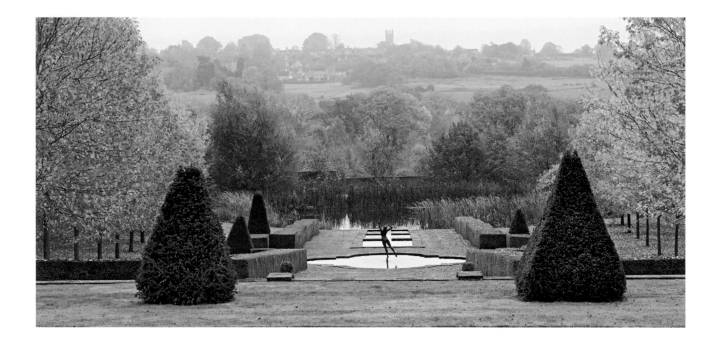

*The Kitchen Garden —
once a sea of brambles —
is now a series of terraced
lawns, with a central
cascade leading to a
reed-fringed lake.*

ABOVE The avenues that lead down to
the lake in the former Kitchen Garden
also frame a view of Churchill village,
with its landmark church tower.
OPPOSITE Autumn is one of the
highlights of the year at Kingham Hill
House, with both native species such
as beech and non-native species
such as Japanese maples contributing
to a blaze of colour.

gimmick or mannerism. He believes that the starting point for any garden design
should be the house. In his book, *The Well-Planned Garden*, he writes: 'From
the proportions and façade of a house, you will still find inspiration for lines
of paths, the position of a gateway and the proportions of a border. The well-
planned garden should help to merge a house into its immediate surroundings,
giving the impression that the house has grown up out of the garden.'

This does not mean a strict adherence as to how the original garden would
have looked, Golby explains: 'Some of the finest gardens have been made over
a long period and owe their beauty to a succession of stages which time has
helped to unite. But the use of sympathetic material of period features will
significantly ease a newly designed or redesigned garden into its context.'

Church tower

Much of the garden at Kingham Hill has therefore been designed to take
advantage of the house's high position above the surrounding countryside.
Avenues of trees, such as ornamental pears (*Pyrus calleryana* 'Chanticleer'), with
their neat, upright form, or clipped hornbeam (*Carpinus betulus*), or the limes
(*Tilia*) which lead the eye from the croquet lawn on the west side of the house
beyond the ha-ha to the horizon not only focus attention on the views, but also
act as a formal echo of woods and hedgerows in the surrounding countryside.

On the east side of the house, the terrace has four formal box parterres
planted with germander and lavender. The land slopes away quite steeply
here, so the parterres provide orderly, evergreen ornamentation without
interrupting the spectacular view of the Cotswolds – an Area of Outstanding
Natural Beauty (AONB).

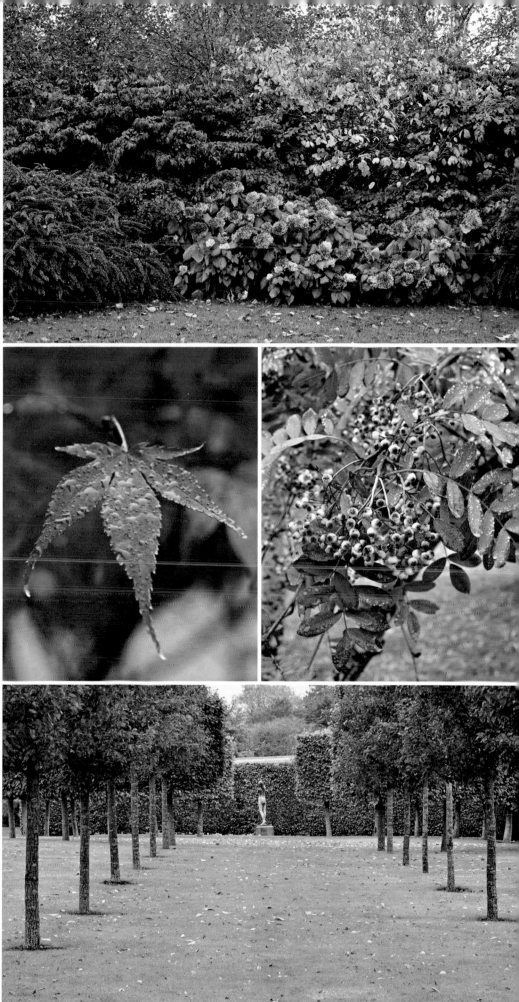

14
Rockcliffe

Upper Slaughter

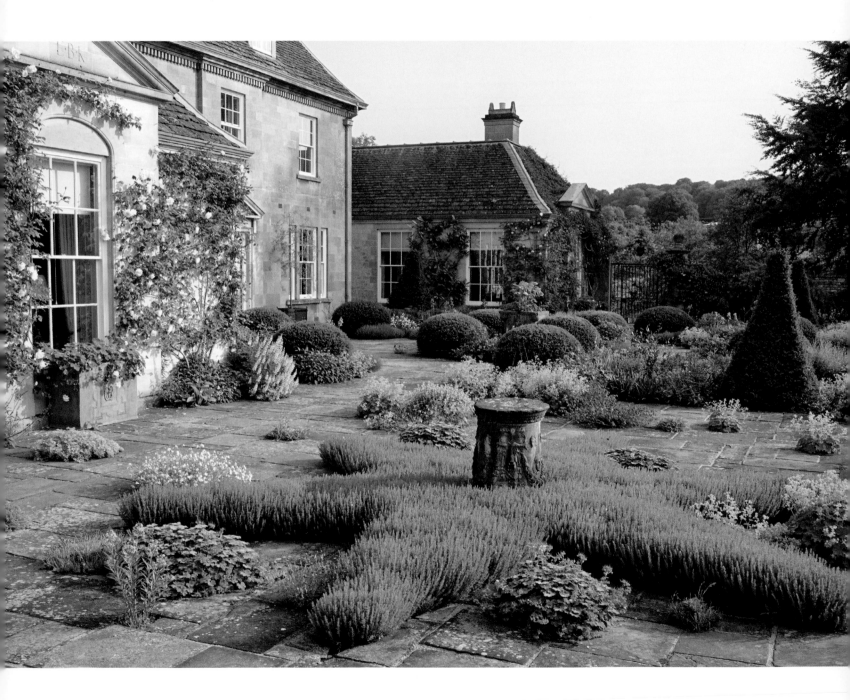

IF YOU HAVE EVER VISITED a garden outside the UK that is billed as a typical English garden, you will know how tricky it is for outsiders to recreate the quintessential British plot. The classic English garden is more than just the sum of its parts.

Yes, you can include roses, lavender, herbaceous borders, clipped box hedges and yew topiary. If you do not put them together in the right way, however, they will not have that essential Englishness. Paradoxically, the addition of something very un-English can often be a key factor. Other important ingredients of a typical English garden are wit and whimsy – subtle commodities that are impossible to counterfeit. Add to these a sort of confidence that English gardeners seem to inherit along with centuries of garden history, and you have the raw material for gardens that are at the same time clever yet comfortable within their landscapes.

Emma Keswick's garden at Rockcliffe, 3.2 kilometres/ 2 miles south-west of Stow on the Wold, is a good example of this approach. You often see it described as a traditional English garden, and its 3.2 hectares/8 acres certainly include yew hedges and topiary, a Pink Garden, a Blue Garden, a Kitchen Garden and a Croquet Lawn.

The soil at Rockcliffe, as the name suggests, is poor. It is typical Cotswold brash, says head gardener Thomas Unterdorfer, that is, free-draining, often shallow soil with a high stone content. It is very hungry, which means that moss (always keen to move in where conditions make life difficult for grass) is a problem.

It seems churlish even to mention problems, though, because this is a garden that has benefited from a great deal of flair and care. When you step out on to the south-east terrace in front of the house, with its enormous yew spheres, you are not aware that the terrace planting is aligned with the two rows of beech (*Fagus*) pyramids which stand to attention on each side of the lawn. The design becomes apparent only when seen from above.

LEFT On the terrace at Rockcliffe, herbs and alpines grow amid paving stones and spheres of clipped yew. The star-shaped topiary is clipped hyssop.
RIGHT Garden designer Emma Keswick created the gardens at Rockcliffe, where she lives with her husband, Simon.

There is a sort of confidence that English gardeners seem to inherit along with centuries of garden history.

Another striking feature at Rockcliffe is the formal pond to the west of the house, which is surrounded by six 'wedding-cake' trees (*Cornus controversa* 'Variegata'). In the middle of the pond is a statue of Nandi, the white Brahman bull that the god Shiva rides in Hindu mythology. The Indian theme is continued in the Vegetable Garden, where the fruit cages are decorated with a fretwork edging that is reminiscent of Indian teak carvings.

The view through the Vegetable Garden leads your eye up to a dovecote, which houses white doves, and the path up the hill is lined with yew topiary, clipped into

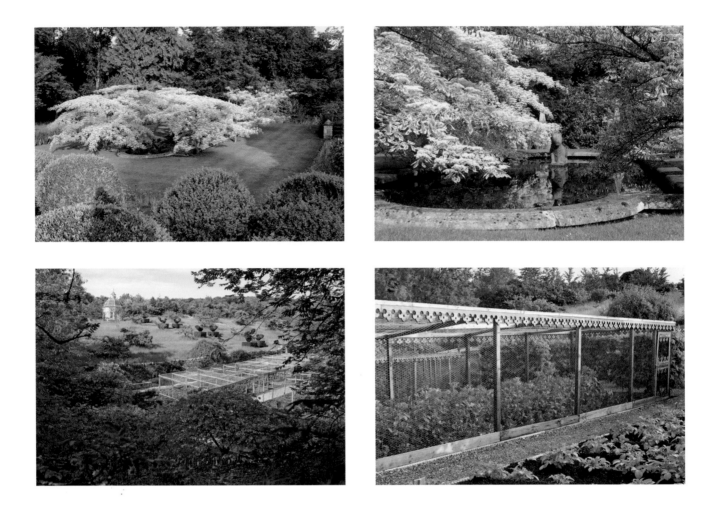

TOP LEFT The *Cornus controversa* 'Variegata' trees planted around the pool at Rockcliffe have become one of the iconic features of this garden.
TOP RIGHT At the centre of the pool is a Nandi bull, from Hindu mythology.
ABOVE LEFT, ABOVE RIGHT Even in the Vegetable Garden, there are exotic touches, such as the fretwork trim on the fruit cages.
OPPOSITE Two rows of topiarized birds form a guard of honour in front of the dovecote.

the shape of doves, reminiscent of those at Hidcote. It is very theatrical, very confident and a lovely visual pun.

In spring and summer, the grass in front of the dovecote becomes a meadow with ox-eye daisies (*Leucanthemum vulgare*) and other wild flowers. Beside the dovecote, the latest project at Rockcliffe is taking shape: winding paths outlined with box lead past more meadows planted with trees. They are mainly sorbus, underplanted with spring bulbs and interspersed with *Rosa* 'Cerise Bouquet', a modern shrub rose that forms a tall, arching shrub.

Evergreen interest

The house itself at Rockcliffe is Queen Anne Revival, built in 1890. The two symmetrical wings were added in 1983, and the pitch of the roof was raised at the same time so that it would be in proportion with the new extensions. The terrace was redesigned in 2012, and includes formal beds, around a gigantic pot of *Melianthus major* and a topiary star of clipped hyssop. In late spring and summer, pots of *Lilium regale* stand outside the Orangery while, inside, the exploratory shoots of *Jasminum samb*ac trace a pattern on the walls.

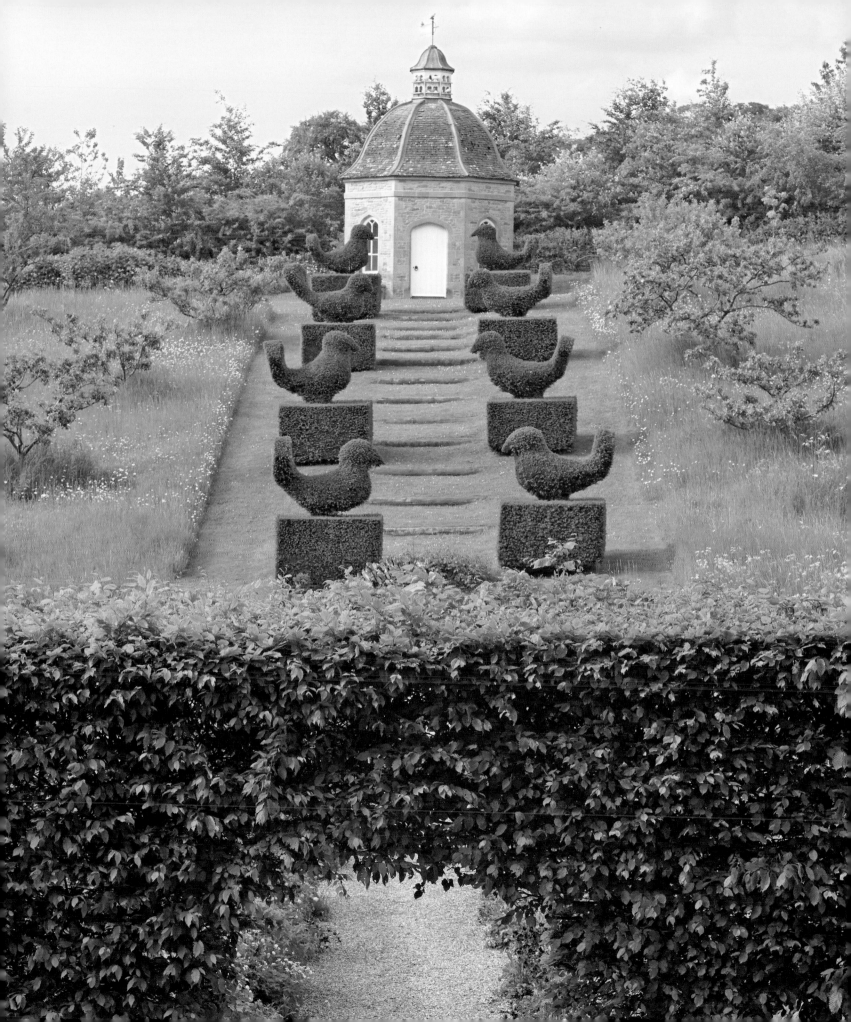

OPPOSITE Topiary is a huge part of the design at Rockcliffe, whether to provide evergreen interest, structure or just an element of fun.
BELOW The rose border is punctuated by statuesque Irish yews.

From the terrace, a path leads up past the rose border, where Irish yews (*Taxus baccata* 'Fastigiata') provide evergreen interest amid climbing roses, peonies and herbaceous perennials. Opposite, the Croquet Lawn is flanked by two formal pools with stone benches at either end, and an avenue of pleached limes (*Tilia*).

Behind the Irish yew hedge is the Pink Garden, with pink lavender, *Rosa gallica* 'Versicolor' and the orange-scented rambler *R.* 'Veilchenblau'. Adjacent is the White Garden, with *Iris* 'White Swirl', white agapanthus and white lilies. The Pool Garden has a simple pavilion with classical columns, over which *R. filipes* 'Kiftsgate' throws a lacy white veil in early summer.

Rockcliffe is an intriguing garden in which the things that look old very often turn out to be new. The dovecote, for example, was built to mark the millennium in 2003. But the sense of confidence that you find here – and artefacts such as the Nandi bull and the contemporary sculpture by Nigel Hall on the lawn with the beech pyramids – indicate that Rockcliffe is very far from being a pastiche. Emma Keswick has used the classic English garden ingredients – yew, beech, roses, lavender – because they are appropriate to the landscape and to the environment, and that is a very contemporary design solution indeed.

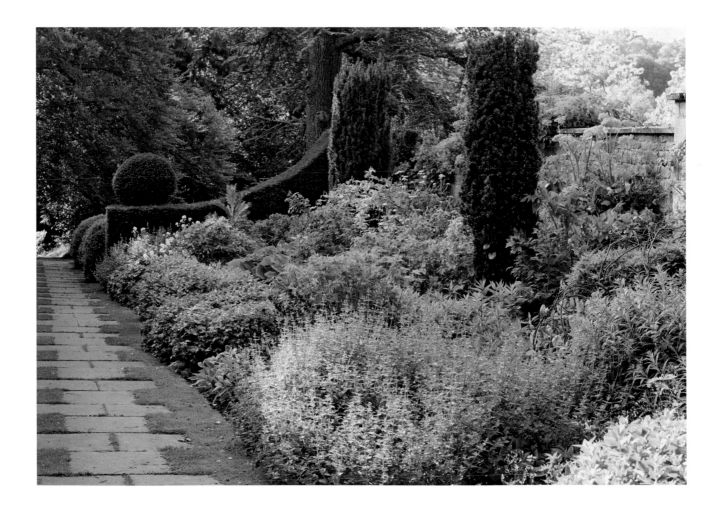

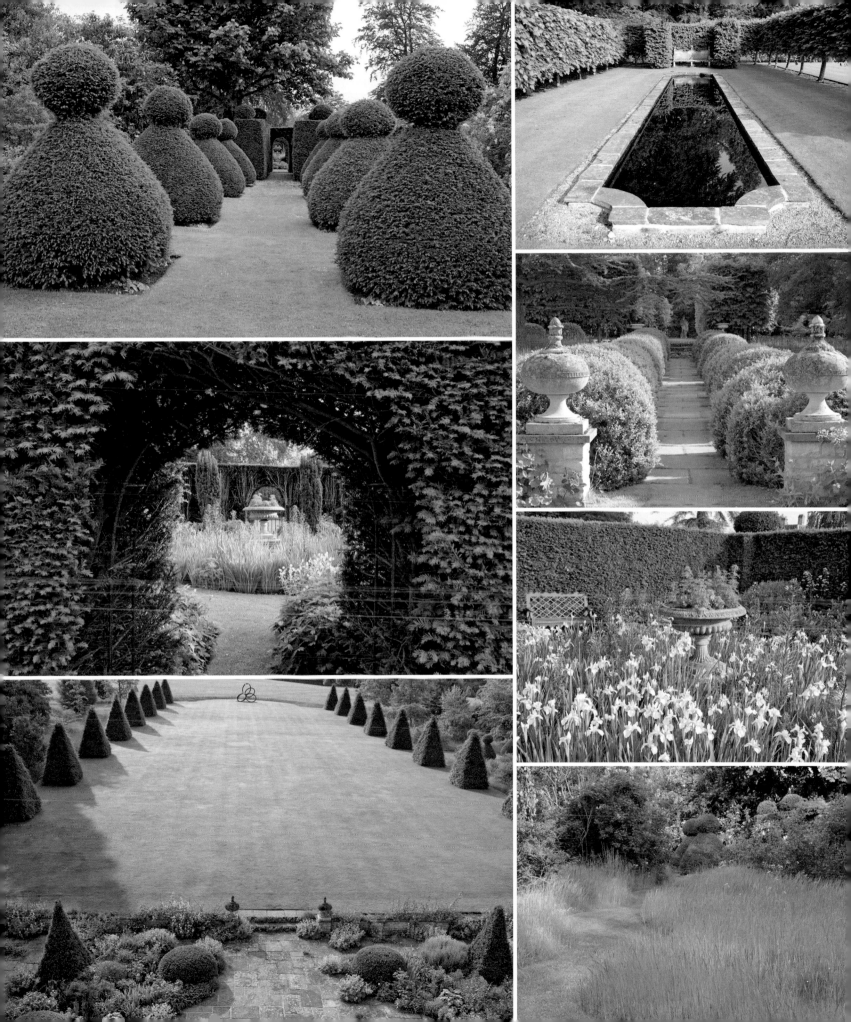

15
Sarsden

Sarsden

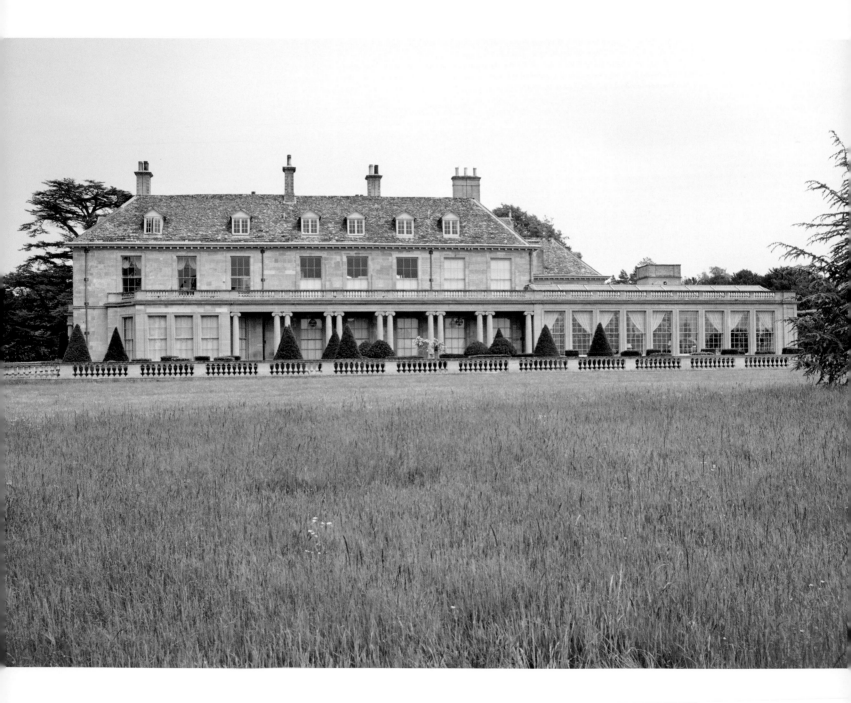

IT SAYS MUCH about England's abundant heritage of architecture and landscape design – not to mention the social and economic fallout of two world wars – that a house such as Sarsden can still be relatively unknown to the general public. There has been a manor house there since the Norman Conquest of 1066, but the story of the gardens as they exist today really begins in the late-eighteenth century.

In 1792 the Sarsden estate was bought by James Haughton Langston, a merchant banker. He died three years later, but his son John, who inherited the house, commissioned Humphry Repton, one of the most famous names of English landscape architecture, to redesign the grounds. Prior to this, a series of formal gardens had surrounded the house.

In early spring 1796 Repton produced a Red Book containing his proposals for the park and pleasure grounds. Repton's Red Books foreshadowed the 'makeovers' seen on television today; they consisted of explanatory text and watercolours, with a system of overlays that showed 'before' and 'after' views of the grounds. Indeed, it is thanks to Repton's Red Book that it is possible to see how the old, formal gardens at Sarsden looked.

Repton, like Lancelot 'Capability' Brown, was an adherent of what is now called the English landscape style, in which the grounds surrounding the house were transformed into an pastoral idyll of lakes, meadows and groves of trees, punctuated by classical elements such as temples and ruins. He, however, came to favour formal gardens around the house, believing that this helped to create a logical, aesthetic progression from the organized lines of the architecture to the natural world in the far distance. (One of the criticisms of Brown's work was that you walked out of the house straight on to the lawn.)

In those days, landscaping was a long-term business, and the changes took place over several decades. John Langston died in 1812, and his son, another James, continued with the Repton plan, employing Repton's son George throughout the 1820s. The latter made

LEFT George Repton made improvements to the house in the 1820s, including the addition of the Orangery.
RIGHT Rita Gallagher and her husband, the businessman Tony Gallagher, are the current owners of Sarsden.

further improvements to the estate, including extending the chapel that adjoins the house, and building a new balustraded portico supported by four pairs of Ionic columns. At the southern end of the house, he added an Orangery with a double-span roof.

Beyond the formal gardens around the house, the grounds were laid out in the English landscape style, with majestic cedars of Lebanon (*Cedrus libani*) around the house, and groves of trees leading the eye down to the serpentine lake. A rusticated stone bridge provides a focal point at the western end of the lake, while at the eastern end there is a boathouse built in the form of a classical temple, with Doric columns. From a distance, it looks as if it is made of stone, but when you get closer you notice that the columns and the interior of the temple are decorated with bark and coppiced hazel. Drawings in the collection of the Royal Institute of British Architects (RIBA) suggest that

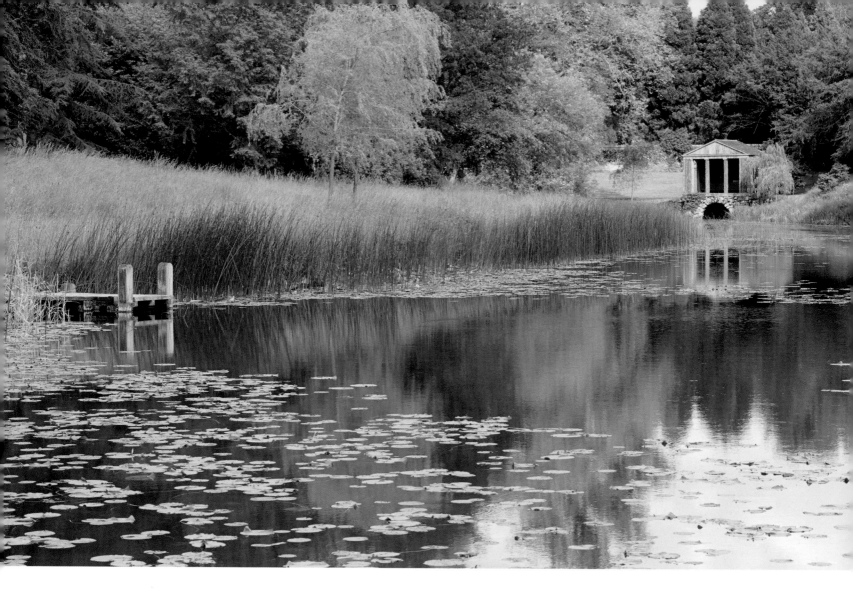

At the eastern end of the lake, there is a boathouse built in the form of a classical temple, with Doric columns.

Repton intended the boathouse to be built of stone with Ionic columns, but the only stone structure in evidence is the substructure beneath the temple, where a boat can be moored.

Most of Repton's work was done during the Napoleonic wars, the cost of which had resulted in higher land taxes and a new income tax. It is possible that his clients had decided to embark on a policy of fiscal prudence by this point.

George Repton also designed Sarsden Glebe, built as a rectory in 1817, and it is thought that the grounds for the Glebe were laid out by William Smith, better known today as the 'father of English geology'. Smith, who was born in Churchill, is credited with creating the first geological map of England and Wales.

Not all the changes on the Sarsden estate were made by the Reptons. In 1825 James Langston was given permission to demolish the old parish church in the nearby village of Churchill and a new building, with a tower that is a two-thirds scale copy of Magdalen College, Oxford, was designed by James Plowman, an Oxford architect. One of the best views from Sarsden is of the church, although mature trees now hide it from the north front of the house.

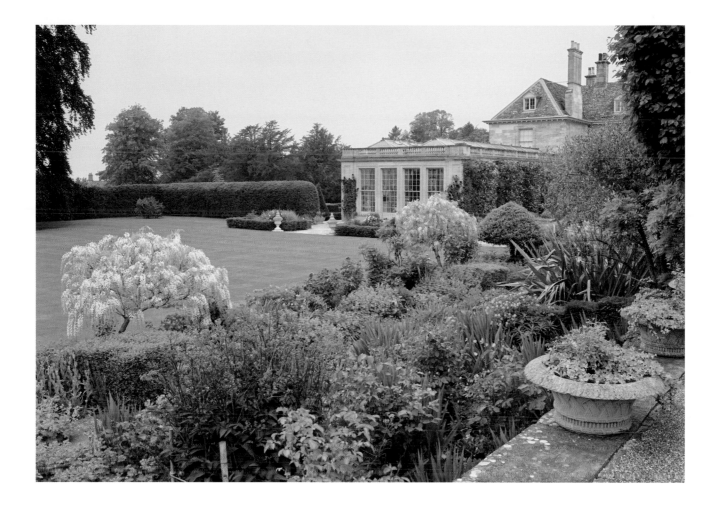

During the early part of the twentieth century, the house and gardens both fell into disrepair. The vast estate was divided up in 1922 and, during the Second World War, American and British troops were billeted at Sarsden. (Many of the great country houses in the Cotswolds were pressed into service as temporary accommodation for troops preparing for the D-Day landings.)

Pleached limes

Sarsden did not really regain its former glory until Shaun Woodward, the former Conservative MP who defected to Labour in 1999, bought the house with his wife Camilla and began a huge programme of restoration. They employed garden designer Christopher Masson, who was responsible for the Pool Garden, with its massive Cretan pots, the White Garden designed for Shaun Woodward's fortieth birthday and the formal planting around the house, which incorporates yew topiary alongside more contemporary planting, such as phormiums and hebes.

The White Garden, as its name suggests, is in the form of a parterre featuring plants with white flowers, including agapanthus, hellebores and roses, flanked

OPPOSITE The lake is part of Repton's original design, as is the Doric boathouse. The base of the boathouse, where the river enters the lake, is made of stone while the pillars and the superstructure are of wood.
ABOVE The formal gardens around the house, with their standard white wisterias, were designed by Christopher Masson.

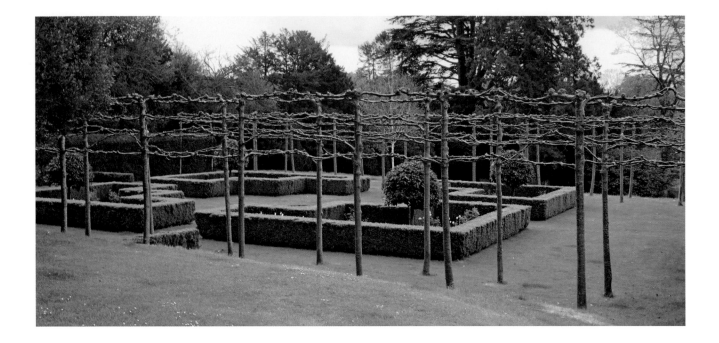

by two avenues of pleached limes (*Tilia*). In the middle of each bed stands a topiarized Portugal laurel (*Prunus lusitanica*), a plant that has won a place in most formal gardens in the UK today because it is so tough, drought-resistant, unfussy as to soil and reliably hardy.

In the walled Kitchen Garden, the Woodwards installed a wrought-iron gate commemorating the millennium, and an avenue of standard roses. Like many of these vast former vegetable plots, it is now mostly an ornamental garden, with pergolas and arches of roses and hornbeam (*Carpinus*). The Woodwards also created a Rose Garden, with formal beds of David Austin roses. Since they sold the house in 2006, the rose beds have been underplanted with herbaceous perennials such as alchemillas, hardy geraniums and euphorbias at the suggestion of garden designer Rupert Golby, who is advising the new owners.

Head gardener Peter Simmons has been at Sarsden since 1996. He grew up in Churchill, and his first experience of the garden was when he came to do work experience. There are currently four Sarsden gardeners, who divide their time between the parkland and the formal gardens, with their relentless programme of clipping and topiarizing. The newest part of the garden, the Chapel Garden, designed by the new owners, has four box parterres planted with pale pink roses, and yew buttresses, while beyond it a yew

corridor separates the area around the house from the pool and the tennis courts.

Simmons likes to do the topiary himself, and the results are a testament to years of experience. It is no wonder, though, that his favourite area is the lake, where the trunks of oak (*Quercus*), beech (*Fagus*) and yew rise like massive stone columns from the woodland floor and the telltale streams of bubbles from feeding tench break the surface of the water.

ABOVE The White Garden was also designed by Christopher Masson, and planted with white roses and agapanthus. The strong lines of the pleached trees and the box parterres provide architectural interest throughout the year.
OPPOSITE Statuary and ornamentation are themes at Sarsden, as exemplified by the lead figures of a shepherd and his sweetheart at the entrance to a path between two yew hedges, the carved stone of an antique well head, and the group of bronze deer beneath a cedar of Lebanon at the entrance to the park.

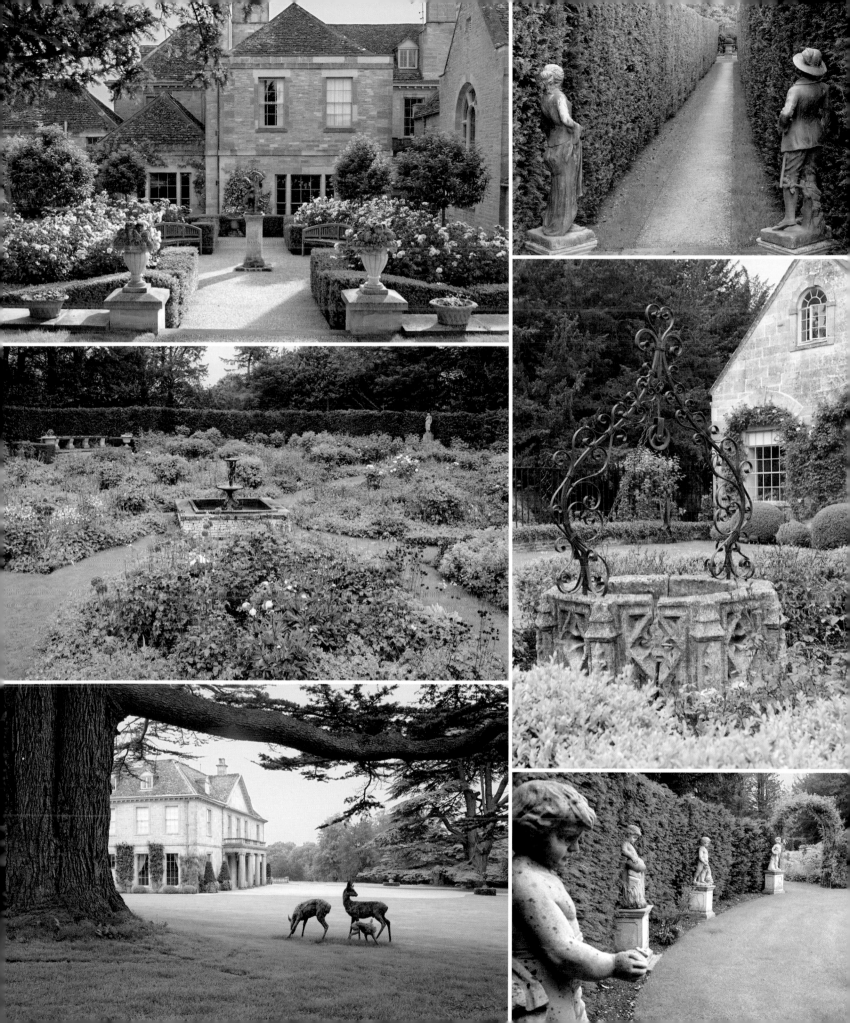

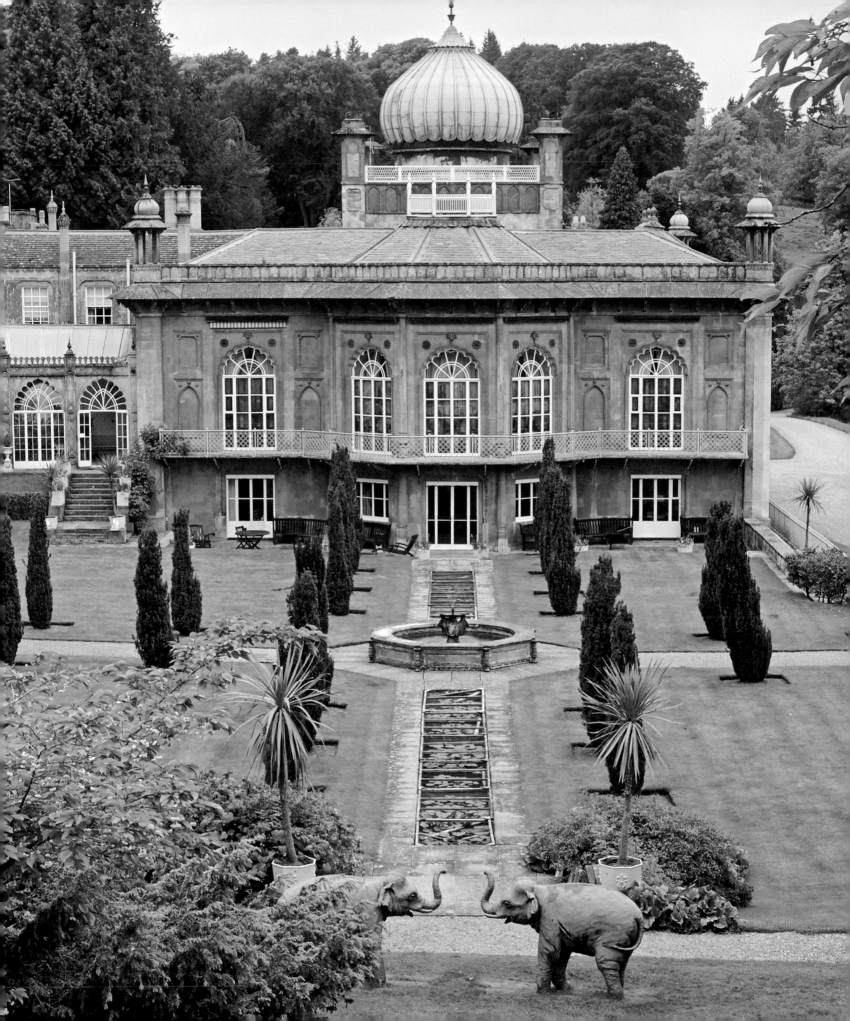

look. However, he did do a sketch with an overlay for the South Garden, and the impression of the gardens as you look out from the house is that of a classic Repton garden.

Indian elements

Despite this, there are some obviously Indian elements too. The Indian Bridge, with its Brahmin bulls, and the Temple, which stands above a circular pool, were both designed by Thomas Daniell. He is also credited with the design of the Thornery, the gardens to the north of the house, but it is now thought that in Daniell's time it was more of an arboretum. Today, the Thornery is a fascinating playground for plantaholics: it includes an Indian bean tree (*Catalpa bignonioides*) collection, a *Cedrus deodara* grove and a row of majestic cedars of Lebanon (*Cedrus libani*). Its great charm lies in the Water Garden, which leads from the Temple Pool down to the Island Pool, through a huge variety of shrubs and trees. These include acers, bamboo, several different species of hydrangea, viburnums, magnolias, Chinese peonies (*Paeonia lactiflora*) and cornus. The herbaceous planting is also interesting, especially the large-leaved plants,

Some of the ingredients may be exotic, but the general effect is unmistakably English, with its sense of informality and seasonal interest.

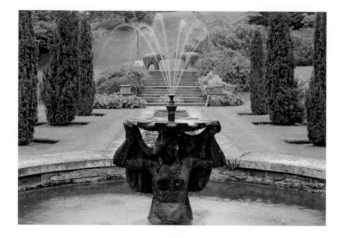

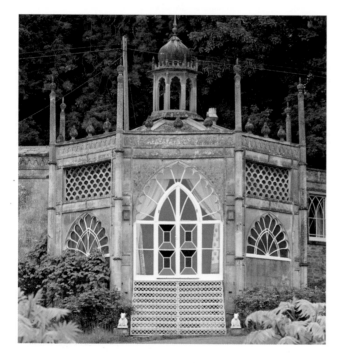

which helped to create an atmosphere of lush seclusion. *Veratrum album* and *Rodgersia podophylla* grow alongside hostas and alchemillas, while *Darmera peltata* flourishes by the stream.

You can walk under the Indian Bridge by means of stepping stones (there is even a little stone seat), in order to arrive at the Snake Pool, dominated by a fountain in the shape of a fearsome serpent. Some of the ingredients may be exotic, but the general effect is of an unmistakably English garden, with its sense of informality and seasonal interest. Ironically, the part of the garden that is most Mogul in character is the latest addition – the Persian Garden, created by Lady Kleinwort after a visit to India in 1965. She decided that the South Garden, which flanks the Orangery, would be an appropriate site for a traditional *chahar bagh*, or paradise garden, and enlisted the help of Graham Stuart Thomas, who had revitalized so many National Trust gardens.

Traditionally, a *chahar bagh* is a garden divided into equal parts by canals or rills that represent the four rivers of paradise, and is planted with cypresses (*Cupressus*) – symbolizing death – and fruit trees – symbolizing life. In practical terms, these four canals irrigate the garden, while the trees provide fruit, shade and a haven for birds. At Sezincote, the Persian Garden is planted with fastigiate Irish yews (*Taxus baccata* 'Fastigiata'), a more pragmatic choice for a wet and windy Cotswold site. A path leading to the south pavilion of the Orangery takes the place of a canal, so the effect is that of a quadrant.

Thus, Sezincote is a fascinating garden that challenges the visitor on many levels. Even its name sounds exotic, until you discover that it is a corruption of Cheisnecote – 'the home of the oaks' (*chêne* being the French word for oak). What could be more English than that?

TOP LEFT This pool is in the centre of the Persian Garden.
CENTRE LEFT The Tent Room is hung with Indian fabric.
BOTTOM LEFT Two Brahmin bulls sit at the foot of the steps leading to the Tent Room.
OPPOSITE Indian details and references can be found everywhere at Sezincote. They include (clockwise from top left): the Folly; the Indian Bridge with its Brahmin bulls; the fountain in the centre of the Temple Pool; two elephants at the top of the steps leading down to the Persian Garden; the serpent sculpture in the Snake Pool; and a carving of the Hindu deity Krishna.

17
Stowell Park

Yanworth

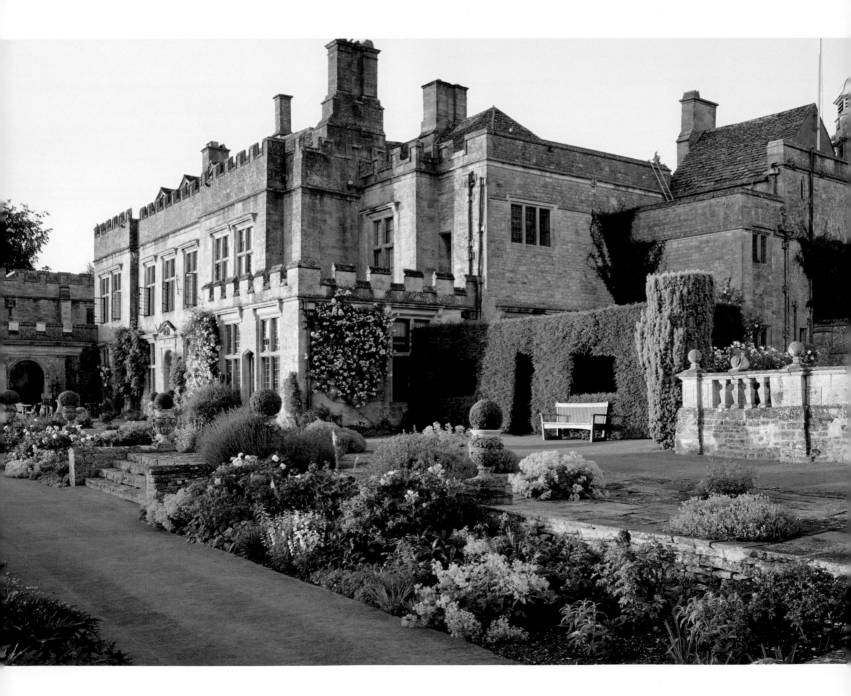

As you make your way from the magnificent kitchen gardens to the main terrace at Stowell Park, your eye is caught by a landscape-shaped 'window' cut into a tall yew hedge beside the house. It frames the magnificent views over the surrounding countryside, and it seems to sum up the impact of the garden in one rectangle: picture perfect.

If you have perfectionist tendencies, Stowell Park is a good place to indulge your obsessions. The terrace lawns, for example, defy comparison with anything so mundane as carpet. They are pristine turf of a grass so fine that each blade looks as if it could be threaded through a needle. The secret, says head gardener Neil Hewertson, is a lot of effort and expensive fertilizers. 'Fred Nutbeam, the former head gardener at Buckingham Palace, used to say that if you get your lawns and edging sorted', he says, 'the whole garden looks better. You need the right frame for the picture.'

Hewertson belongs to the modern breed of head gardener. He has a degree in botany, but he has also benefited from a more traditional training background – he came to the Cotswolds from Hampshire, where Fred Nutbeam was his mentor. He may use a smartphone to show you pictures of what the garden looked like last year, but he still writes everything down – notes, instructions, plant lists – in a battered notebook that he carries in his back pocket. He has been at Stowell for thirty years, and in that time has helped the owners, Lord and Lady Vestey, to create gardens that are a beguiling mixture of formality and relaxed charm.

While clipped yew buttresses echo the soldierly, straight lines of the stone steps down to the main terrace, the steps themselves are softened by the exploring tendrils of *Vitis coignetiae*, with its huge, heart-shaped leaves. In high summer, between the buttresses, the enormous leaves of *Rodgersia pinnata* jostle with *Actaea simplex* (Atropurpurea Group) 'Brunette' and *Agapanthus* 'Loch Hope', with its clusters of deep blue flowers.

You might expect, in a more conventional border, to see roses, delphiniums and lupins. What you get is fabulous foliage.

The gardens consist of four main areas: the Kitchen Garden (which also include the glasshouses, an orchard area and a herbaceous border); the Walled Garden; the formal terraces; and what is fast becoming an arboretum, in which trees such as *Sorbus sargentiana* (a wonderful tree for small gardens as well as large estates) and *Acer griseum* offer spectacular autumn colour.

After so many years at Stowell, Hewertson can point to most plants and remember the day they were planted. He is a great believer in the right plant for the right place, but he is not afraid to experiment. In autumn, the bright foliage of *Ginkgo biloba* 'Autumn Gold' flaunts itself against the wall of the ballroom, echoing the dying leaves of the neighbouring wisteria. Ginkgo against a wall? 'They said it could not be done', says Hewertson, 'but as you can see, it can.'

OPPOSITE The terrace at Stowell Park faces west, and in summer the late afternoon sun heightens the honey colour of the Cotswold-stone walls.
RIGHT Lord and Lady Vestey have employed head gardener Neil Hewertson at Stowell Park for thirty years.

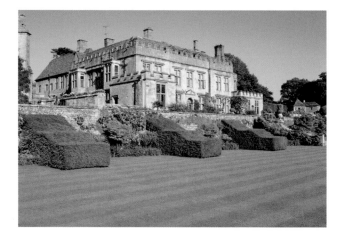

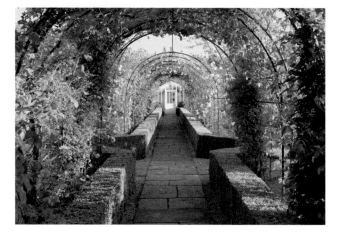

He points to the cold frames not only as a source of home-grown plants but also inspiration:

'Gertrude Jekyll said in *Wood and Garden* that all the best gardens have cold frames. It means that if you have propagated some rare peonies, for example, you will have twenty instead of two. You might suddenly think, why not try them in this or that particular spot. Or if you have a new bit of planting to do, you have the plants right there in front of you, instead of having to order them from miles away.'

Each area of the garden leads into another without any sudden jolt or change of pace. The estate is still very much a community – it is the size of a small village – and even has its own Norman church, boasting the remains of twelfth-century wall paintings. Sadly, points out Hewertson,

a Victorian 'restoration' inadvertently obliterated God the Father, God the Son and God the Holy Ghost.

There is a sense of purpose at Stowell Park, but at the gentle, steady pace of country life. Chickens scratch beneath the trees and heaps of horse manure steam beside the stables, before being carted off to the kitchen gardens.

If you visit Stowell Park on a National Gardens Scheme open day, the Kitchen Garden is where you will begin your tour. They are huge, and there is so much to see that you have to tear yourself away in order to have time for everything else.

At one end of the Kitchen Garden, a herbaceous border is planted up with the smoky purples of alliums, wisterias and hazel, echoing the flowers of the clematis on yet another pergola in the old orchard. At the other end are the cutting beds, where aquilegias pop up cheekily among the peonies and herbs. Here an archway leads to

the Walled Garden, where in early summer dozens of irises vie for attention with alliums against a backdrop of hostas and topiary.

Carnations for Ascot

The Vestey family has owned the estate since 1923. In the fourteenth and fifteenth centuries, like so many Cotswold manor houses, it was the home of wealthy wool merchants. One of its most distinguished inhabitants was John Scott, 3rd Earl of Eldon, who was responsible for financing the excavation and preservation of the Roman villa at neighbouring Chedworth, from 1864 to 1868.

The current Lord Vestey asks for five things from his garden: white peaches – from the 55m/180ft glasshouses, built in the 1880s; grapes; asparagus; runner beans; and his famous carnations for buttonholes at Royal Ascot and other ceremonial duties with Her Majesty the Queen.

Through an archway is the Walled Garden, where in early summer irises vie for attention with alliums.

OPPOSITE ABOVE LEFT, OPPOSITE BELOW LEFT Stone steps lead from the terrace to the lower lawns, where yew buttresses have been cut in the same shape as the steps.
OPPOSITE ABOVE RIGHT, OPPOSITE BELOW RIGHT The glasshouses and the rose walk are in the Kitchen Garden. The lowest metal joints in the framework of the pergola are used as a height guide for the box hedges.
ABOVE Between them, Lady Vestey and Neil Hewertson have planted every single plant in the Walled Garden.

The branches of the meticulously pruned peach trees trace a pattern on the walls of the glasshouses, while, outside, a pergola of roses runs the width of the garden. Lady Vestey's passions for roses and peonies are apparent in all parts of the garden.

It is easy to look at the gardens of the Cotswolds and think that, within their stone walls and yew hedges, time stands still. They have a sense of serenity, it is true, but most have undergone radical changes in the past hundred years. Gone are the armies of gardeners who used to tend herbaceous borders and prick out bedding plants.

ABOVE In early morning the spectacular view of the Coln valley below the house is wreathed with mist.
LEFT The lowest lawn became a swimming pool when the house was used as a school during the Second World War. It is now edged with wild flowers.

Today, the emphasis is on conservation and sustainability not necessarily going back to the past, but ensuring a healthy future for plants and wildlife.

At Stowell Park, a glorious tangle of shrubs beyond the ha-ha provides a refuge for birds and other wildlife, while in a corner of the garden there are several beehives. In early summer, the grass here is starred with ox-eye daisies (*Leucanthemum vulgare*), bringing the countryside almost up to the threshold of the imposing house.

The latest project has been to extend the vista that runs along the formal terraces and up through a meadow, which in summer is grazed by sheep. Tonnes of earth have been moved so that the gate pillars at the top of the meadow may be seen as part of a continuous sightline, but it already looks as if it has been that way for years. Like so much at Stowell Park, it is a modern interpretation of an old and beautiful theme.

18
Upton Wold
Moreton-in-Marsh

BRENDA COLVIN was in her eighties when she came to Upton Wold in 1973, to advise Ian and Caroline Bond on their new garden. Being one of the most influential figures in twentieth-century British landscape architecture, she distilled a lifetime of knowledge and experience into her response. Leaning on the arm of her young business partner, Hal Moggridge, Colvin stepped out on to the south-east lawn, looked at the glorious view over the rolling fields and woodland, and said: 'Well, dear boy, if they want to keep the vista, take the job on. If they do not, do not touch it.' The Bonds kept the vista, Moggridge accepted the job and thus a neglected estate became the garden that it is today.

Upton Wold is not the easiest of sites. When the Bonds first arrived, it was little more than a farmyard: 'There were pigs,' says Caroline, expressively. The garden sits 213–244m/700–800ft above sea level, and water at this height is in surprisingly short supply. The soil is Cotswold limestone, which means that it is free-draining, and when the wind is blowing from the north-west – which it inevitably is in the depths of winter – you feel as if you are about to be whisked away. Yet in this garden you will discover some of the rarest and most unusual plants to be found anywhere in the Cotswolds.

Walnut collection

Upton Wold is the home of the National Collection of walnuts (*Juglans*) and wing nuts (*Pterocarya*), which are members of the walnut family. The National Collection Scheme is administered by Plant Heritage, a horticultural charity whose aim is to maintain as far as possible the huge variety of plants that have been collected or hybridized over the years. Britain's temperate climate, and its history of exploration and colonization, have resulted in a wealth of plant material. As the charity puts it, with a little care the British can, and do, grow virtually anything.

Ian Bond first fell in love with walnuts when he moved to Hampshire from the Scottish Highlands at the age of ten. Behind the pretty Queen Anne family house stood an 'amazing' tree – walnuts, he says, have the biggest canopy of any tree. He enjoyed picking the fruit, he relished eating the fruit and pretty soon he started growing them too. Today, his collection includes eighteen of the twenty-one walnut species that can be found worldwide,

TOP The house dates from the seventeenth century.
ABOVE Caroline Bond and her husband Ian have spent the past thirty years restoring the gardens.
OPPOSITE Yew hedges help to shelter the gardens on either side of the vista that Brenda Colvin admired.

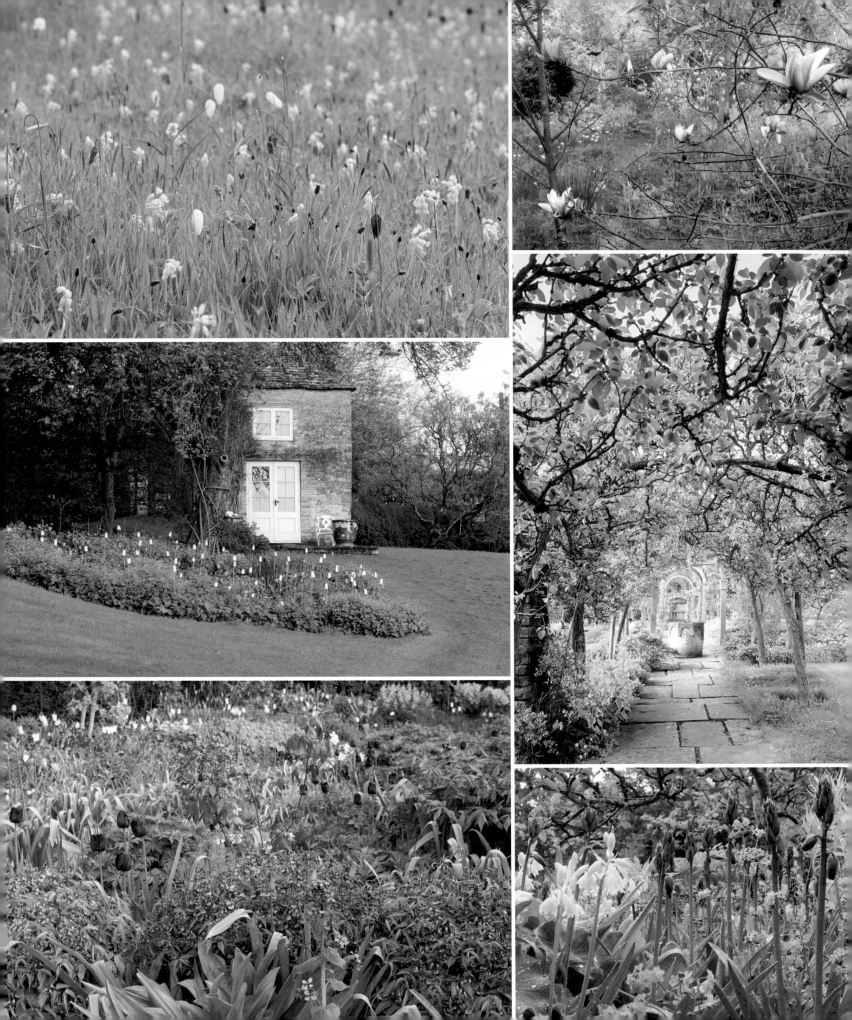

and he is still in search of more. His ambition is to go plant hunting in South America with Tony Kirkham, head of the arboretum at the Royal Botanic Gardens, Kew.

Ian's specimens have come from all sorts of people all over the world. A quick glance at his National Collection list confirms this: *Juglans mandshurica*, syn. *J. cathayensis*, collected by Bleddyn Wynn-Jones of Crug Farm in Sichuan in 2000; *Juglans* x *intermedia* var. *pyriformis*, from seed collected in Venta Grande, Mexico, by the British botanist Allen Coombes; numerous cultivars from the Holden Arboretum in Ohio, and yet more from the University of California, Davis. Of the 173 cultivars in the collection, many are yet to be named — they are still numbers.

It was at the University of California, Davis, that Ian discovered one of the most intriguing facts about walnuts. The membrane which forms the partition of the nut (in other words, between the two halves) is very flexible,

Cowslips seed themselves with abandon in the wildflower meadow, and around the dew pond there are snowdrops and hellebores in early spring.

TOP LEFT, TOP RIGHT, ABOVE LEFT, ABOVE RIGHT
The dew pond and a mown path through a meadow of daisies provide a relaxed contrast to the formal borders. OPPOSITE In spring, self-sown cowslips bloom in the wildflower meadow. In the Hidden Garden, there is magnolia blossom, while bluebells and forget-me-nots may be found in the old Vegetable Garden, and tulips are planted in the Dovecote Garden.

very lightweight and heat-resistant – so much so that it was used to line the module in the rocket that took men to the moon.

Ian may be the walnut specialist, but his wife Caroline is also a knowledgeable plantswoman, and the rare specimens are not confined to the walnut grove. Upton Wold is a pen-and-notebook garden: there are so many things that you will not come across outside a specialist nursery.

The Dovecote Garden shelters many of these, such as *Philadelphus maculatus* 'Mexican Jewel', with its sweet-scented, white flowers with pinky red centres. Collected by Martyn Rix in Mexico, it looks a little bit like a delicate mallow. *Heptacodium miconioides*, with its curious, curved leaves and star-shaped, white, perfumed blossom, is also here, as is *Emmenopterys henryi*, a native of China, which is said to flower only after thirty years. On the wall of the dovecote itself is *Lonicera tragophylla* 'Maurice Foster',

which has exotic clusters of bright yellow flowers, and on the south wall of the house is *Buddleja agathosma*, with lilac flowers and huge, serrated, grey, velvety leaves.

On the west side of the garden is a wildflower meadow, where cowslips (*Primula veris*) seed themselves with abandon, and at the far end a dew pond is a cool oasis, with snowdrops (*Galanthus*) and hellebores in early spring.

Full use is made of any available shelter. On the other side of the lawn is the Hidden Garden, where there is a growing collection of young magnolias and a handkerchief tree (*Davidia involucrata*). At the top of the Hidden Garden, on the right side of the Broad Walk, is one of the most impressive trees in the garden – *Pterocarya fraxinifolia*, with its ash-like foliage (hence its name) and 30cm/1ft-long racemes of flowers. Below this point is the canal, with its fountains and weeping mulberry (*Morus*) trees. It was designed by Anthony Archer-Wills.

Labyrinth design

Hal Moggridge has continued to be involved with the garden at Upton Wold, and he was consulted when the Bonds had the idea of building a labyrinth to act as a focal point for the arboretum. Construction began in the winter of 2012 – one of the wettest for decades – and finished in early spring 2013, just in time for one of the hottest summers for decades.

In medieval times, the labyrinth was said to symbolize the difficult path from birth to heaven. At Upton Wold, the labyrinth could be said to symbolize the forty years of hard work that the Bonds and their gardening staff, led by Theresa Jones, have put into this extraordinary place.

LEFT The sculpture of a walnut marks the entrance to Ian Bond's National Collection of *Juglans*.
OPPOSITE ABOVE The labyrinth is designed to look like a circle of ancient standing stones.
OPPOSITE BELOW The canal is by Anthony Archer-Wills, one of the foremost designers of water gardens in the UK.

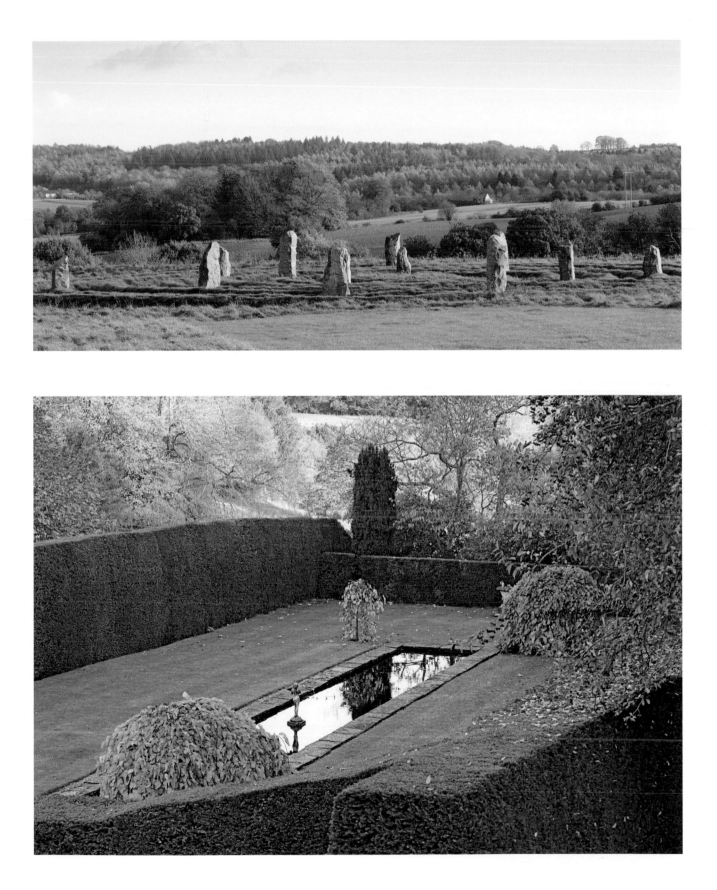

19
Walcot House
Charlbury

ARTISTS THROUGHOUT THE CENTURIES have been fascinated by the challenge of reproducing a landscape as a work of art. For Silka Rittson-Thomas, the challenge at Walcot House was to reproduce a work of art in the landscape.

Silka and her husband, Hugo, moved to Walcot in 2007, although they bought the property in the 1990s. They both have an art background and both attended Goldsmiths College (part of the University of London). Silka, who also studied art history in New York and has a Masters degree in critical and creative analysis, is a collector and art adviser in contemporary art, while Hugo is a photographer.

When the couple bought the house, it was derelict and the garden was a wilderness. They called in the garden designers Julian and Isabel Bannerman, whose work includes the Stumpery in Prince Charles's garden, at Highgrove, and Asthall Manor (see pages 24–31), for advice. Thanks to the Bannermans' research, it became apparent that, although Walcot had fallen on hard times, it had a fascinating history. Below the existing farmhouse were the remains of a much older, much bigger house, and the Bannermans also unearthed evidence of five medieval carp ponds in the grounds – a clear sign that this had been a substantial estate at one point. The ponds are now a Scheduled Ancient Monument.

One of the ponds has now been excavated and in this area of the garden Silka wants to recreate American artist Joan Mitchell's La Grande Vallée (The Great Valley) series of abstract paintings, with their brilliant blues, yellows and greens. Much of the soil taken out as part of the excavations has been included in a mound shaped like an amphitheatre, which the Rittson-Thomases hope to use for performance art.

TOP The house stands on the site of a much bigger manor house, which was demolished in 1759.
ABOVE Much of the garden design is both formal and traditional, but the mown areas and the lawns give a very contemporary, restrained feel.
OPPOSITE The earth that forms the mound was excavated during the restoration of three of the five medieval carp ponds.

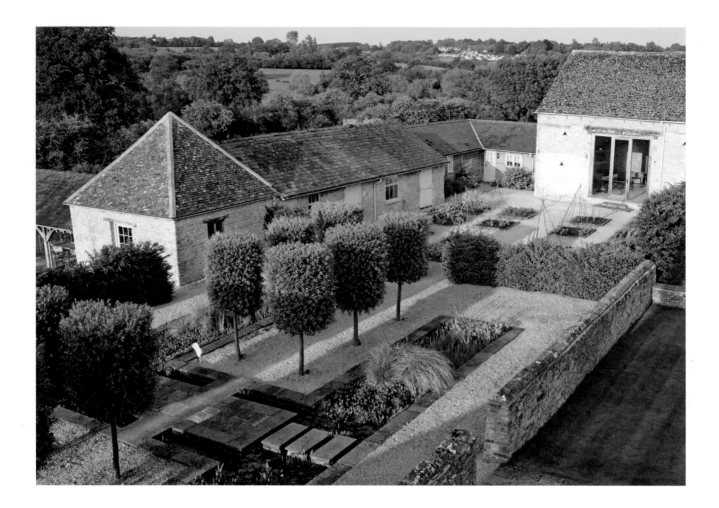

ABOVE The 'H' Garden, designed by Marie-Christine de Laubarède, uses standard holm oaks to form an allée between two rills linked by stepping stones.

OPPOSITE The White Garden, also a de Laubarède design, marries yew pyramids and white shrubs with perennials such as verbascums, delphiniums, spirea and choisya.

Historic remnants

Walcot was once the country seat of the Jenkinson family: the will of Sir Robert Jenkinson of Walcott (sic), dated 1709, notes his request to be buried in the parish church of Charlbury. (He was an ancestor of Robert Banks Jenkinson, the 2nd Earl of Liverpool, who served as British prime minister in the final years of the Napoleonic wars and the decade afterwards.) In 1759 Walcot was bought by the 4th Duke of Marlborough. He promptly pulled down most of the house, to provide stone for building work on the estate at Blenheim Palace, but some of its cellar walls are still evident.

The White Garden

Soon after they arrived at Walcot House, the Rittson-Thomases commissioned garden designer Marie-Christine de Laubarède to landscape its gardens. Like them, she has an art background: she read history of art and archaeology at the Sorbonne. On the English side of Marie-Christine's family, however, there were horticultural roots: her aunt, Cecilia Christie-Miller, was an amateur alpine specialist, whose collection was donated to Waterperry Gardens, near Oxford,

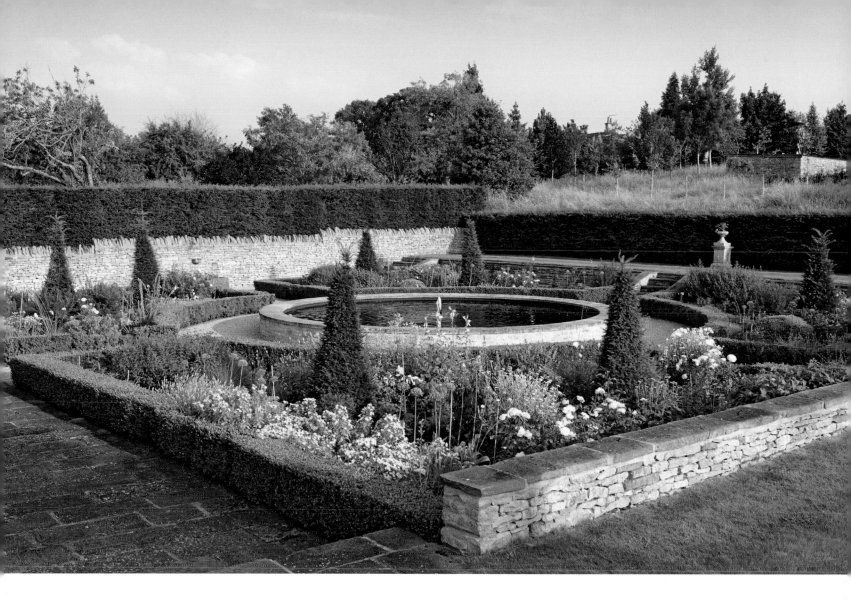

after her death; and her grandfather, Charles Wakefield Christie-Miller, was an amateur iris expert.

Marie-Christine's first task at Walcot, she recalled, was to level the terrace in front of the house so that it framed the building and sat more comfortably in its surroundings. Most of the Walcot estate is on a slope, and on one side of the house the soil depth came to just below window level. This has now been dug out to accommodate the White Garden, which follows a conventional parterre layout – four quadrants edged with box around a large circular pool inspired by the one at Hidcote, Lawrence Johnston's world-famous Gloucestershire garden.

If you look at the planting plan for the White Garden, there is nothing on it that is particularly rare or difficult to grow. Shrubs include stalwarts such as *Sarcococca confusa*, *Choisya* × *dewitteana* 'Aztec Pearl', *Philadelphus* 'Manteau d'Hermine', *Osmanthus delavayi* and *Cistus* × *corbariensis*. There are roses – *Rosa* Glamis Castle, Winchester Cathedral and Francine Austin – and a full supporting cast of perennials such as *Lychnis coronaria* 'Alba', *Delphinium* 'Galahad' (Pacific Hybrid Series) and *Geranium clarkei* 'Kashmir White'. The overall effect is of sophisticated elegance.

The overall effect is of sophisticated elegance, with the arching sprays of Stipa gigantea *waving amid the unyielding blocks of yew.*

ABOVE LEFT Silka Rittson-Thomas stands reflected in the formal pool behind the house.

ABOVE RIGHT The steps behind the formal pool lead down to the old carp ponds.

OPPOSITE Mown paths, meadow grass and a wooden jetty give a countrified air to the area around the carp ponds.

Behind the White Garden, the slope has been converted into a series of terraces, with 'green walls' of yew hedging. The ideal, said Marie-Christine, would have been traditional drystone retaining walls, but English Heritage felt that these would not be true to the original.

A young garden

The Mirror Pond behind the house was inspired by the pool at the interior designer David Hicks's Oxfordshire garden, The Grove, at Brightwell Baldwin, about 8 kilometres/5 miles from Wallingford.

At the front, beside the main courtyard, is the 'H' garden. This was inspired by Gertrude Jekyll's design for Deanery Garden at Sonning, Berkshire. The 'H' garden is planned so that you can enjoy it by walking through it year-round. It has clipped holm oaks (*Quercus ilex*) lining the two vertical sections of the 'H', and a broad path and stepping stones across the horizontal part.

Walcot is a comparatively young garden, and the new yew hedges are only just beginning to thicken up. Yet it sits so naturally within the landscape that it seems as if it has been there for centuries.

20
Westwell Manor
Westwell

ONE OF THE BEST VIEWS of Westwell Manor is from above. If you look at a satellite image, the pattern of 'rooms' that make up the gardens can be clearly seen, and vistas that are not even apparent at ground level, but which help to give the gardens a sense of sitting comfortably in the surrounding landscape, can be traced from the very doors of the house out into the countryside.

Anthea Gibson, who created these gardens, studied fine art at university, but her only formal garden design training was a ten-week course at the Inchbald School of Design, then based at the Chelsea Physic Garden. Yet her touch was so sure, and her sense of graphic design so well developed, that each room looks good from every angle. As you pass from one to another, each area offers a change of pace or planting that both contrasts and complements. Gibson's skill in this has led many to compare her to garden makers such as Vita Sackville-West and Lawrence Johnston. Rosemary Verey, the creator of the gardens at Barnsley House and an adviser to Prince Charles at Highgrove, said of her: 'Now I can die in peace. My mantle can fall on her shoulders.'

Gibson seems also to have had a sense of fun and a willingness – that is by no means universal in the Cotswolds – to experiment with new design ideas. To complement Westwell's traditional English garden features – topiary, a Rose Garden, herbaceous borders, a Kitchen Garden – Gibson introduced more contemporary ingredients, such as the diagonal stripes of lavender in the Breakfast Garden, or the white trunks of birches in the Moon Garden, rising above a circular, yew hedge like pale statues, or the still, mirror-like surface of the Black Water.

The two styles do not jar – there is no sense that this is 'the new bit'. One could argue that this is because Gibson's ideas for 'new bits' for Westwell were vastly more sophisticated than the ingredients she inherited when she and her husband Thomas bought the property in 1979.

LEFT The Rose Garden is underplanted with box spheres and bisected by an allée of clipped holm oak.
RIGHT Anthea Gibson designed the gardens at Westwell Manor, where she lived with her husband Thomas and their three sons. She died in 2010.

Arts and Crafts style

Westwell Manor itself dates from 1543, and the estate was given to Christchurch College, Oxford by Henry VIII as a means of raising revenue. In 1912 the Holland family bought the estate and laid out the gardens in typical Arts and Crafts style – a fashion that harked back to the medieval era – with hedged enclosures and stone wall.

After the Second World War, the Hollands sold up. By the time the Gibsons bought Westwell Manor, remembers head gardener David Baldwin (who worked at Westwell from 1962 to 2013), the garden rooms contained orange Hybrid Tea roses, leylandii conifers and not much else. It was a typical 1970s garden, in a style that has resulted in conifers being exiled to the far reaches of horticultural bad taste ever since.

The first task for the Gibsons was to remove the leylandii. The second was to construct a series of garden

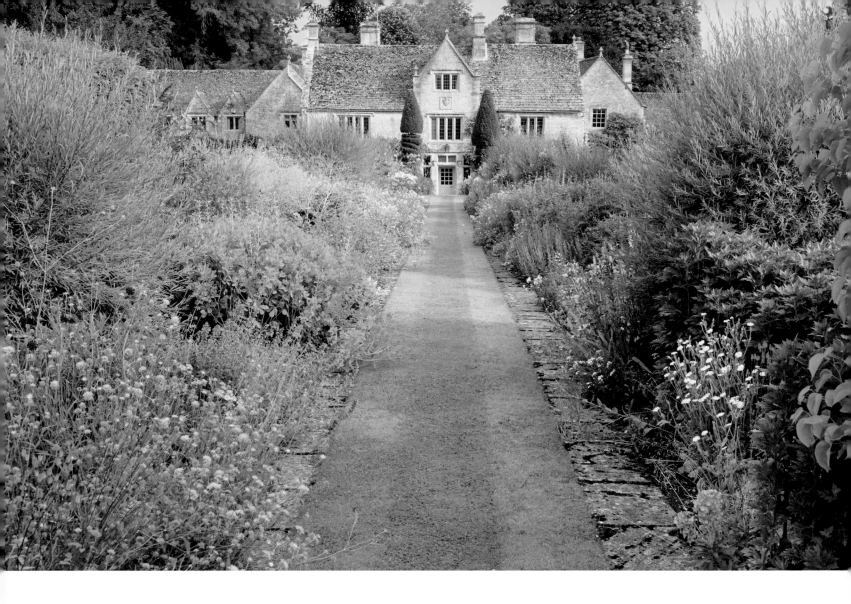

ABOVE Two enormous herbaceous
borders line a grass path leading to
the south side of the house, where two
extremely tall yew topiaries grow each
side of the door.

OPPOSITE An antique stone obelisk
makes an effective focal point beneath
this arch of roses.

rooms that would frame the house and provide shelter from the storms that
sweep across Oxfordshire from the west.

Gibson never used new materials where she could find old. When
constructing the brick paths, recalls Baldwin, she deliberately bought seconds,
so that the end result would not look too slick or smooth. In the Kitchen Garden,
the bars of the gates are made from coppiced hazel. 'You have got to be in tune
with whatever landscape you are in', Gibson once said. 'Natural landscape is so
often vastly superior to anything you can produce yourself that it can make any
garden feel like mere frumpery.'

Hidcote-style pavilions

One of the most impressive vistas at Westwell Manor is the view of the house
from the south-east, looking along the herbaceous borders that line the central
path to the extraordinary yew topiary 'pillars' either side of the entrance to
the house. They are so tall that they move in the wind, which makes pruning
them an interesting experience, remarks Baldwin. On the lawns either side of
the borders are two allées of pleached hornbeams (*Carpinus*).

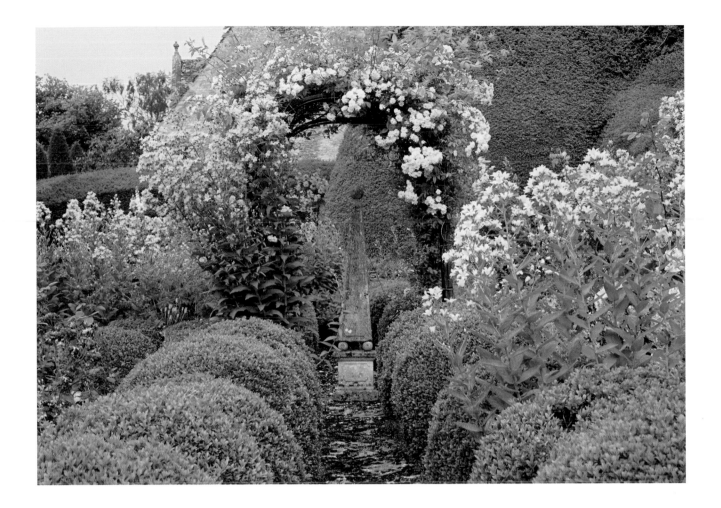

A path leads from the house through a yew hedge to the Rose Garden, where clipped holm oaks (*Quercus ilex*) provide a central avenue, and box balls mask the leggy growth of the roses themselves. It is a very effective variation on the usual box hedging – the roses look as though they are growing in a bed of moss. Box and roses like the same sort of soil – neutral and well drained – so they are good partners.

From the Rose Garden, you pass the bell tower and the barn and come to the Black Water, a still pool that mirrors the sky and the surrounding trees. A solitary post, painted in stripes like a mooring for a Venetian gondola, stands at the jetty. How is the water kept free of leaves? Two people, one each side of the water, pull a thick rope along the surface, says Baldwin, and this scoops up any detritus.

Water is a constant theme at Westwell. As well as the Black Water, there is the lake (recently restored by experts from Bibury Trout Farm) and the double rill, which runs down from the Rose Garden towards the orchard. Cunningly, old roof tiles of different shapes have been inserted into the channels, so that each rill makes a different sound as the water flows through it.

Box balls in the Rose Garden provide an effective variation on the usual box hedging – the roses look as if they are growing in a bed of moss.

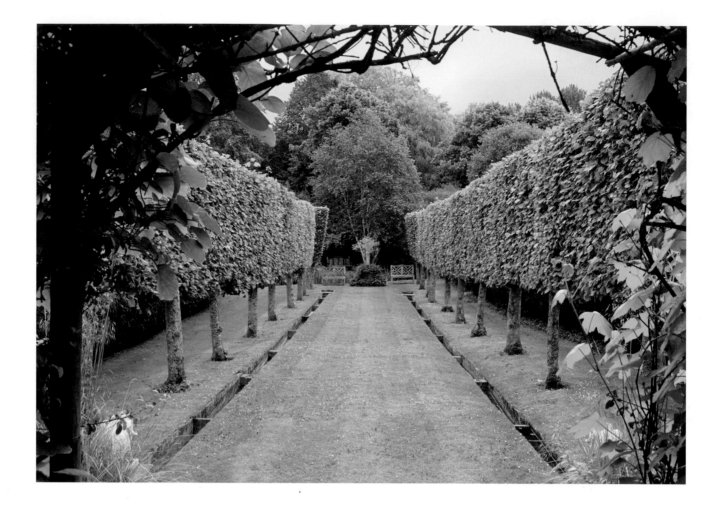

ABOVE Terracotta tiles of different designs have been set into the double rill to change the sound of the water as it flows over them.

OPPOSITE Each of the garden 'rooms' at Westwell has its own distinct character. Some features, such as the wicker hurdles around the vegetable beds, or the wisteria pergola, are traditional, while others, such as the diagonal lines of lavender in the Breakfast Garden, or the Black Water (with its Venetian-style mooring) are more contemporary in feel.

Close by is the swimming pool, enclosed by a beech (*Fagus*) hedge. It has two little pavilions, modelled on those at Hidcote, which at first glance appear to be his and hers changing rooms. In reality, only one is a changing room, while the other houses the pump and the heat-exchange mechanism for the pool.

Sadly, Anthea Gibson died of a heart attack in 2010 at the age of sixty-eight, but the enthusiasm that she poured into her garden is still apparent. Baldwin affectionately remembers that: 'We used to be able to time how long it took for the car to arrive at the house for the weekend, and then for Anthea to appear in the garden. It was only a matter of seconds. She just could not wait to see how it was all looking.'

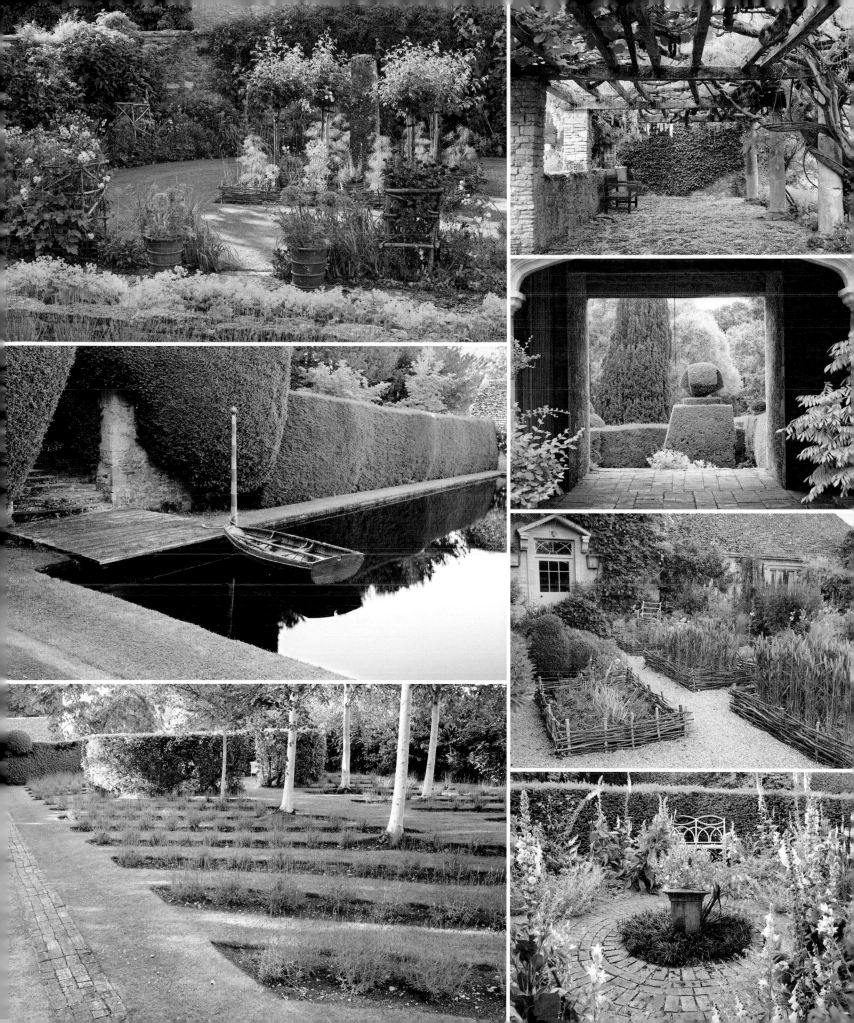

Garden opening information

At the time of publication, fourteen of the twenty gardens open to the public at some time during the year. Please check opening times on the website or with the garden owner before travelling. The six gardens that do not open to the public are: Burford Priory, Cornwell Manor, Dean Manor, Kingham Hill House, Sarsden and Walcot House.

Abbotswood

Stow on the Wold, Cheltenham, Gloucestershire GL54 1EN
Open to the public two days a year under the National Gardens Scheme (NGS); www.ngs.org.uk/.
Tel: 01451 830173.

Ablington Manor
Ablington, Bibury, Cirencester GL7 5NY
Open for charity one day a year and for private parties by appointment.

Asthall Manor
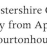
Asthall, near Burford, Oxfordshire OX18 4HW
Open to the public one day a year under the National Gardens Scheme (NGS); www.ngs.org.uk/.
Tel: 01993 824319; www.asthallmanor.com/.

Bourton House
Bourton on the Hill, Gloucestershire GL56 9AE
Open to the public regularly from April to October.
Tel: 01386 700754; www.bourtonhouse.com/.

Burford Priory: NOT open to the public.

Colesbourne Park
Colesbourne, near Cheltenham, Gloucestershire GL53 9NP
Open to the public for snowdrop days at weekends throughout February.
Tel: 01242 870567; www.colesbournegardens.org.uk/.

Cornwell Manor: NOT open to the public.

Cotswold Wildlife Park & Gardens
Bradwell Grove, Burford, Oxfordshire OX18 4JP
Open to the public every day except Christmas Day (25 December).
Tel: 01993 823006; www.cotswoldwildlifepark.co.uk/.

Daylesford House
Daylesford, near Kingham, Gloucestershire GL56 0YG
Open to the public one day a year under the National Gardens Scheme (NGS); www.ngs.org.uk/.
Tel: 01698 658888.

Dean Manor: NOT open to the public.

Eastleach House
Eastleach, Cirencester, Gloucestershire GL7 3NW
Open to the public by appointment under the National Gardens Scheme (NGS); www.ngs.org.uk/.
Email: garden@eastleachhouse.com; www.eastleachhouse.com/.

Eyford House
Upper Slaughter, near Cheltenham, Gloucestershire GL54 2JN
Open to the public two days a year under the National Gardens Scheme (NGS); www.ngs.org.uk/.

Kingham Hill House: NOT open to public.

Rockcliffe
Upper Slaughter, Cheltenham, Gloucestershire GL54 2JW
Open to the public two days a year under the National Gardens Scheme (NGS); www.ngs.org.uk/.

Sarsden: NOT open to the public.

Sezincote
near Moreton-in-Marsh, Gloucestershire GL56 9AW
Open to the public from January to November.
Tel: 01386 700444; www.sezincote.co.uk/.

Stowell Park
Yanworth, Northleach, Cheltenham, Gloucestershire GL54 3LE
Open to the public two days a year under the National Gardens Scheme (NGS); www.ngs.org.uk/.
Tel: 01285 720247; www.stowellpark.com/.

Upton Wold
Moreton-in-Marsh, Gloucestershire GL56 9TR
Open to the public by appointment and one day a year under the National Gardens Scheme (NGS); www.ngs.org.uk/; www.uptonwoldgarden.co.uk/.

Walcot House: NOT open to the public.

Westwell Manor
Westwell, near Burford, Oxfordshire OX18 4JT
Open to the public one afternoon each year under the National Gardens Scheme (NGS); www.ngs.org.uk/.
Tel: 02074 998572.

N

BANBURY

18

4

Moreton-in-Marsh

16

1

7

CHELTENHAM

9

13 Chipping Norton

12

14

Stow on
the Wold

15

10

19

Bourton on
the Water

5

3

6

17 Northleach

Burford Witney

Painswick

20

8

OXFORD

STROUD

2

11

Bibury

CIRENCESTER

LOCATION MAP FOR
SECRET GARDENS
– of the –
COTSWOLDS

2.5 km/1.5 miles

Index

Acknowledgments

I'd like to dedicate this book to the memory of my husband, Craig Orr, who did so much to encourage me both as a gardener and as a writer. I'd also like to thank my children, Rory and Nevada, who probably would not have chosen to visit so many gardens while growing up.

I would like to thank Anna Pavord, Mary Keen, Catherine Horwood and Anne Wareham for showing me that garden writing is about what goes on inside people's heads as well as in their gardens.

I also owe a huge debt to my dear friends Joanna Blythman, Penny Fox, Marty Wingate, Charlotte Weychan, Michelle Chapman, Helen Johnstone and Lynda Brown, without whom I would not have survived the move to the Cotswolds and the writing of this book. Finally, my thanks to Helen Griffin at Frances Lincoln for having faith in me, to production team Joanna Chisholm and Anne Wilson for their patience, and to Hugo Rittson-Thomas, whose dedication to his craft is so great that he even taught my dog to steal biscuits off the table in order to get a good photograph. **Victoria**

To all the owners and gardeners for sharing their wonderful creations so generously. A special thanks to Victoria Summerley whose golden words illuminate with history and intrigue as the very Cotswold stone itself. I would like to acknowledge the hard work and dedication of my studio assistants Dominika Cecot, Romain Foquy and Edwina Dvorak.

I would also like to thank Danny Chadwick, David Macmillan, Mr and Mrs P Fleming, Lord and Lady Rotherwick, Dr C Wills, Major Tom Wills, Mr and Mrs A Wilmot-Sitwell and Andrew Lawson.

To my wife Silka for so much, and to Helen Griffin at Frances Lincoln, for her wisdom throughout. **Hugo**

The extract from *The Education of a Gardener*, by Russell Page, is reproduced by kind permission of Random House, while the extract from *The Well-Planned Garden*, by Rupert Golby, is reproduced by permission of the Octopus Publishing Group © Rupert Golby 1994.